The vision of the world as a thing

VISUAL
THE VISUAL
A VISUAL LANGUAGE (does it exist)
CURIOSITY —
DECORATION
DESI TO
TO
QUESTIONS?
POWER — death

STINCT.
RESPONSIBILITY
RESPONSIBILITY
OTECTS

(all children draw)

SO

On The Way
To Work

Damien
Hirst

Gordon
Burn

ff

faber and faber

INTRODUCTION

SNOOKER ROOM.
DH'S HOUSE.
COMBE MARTIN
THURSDAY.

29.03.01

Maia Norman, Connor Hirst, DH, Mexico, 1999

DH, 1983

'First thought, best thought'.

This was the principle that Allen Ginsberg, a practicing Buddhist all his adult life, lived and worked by. It's reiterated in Damien Hirst's belief that 'once you rub something out, it's still there really, isn't it? I mean it actually physically is there. That's why [Francis] Bacon's fantastic, because he doesn't rub out. He just accepts his lot... It's not like acting, being an artist. It's like: "Live with it, you cunt". If it's weak, that's you. To be weak publicly is a great way to make art.'

It was this kind of 'first thought, best thought' risk-seeking spontaneity that Hirst demonstrated when it came to recording these interviews. It's what made transcribing the tapes, usually a miserable chore, not a hard thing to do. In every re-wind, every chance of a new nugget. A bit like music, then. A bit like listening to Art Pepper, or a player like Miles Davis, who basically wouldn't tell anybody what to do: his arrangement was the choice of musicians you had in the first place – 'The shrug', as one writer on Davis put it, 'that half-conceals a depth of thought and feeling.'

Not giving a shit for the opinions of others is one of the things that has freed Damien Hirst to make an uncute, uningratiating, non-provincial, very un-British kind of art. The conversations here are largely as they came. They have been edited only for reasons of repetition or libel.

DH, Gordon Burn, 2000

6

<Gordon Burn> You usually expect a lot of wastage with these kind of tapes. We've had to throw very little away.

<Damien Hirst> You sent it to me in dribs and drabs and bits and pieces. So I read a bit and forgot about it, read a bit and forgot about it... I read the first bit and I thought it was good. Then that other stuff started coming in and I just started getting like: *Oh God*. I lost the context of it.

It was mainly talking to [the artist] Georgie Hopton, who said it was good to see change and development happening – a person developing – that convinced me to use the early tapes. The book was only going to be what we put down in the last two years originally. It's great, because it's kind of erratic. It doesn't really begin anywhere, and it doesn't kind of end anywhere. I mean, you could record your whole fucking life, couldn't you? It's ridiculous.

It's a relief to have it. Because, like you said today, there's no way you could create it.

You couldn't go back and re-do it. You couldn't go back to you in 1992 sitting in the ICA, young and keen with your show up there...

Because it's dialogue and not something you've worked out. You say one thing, and then you say another. It's like, when you first read it, you just think: Ah fucking hell. You're letting this thing loose. It's sort of chaos.

Like, going through it, I had fucking massive fear. *Massive* fear. When I got the first [transcripts], they're quite tame really, and I thought it was alright. But then when it started... I don't know. I kind of edit myself, d'you know what I mean? Normally. In the media. A big self-edit. But here... So your first reaction is it's fucking terrible. What you're saying's terrible. It's like a way that I am, or something. A portrait. A moving picture. Plus it's the way that you were. I was never aware that I'd changed.

You said when you read the 1992 interview for the first time recently, you ended up close to tears.

Just because I'd changed so much. It just seemed so far away. I'd kind of forgotten about it. It's just... I don't know... Just so fucking optimistic, and hopeful. I think I was kind of fooling myself that I was still that optimistic. That I hadn't changed. Then you realise that you've picked up this fucking baggage,. . and all that stuff's gone.

What was striking in the early days was that, not only were you making original art, but you could talk about it in an enviably original way. It seemed to me that you'd worked out your script for what interviews would be like; that you had rehearsed them in your head for when you made the cover of the NME.

There was one point when I was reading [the book] where I was actually reading it as if it was something that I'd created with you like a few years ago. Where we'd actually sat down and worked out what was best to say and how we should say it. And I was reading it like we'd done that. Until I thought: No, fuck off, it's not that; this is what I was actually saying. It's just dialogue. It's what we said when we were saying it. The truth doesn't come into it, at the end of the day.

It's odd that in most situations you're very unforthcoming. You're actually extremely reticent to engage in conversations, particularly with somebody you might not have met before.

I suppose I didn't used to be like that.

Talking through the media – living in the media – it's very easy to… There's something lacking. There's something unreal about what you really feel about what's really going on. I think that's what's good about this. I'm so pleased that we've got it. Because it's *so easy* to not have it, d'you know what I mean? And then nobody would ever know that you've actually fucking been thinking. And you end up at the end of it with a big red nose on like some fucking clown, going *Ha-ha-hee!*

Once you get attention – once you get famous – people don't want dialogue. People don't want to fucking know what your work's about. They want to climb on board, get involved and have a piece of it. They don't really want to know what you're actually driving at. So you shut the fuck up.

But I definitely feel that with it we've got something really fucking helpful. It's not a *story*. But it's just enough of a chunk of a thing to give you a feel…

It feels comprehensive. And yet you know there have got to be lots of bits that are missing. So that you could almost have a different, parallel version.

I'm always being called on to stand up and respond to criticisms about what I fucking 'represent'. But rather than to have to stand on my hind legs and *explain* what's important and de-dah-de-dah, it's important to be able to be seen to just shit it out. Just this poured-out steaming chunk, with inconsistencies and contradictions, where people can make their own mind up what they think. And then everybody's complicated.

It's partly a question of language. I thought it was really good to hear complex, abstract, often difficult possibilities articulated in trash talk and what people with a conventional intellectual perspective would regard as gutter language.

I was laughing my fucking head off, reading it. But there's a kind of poetry with it as well. It's not like we're just going: Ah they're all fucking cunts…

[Pause] What about my dad painting spots on the door? He painted spots on our front door at 24 Stanmore Place, Leeds. Blue spots on a white door. He drew round a bowl. 24 Stanmore Place. Can't miss it, missus. White door with the spots.

Why did he do it?

I don't know. You'll have to ask me mum. Shall I ask her now? [Shouts through to the next room] Mum! Why did dad paint blue dots on the door?

<Mary Brennan> Because I asked him to! Because I liked them!

We've got her going now. She was probably winding my dad up about being the same. Because she wanted to be different. [Shouts] Didn't you! You wanted to be different!

And that's a good ending.

Oh God. I hope I don't die soon. 'Cause it's just one of them books, d'you know what I mean? Kind of said it all. And then – *Pop!* A babbling fucking madman. Gone.

That's a better one.

Angus Fairhurst, DH, A Couple of Cannibals Eating a Clown (I Should Coco), 1993

First published in 2001
by Faber and Faber Limited
3 Queen Square London WC1N 3AU

Designed by Jason Beard at Barnbrook

Printed in Italy

A CIP record for this book
is available from the British Library

ISBN 0-571-20257-8

2 4 6 8 10 9 7 5 3 1

also by Damien Hirst

I WANT TO SPEND THE REST OF MY LIFE
EVERYWHERE, WITH EVERYONE, ONE TO
ONE, ALWAYS, FOREVER, NOW

THEORIES, MODELS, METHODS, APPROACHES,
ASSUMPTIONS, RESULTS AND FINDINGS

also by Gordon Burn

non-fiction

HAPPY LIKE MURDERERS
SOMEBODY'S HUSBAND, SOMEBODY'S SON
POCKET MONEY

fiction

ALMA COGAN
FULLALOVE

Damien and I met for the first time in January 1992, when a magazine sent me to write about *Young British Artists 1,* which was a few weeks away from opening at the Saatchi Gallery. The term 'YBA' hadn't yet been adopted as shorthand for the emerging 'movement', mainly of former students of Goldsmiths' College in South London; but Damien Hirst was already marked for notoriety. His shark for *YBA1* (The Physical Impossibility of Death in the Mind of Someone Living), and his sculpture featuring a dead cow's head and a dirty cloud of flies (A Thousand Years), would establish him as the ringleader and alpha talent of the most startling artistic development in Britain for half a century. The 1990s in London would soon seem like a time when all of it was easy and like a party. You had an idea and you grabbed it and – hey! – next day you were in the papers.

'Don't you dare make me laugh,' Rachel Whiteread had warned him when they were having a group picture taken a few days earlier. And this seemed to be his reputation: for being a bit of a knockabout, a joker, a load of laffs. All of which he is, and was.

He had a show called *Internal Affairs* running at the Institute of Contemporary Arts on the day we arranged to meet there to do the interview. The pivotal piece in the show, I want to spend the rest of my life everywhere, with everyone, one to one, always, forever, now, at first seemed nakedly autobiographical; it seemed to suggest playfulness and easy optimism and barmy insouciance and all the things that people would come to associate with Damien Hirst. At one end a ping-pong ball bobbed breezily on a fragile column of air. But the lightness and carnival spirit were counterweighted by the elongated glass plinth to which the air supply was anchored: this consisted of a couple of uprights with lethal lacerating edges, raw from the industrial cutting, with the potential to inflict horrible damage on anybody unlucky enough to trip and fall.

The fragility of existence was Hirst's big theme from the beginning. The action of the world on things. It's why he puts things behind glass, and in formaldehyde in big steel and glass cases: to hold off the inevitable decay and corruption; as part of a futile effort to preserve them.

Damien Hirst
I'll Love You Forever
1994

Steel cage, padlock and medical waste
4 x 4 2.5 feet
Photo Credit: Stephen White

Francis Bacon said repeatedly that he was committed to 'the brutality of fact'. Echoing this Damien Hirst has said he likes 'the violence of inanimate objects'. Typically this has meant everyday objects – Formica-ed tables, office chairs, ashtrays – being bifurcated and mutilated in predetermined, precise ways in a symbolic enactment of the 'hurtability' of human beings. At other times, the violence has resided in Hirst's choice of object – most characteristically, medical apparatus and equipment with the power to lift pain and its attributes out of the body and make them visible. Duchampian readymades have been transposed from the morgue and the operating theatre to the gallery on the basis of the cold cargo of dread and terror that they carry.

Sometimes I Avoid People in the *Internal Affairs* show at the ICA consisted of two coffinated glass cases, one vertical, one horizontal. Each case, which contained departments for the storage of bodily waste, was supplied with medically useful gases – oxygen, nitrogen, an oxygen and helium mix – from a range of colour-coded cylinders. In *He Tried to Internalize Everything* (1992–94), an anaesthetist's black rubber mask and Halothane dispenser and a swivel chair whose back has been grievously broken – cut through the spine – are encased in one of Hirst's signature twin-celled vitrines.

The direction of his work has always notoriously been towards death and dwindlings. He has said, 'I like creating emotions scientifically.' His disinhabited dumb boxes speak of modern death in tiled hospital rooms, and silent technologized removal. They speak, that is to say, of how death has become increasingly mediated; of how the technological media, which enormously reinforce and heighten the illusion that death happens only to others, have put a distance between us and our own dying.

He was still sharing a flat with friends in a tower block in Brixton in early 1992.

The interview was recorded in the bar at the ICA, surrounded by early lunchers.

13

INTERVIEW 1

INSTITUTE OF CONTEMPORARY ARTS. LONDON JANUARY 1992

publ. 2002

<Gordon Burn> What is the relationship between yourself and the art market? <Damien Hirst> The art market? I guess it's… Well, there's as many art markets as artists, aren't there? You mean finance, money…

Just what people generally think of when they say 'the art market'. They normally think of the relationship between artists and money, I suppose, don't they?

I enjoy it. Completely. A lot of people have problems with it; questions of integrity somehow. But I've always thought that to be an artist and make something in your studio and wait for someone to look you up, then come along and take it away… It made no sense whatsoever. So I've always… Like, early on, I got a space and did a show and then… I find the money aspect of the work part of its life. If the art's about life, which it inevitably is, and then people buy it and pay money for it and it becomes a commodity and manages to still stay art, I find that really exciting.

Why is there such antipathy to the idea of a Goldsmiths' 'school'?

Within the artists, you mean, or outside?

I don't know, I might be wrong. I just sensed there was a growing anti feeling.

No, there is. I think when a lot of things are going on that are interesting, people kind of want to pin it down. And Goldsmiths' is the easiest way to pin it down. And then, as soon as you say, 'Goldsmiths',' you exclude a lot of other colleges. I think, in England especially, people are anti any kind of success really. You're struggling and you cut your ear off; they like that kind of an artist. Whereas if you're making money… They'd rather you were working on a building site and painting in a garret somewhere. I'd say that's a problem.

The weird thing is that what you did, finding spaces and getting finance and organizing shows, seemed like the logical thing to do. I don't see why it seems like such a revolutionary idea or something.

I think it was the logical thing to do. I mean, I had a bit of crisis at one point, where I thought I was just totally egocentric and a complete megalomaniac.

At what point?

When it got successful. My first intention to do this show was just, like, I didn't really expect anybody to go there and I didn't make a big effort. The only thing was, *Freeze* is the kind of exhibition that everybody says they saw and hardly anybody did.

I got some stuff through the post, I don't know if it was for Freeze *or one of the other ones. It was quite slick stuff.*

No, it was one of the other ones. That was afterwards. I did *Freeze* when I was in the second year at Goldsmiths'. And then, after that, I was living with some people and I got working with them, and they were very much more organized. So I was kind of curating, and they were doing all the organization. So it was a lot slicker. But the show wasn't nearly as good. I mean, I was just really lucky with *Freeze*. The first people I approached gave me the building, and the second people I approached for money paid for the catalogue.

Anthony d'Offay was one of the people who put up the money?

Not for *Freeze*… *Freeze* was when I worked there [at d'Offay], but I never got any money off him. Everybody gets it wrong. That was for *Modern Medicine*. He put a thousand pounds into *Modern*

Medicine. That was the whole idea. When we did *Modern Medicine* we thought it would be great to get all the galleries to put some money up and have a big list of names in the back. But they all gave quite a little bit and it's not really that good an idea.

They did all cough up something?
The kind of maximum was a thousand.

Until recently there has always been a resistance in this country to young artists. You were still considered young at forty-five.
Yeh, I think so. I think it's stupid, though – when you think that Gèricault died when he was twenty-six, and throughout history people produced masterpieces when they were twenty-two and twenty-three. I suppose in England people have an idea about the way things should go. People want to be in control. And in the world I don't think you can be in control. Things pop up and disappear all the time. Whereas a lot of people like maybe Nicholas Logsdail [of the Lisson Gallery] have an idea that you work hard for three years in the studio and then you get a show. You leave college, you wait for three or four years, you watch, and you, you know, 'mature'.

None of the people you came up with have gone to the Lisson, have they?
Not my generation.

Was that a deliberate thing, not to get locked in with Richard Deacon and Tony Cragg and the people who had gone before?
I think a lot of people in the year above me talked to Nicholas, and he said, 'I want to watch you for three years.' And then Karsten [Schubert] stepped in and said, 'I'll give you a show now.' So they did that instead. I mean, Nicholas has always been interested. I've always talked to Nicholas. But I think because he's already got a generation of artists from Goldsmiths', he maybe thinks that if he starts showing these young people, he's going to kind of turn Richard Deacon and people like that... They're going to look old-fashioned. They're going to be the old generation if he takes on a new generation. Maybe there's a bit of that in it... It happens to everybody. Not very often will you make a piece of artwork that's going to stand the test of time. Maybe not ever.

Damien Hirst
Installation
FREEZE
1988

Canary Wharf, London

Photo Credit: Courtesy Jay Jopling, London

The link I haven't been able to make is between the neo-expressionist painters of the 1980s – the 'bad' painters like Schnabel and Salle – and the kind of work that you're doing. Was it just a reaction against all that mess and pain and *angst*? Because your work is characterized by a sense of cleanness and control and calm. It's a long way from all the painterly splattering.
For me, personally, I don't think you can have one without the other. So I want a kind of very clean, minimal, kind of acceptable look, with an *intellectual* splatter. You know: you can look good, but you're dying. That kind of thing. Something like that. That's what interests me. But I think that's painting

as well. It's a very different thing, painting. I think even Ian [Davenport] is more to do with sculpture than painting at the end of the day, in his approach. I mean Goldsmiths' is a college where they don't have a distinction between painting and sculpture, so maybe that's something to do with it. It's just like, you go there, and you can do anything. And that's the reason I went there initially.

You made a conscious decision to go there because of that?
Yeh. I'd had two years out before that. I applied to St Martin's straight out of foundation and didn't get in. Then had two years out and looked around in that two years, worked on building sites… I had a friend, Marcus Harvey, who was there [Goldsmiths'] and I kind of looked round all the colleges and for me to make a decision at that point as to whether I was going to do paintings or sculptures was ridiculous, 'cause I was doing everything. So I just thought, well, that's the place for me.

Who was the key figure? Richard Wentworth taught there, didn't he?
Yeh, I was in his group in the first year. I like his work. I think he's good. But I think with all that Lisson

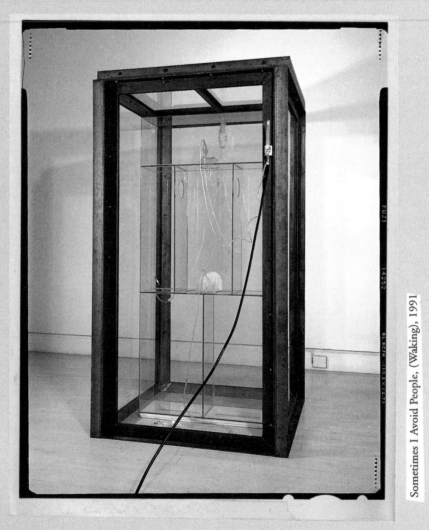

Sometimes I Avoid People, (Waking), 1991

school there's a kind of quirky sense of humour that I don't like really in art; something that's a little bit jokey, which makes you able to dismiss it. They're kind of nice objects. But, at the end of the day, with all good art I always want to feel something about my existence or something. Not have it driven down my throat or anything. Just somehow be reminded. Even if it's just laughing hysterically, I want to feel something. I just want to *feel*.

Your work is being compared to the minimalism and conceptualism of the 1970s – to idea art, that often only ever existed as that; as an idea outlined on a piece of paper. Yours is almost the opposite: the work exists, and its existence encourages explanations or explications of what it might mean; of why it's there.
I'm kind of old-fashioned, I guess really, in terms of ideas.

Your work's quite romantic, isn't it?
Yeh, I think so.

I think the titles are really good. Do you get the title before you make the piece?
Every way round. If I think of a title I try and look out for… I mean, the title explains an idea in the same way a piece does. The ideas are always about something quite similar. They're all ideas that are floating around in my head all the time. Sometimes the title can sum it up completely, and sometimes the piece does. And then I try and find a title that does the same.

What's the title of the big piece you're doing for the Saatchi Gallery?
The Physical Impossibility of Death in the Mind of Someone Living. That's a title from a long time ago. That was the first piece I made. It was a line from an essay I was writing, actually. It was an essay about Robert Longo. I just wrote it was about the physical impossibility of death in the mind of someone living. And the kind of way it went *bubbada-bubbada-bubbada*… You know, kind of poetically, and the clumsy *b*s and *p*s in it, and how it tried to explain something that wasn't there, or was there. I just really liked it. It really stuck in my mind. And I'd always wanted to do a work with sharks. I'd always seen the shark as, like… I've always looked at pictures and read stories about sharks. They've got this really kind of powerful horror. And then I worked out that if I could actually get a shark into a gallery… Because I didn't want to paint one, and I didn't want to have, like, a really beautiful Cibachrome lightbox or a photograph. And then I thought, well, if I can get one in a big enough space, actually in liquid, big enough to frighten you, that you feel you're in there with it, feel it could eat you, it would work.

And is that how you sold the piece to Saatchi?
Well, he'd bought some other pieces. I had drawings made. When I can't afford to make pieces, I get models made and have drawings done and work it out.

You don't make them yourself?
Well, no. I'll do a drawing and then I'll have it done by somebody who's got a computer. It's like a fabrication drawing, basically, so it can be made from that drawing.

Do you go through an intermediary, dealing with somebody like Saatchi?
Yeh, well, I do, definitely. I didn't have to, but…

It surprised me that none of the other artists [in Young British Artists 1] I spoke to had ever met him.
I've met him, but I've kind of avoided meeting him. I know I'll meet him properly on this show, but I just think there's so much myth surrounding him, I think it's quite good that he's buying my work and I haven't met him…

He bought quite a few from me before. I mean, basically, I've always done my own shows. So when I did *Modern Medicine*, or *Gambler*, it's, like, you just put a price on it, and I wasn't involved in the selling side of it; two people I was working with were. So, basically, Charles goes in and says, 'I want it'; they say, 'Have it'; they invoice him; he buys it; Momart collects it. It's as simple as that really. Once you put a price on something, you don't really decide who buys it. Which I quite like as well.

Was this before your involvement with, er…
With Jay. Jay Jopling. He's not a gallery. He's twenty-eight. He just took on two artists. I'm one, and he's got another artist.

Who's the other one?
Marc Quinn. He did a portrait of his head in his own blood. It always looks like it's melting and it never does. Kind of like a sorbet.

How will you feel about your pieces at some time in the future being offloaded by Saatchi? Sold on. There's no commitment on his part that your work will be kept together.
I think that's the way the world is. I quite like it. I mean, it'll affect me and I'll have to adapt to whatever happens in that situation. I mean, a lot of galleries have an idea about control throughout the years, over prices and things like that. But…

People like Schnabel claim that when Saatchi bought his best pieces, the understanding was that they'd be kept together as part of this major collection. Is that just whining by Schnabel now, after the fact?
Well, maybe in earlier times Charles gave that impression, but I don't know anything about that. I mean, if he told people he was never going to sell them, and then did, it's kind of naughty and he needs his bottom smacked. Not a lot more than that. I mean, if you sell something to somebody, you sell it to them. I can't see how you can sell something to somebody and expect to have control. I find it quite exciting. I mean, I always find it easier to make work when things aren't going too well anyway. So it can come crashing down in twenty years' time, or ten years' time. When no one wants to know, I hope it'd inspire me to… make something else. Get another warehouse together and do a show.

There was one review of In and Out of Love, your butterfly piece in which the butterflies come out and fly around in one room, and then in another room downstairs they're captured, embedded in paint, dead. The reviewer drew parallels between this and Charles Saatchi with young artists, getting to them when they're unknown and cheap, collecting them and

watching the value rise. That wasn't in your mind when you made the piece?

I think it was. I mean, you know, I think about life and death on every level. In that way and any way. Like, with the butterfly show, I worked out loads and loads of trajectories of ideas. And when they're there, you know there are loads of others. Like you can think about death as stubbing out a cigarette or something. I'm aware of art, and people buying it and stuff. I mean, I don't think I purposefully put forward a readable idea like that into the work. But I'm interested in the kind of triggers that can stimulate that kind of thought. So, as far as I'm concerned, that's a perfect reading of it. I mean, I was aware of butterflies and collectors, and art collectors. So…

Nabokov was a big butterfly collector, wasn't he?

Was he? I never knew… There's something sexy about it as well. It seems like something to do with girls. Kind of. Or an aspect of girls. Something about putting a pin through that kind of beauty. Trying to keep something beautiful like that for ever. It's like in a relationship: do you want a relationship with a beautiful person – someone who looks beautiful; an accessory, straight out of *Vogue*? Or do you want a relationship with someone who is alive and is obviously dying? I know what I want. I want both.

When did death become the preoccupation it obviously is? Seeing people as disintegrating and decomposing even when they're well and alive?

It sounds really pessimistic… I think I've got an obsession with death, but I think it's like a celebration of life rather than something morbid. You can't have one without the other. I read something the other day that Marc Almond had written about Jacques Brel, or maybe Scott Walker, and it said that you listen to

In & Out of Love, 1991

him, and he's got this obsession with death. But every time it's like a really complete celebration of life. I mean, I don't think death really exists in life. I think the only thing that exists is an obsession with it. And an obsession with death is a celebration of life. It's that kind of looking for it, and you can't find it. I always want to slap myself on the head and go: Hang on a minute, you're dying – don't get too smug. It's unavoidable.

Are your parents still alive?
Yeh. I lost my grandparents that I was quite close to when I was about fifteen. I didn't realize it at the time, but I talked a hell of a lot to her about life. It was kind of a weird relationship for a grandparent. It was my grandmother. She'd tell me that Father Christmas didn't exist and all this kind of stuff when I was really young, and was really kind of logical with me. She's not my dad. I'm getting that from my grandma. So I'd got a very realistic relationship with her. I said, 'Do you believe in ghosts?' She said no, but she promised me that if ghosts did exist, she'd come back and haunt me until I died. She said, 'If there's any way they do exist, I'll come and let you know…' So I thought obviously they don't, after a few months. And then recently I kind of thought: Well, maybe they do, and she came back in a way that I don't quite understand.

Did Julian Opie break the mould?
I guess he might have done. I suppose he did to some extent. I don't think it's a case of breaking the mould, really. At the end of the day, what's art about? It's about life, and it's always been about life. Even minimalism. So I don't know. I think on one level he did. But then when you look at Bill Woodrow, Julian Opie's not a lot different to that in a lot of ways… D'you mean at Goldsmiths'?

In Technique Anglaise, they talk about him being the first one to leave Goldsmiths', get a West End dealer, become internationally known…
Maybe Julian Opie was the first time it was noticeable in that decade. I don't know. I mean, Frank Stella started painting for ridiculous amounts of money when he was twenty-two. I don't know how old Julian Opie was. I think maybe locally he did, but I don't think internationally he did anything particularly groundbreaking.

Was that whole 1980s movement in New York of any interest to you? Schnabel getting celebrity in that sort of way, and making lots of money and doing what he wanted to do? Was that in any way a model for how you wanted to proceed?
I guess so; in some ways it must have been. Obviously it's appealing. To be a… star. If you say it isn't, you're lying. Maybe that's another way of coming to terms with death anyway.

Did you ever like Schnabel's work?
I do like it, yeh. I like the plate ones definitely. I just like the idea of painting and making it difficult for yourself.

I interviewed him once and he was such an idiot. He was such a fool.
I think, with a lot of painters, you shouldn't expect them to be able to talk about the work… I think when you start to get successful there's a massive problem where you can't help but get smug. If everybody's telling you you're brilliant, you're already halfway to turning into an arsehole.

Eileen Brennan, 1984

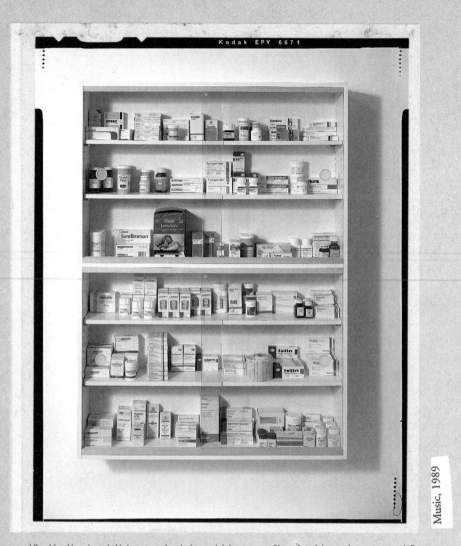

Music, 1989

What's the best thing anybody's said to you after looking at your work?
[*Long pause.*] I had quite a funny one. Someone was looking at the medicine cabinets, somebody who had worked as a nurse in a doctor's surgery somewhere, and she just stood looking at it, puzzling over it for ages. And I was there, and she turned to me and said, 'I can't work it out.' She wasn't somebody interested in art. And I said, 'What d'you mean, you can't work it out; what can't you work out about it?' She said, 'I can't work out the arrangement.' What she meant was, she'd worked with a lot of doctors who have their own personality. Basically you can tell what kind of a doctor they are by the way they organize their drugs – what drugs they have closest to hand; where they shelve barbiturates and the other drugs you use with barbiturates, et cetera. But I was unaware of what the drugs [in the medicine cabinets] do. I just put like with like. So I quite liked the idea that to a hell of a lot of people they looked so confident, but then to somebody who knows what's going on, you know, it's a mess. I suddenly realized there was a limit to the way this work could communicate and that if I'd've thought about that I could even have convinced her.

What was the thinking behind the medicine-cabinet pieces?

Well, everything. I think I'd just been in the chemist's and looked at them all and I was having a lot of conversations with my mum about my art. I'd been trying to explain loads of work to my mum, about what I'd been doing. She's an open-minded person, but she had a completely closed mind about it. 'Well, what's it for?' And there was no way of explaining it. And I was with my mum in the chemist's; she was getting a prescription, and it was, like, *complete* trust on the one level in something she's equally in the dark about. In the medicine cabinets there's no actual medicines in the bottles. It's just completely packaging and formal sculpture and organized shapes. My mum was looking at the same kind of stuff in the chemist's and believing in it completely. And then, when looking at it in an art gallery, completely not believing in it. As far as I could see, it was the same thing. And for a long time I'd seen that. I knew that was going on. And I was thinking, 'If only I could make art that was like that – that did that.' And then, in the end, I just suddenly decided to do it really directly. I've always really loved this idea of art maybe, you know, curing people. And I have this kind of obsession with the body. I like the way that you've got all these individual elements inside a cabinet related to organs inside a body. I like the kind of Koons consumerist feel to it. And then a lot of the actual boxes of medicines are all very minimal and could be taken directly from minimalism, in the way that that kind of minimalism implies confidence.

You like the way that researching a piece takes you into non-artistic territory?

Oh, I love it. Oh, definitely. Oh yeh, I love all that. The less I feel like an artist, the better I feel. Like a shark. It's great to go get a shark. Anything like that. Go to an abattoir. I really like it if I'm... I hate it if I feel like an artist. I like it if it involves a lot of people who wouldn't normally get involved with art. I feel that it's more about life then, which art has to be about. You can suddenly be wandering around... Like, I need to buy a settee now. I want to buy a settee, and it's fantastic to go out there with the artistic idea about buying a settee. I want a grey one that maybe looks a bit like a shark for a sculpture I'm making, and I've got an idea about what I want. I'll go round all the furniture shops and see if I can find it, and if I can't I'll actually get a furniture designer and I'll talk to him and show him some drawings. I mean, it's kind of vague; it's loose; it's minimal and grey. But there's no way I won't get this settee... I like it that I can sit at home and think, 'Oh, I need a settee, but I can't spend two hundred pounds.' But then for a sculpture I can kind of go, 'Three hundred pounds is fine.' A material cost, rather than a personal cost.

It must be a problem in a time when, on the say-so of the artist, anything can be art – domestic furniture, office furniture, forensic photographs, colostomy bags – to decide which readymades to put in the gallery.

It always has been. If I have problems with selection in what I'm doing I'll become instinctive, and if I have problems instinctively I'll become intellectual. If I can just kind of do it and it feels wrong, I'll work out a maybe fabricated reason for it to be a particular way. And then if I can't completely fabricate all the reasons for why it should be like that, I'll just say it feels right. But I just like taking things out of the world and putting them in a gallery. As long as they're there. And I think you can probably do that without galleries. I mean, you take things out of the world and put them in your house. I like these dual possibilities. I like the fact that you've got inside and outside. Life and death. You've got your insides. You've got yourself and other people. And I see all those kind of structures of understanding as ridiculous at the end of the day. I feel like the tools are completely useless to communicate anything. But then when you do actually communicate... It always amazes me that I can actually say something. And more often

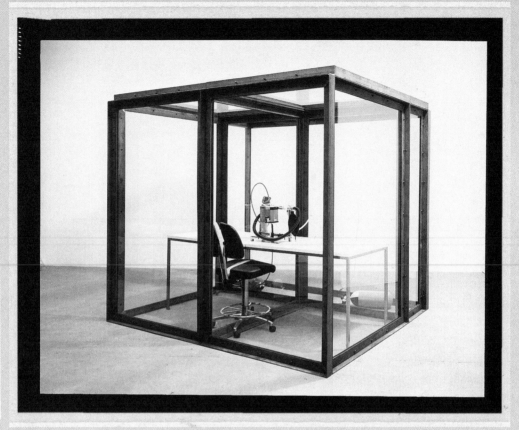

than not it happens when you're not thinking at all. You might say very clever things just by feeling your way in the dark.

An interest you seem to share with many of the artists of your generation is in taking something from life and changing it as little as possible. In other words, to make the artist's intervention as unobtrusive or undistorting as possible.
I think it's probably right. To me, that sort of implies that it's to do with a communication of ideas rather than a communication of personality. I mean, the more I change it, the more I'm talking about myself. Whereas the less I change it, the more I'm talking about a kind of universal idea. It's, like, everyone knows what a settee is.

But I *sneak* myself into my work, definitely. Because I believe in those kind of very human, abstract-expressionist paint-how-you-feel ideas. I can't get rid of those ideas. I've tried. And the more I try, the more they come out in ways I don't expect.

You mean like putting your emotions on display? Hanging yourself on the wall?
I mean like de Kooning: 'I'm sombre today so I'll do a brown and purple painting.' Really getting in there and going, 'This is me.' You know, like when I'm drowning in a melancholic feeling, I can't help wanting to communicate that to people or being with people who go, 'What's it all about?'

I'm aware that when you do that there's a massive amount of indulgence and enjoyment, but I don't think it's very good. A lot of painters I know are people who take it very seriously, these very sad emotional feelings, and make sadder purples... I've always had this idea that when anybody's told me you can't do something, I've always gone, 'Right, OK then', and found a way that you can.

You mean practically?
In any way. Physically, practically... In physics, you know, if they can't find the answer they want, they change the question. As long as you're prepared to do that, or change your way of looking at the question, there's nothing you can't do.

Tell me about the piece upstairs with the office chair and the desk. Where did that come from?
The title came first.

What is the title?
The Acquired Inability to Escape.

Oh, is that that one? I thought that was the ping-pong ball.
No, no. That's called I want to spend the rest of my life everywhere, with everyone, one to one, always, forever, now.

Ah. I thought that was The Acquired Inability to Escape.
No, but it would probably work. I think the changes in the titles are probably possible with a lot of the works. I mean, they're all about the same sort of thing anyway, I think... So, as I say, the title came first. I had a conversation with Ulrich Loock, curator of the Basel Kunstverein, describing a [Bruce] Nauman sculpture. He'd seen it in Basel and he translated the title for me. The actual title was Learned Helplessness in Rats and he said the title is something like 'The Acquired Inability to Escape'. He said it was called something like that. And I thought, 'What a fantastic title!' Then, when I saw the piece, and it was called Learned Helplessness in Rats, I just thought, 'Well, I'll make one called The Acquired Inability to Escape.' Silly not to use such a beauty title.

Where did the elements in the piece come from?
I'd actually made the case for another sculpture, and I thought, spatially, it had this... I mean, I work out all the measurements kind of from the body. So if it's ten feet long, that would be, like, seven feet wide and seven high. And if I have to divide it I don't quite want to be in the middle, so I do two and five, which makes sense if it's seven feet high. So then you get five by ten, 'cause it's half of ten... They're like logical reasons but not any particular reasons. Just mathematical reasons to divide it, so I'm aware that there's some kind of sense behind it. So I'm not kind of going: 'About there.' I'd really hate to go: 'All right, I'll divide it – I don't know – round about here.' I don't want to make that emotional decision. So I'll do it very logically.

It just seemed like a really eerie space. I was going to have it for butterflies. So the gap was for butterflies to get into the other half.

The corridor makes it, actually. The added-on narrow cell. If it was just a simple box with a desk in it, it wouldn't work, I think.

When it stopped being just a vitrine, the space had to have a purpose. And it kind of tied in completely with the objects in it. It's got that kind of narrative mystery, or something.

It's slightly reminiscent of a train – the old trains with individual compartments opening off a corridor.

It's funny, when I made it, I put the middle piece [a glass partition with a narrow horizontal gap at roughly head height, running the full length of it] in first of all… And I kissed someone through it. I was on one side and they were on the other side, so I put my lips through and kissed them. It was kind of weird. Like a train window or something. But I just did it as a joke. It wasn't anything. I was just messing around, installing it. But I remember when it was installed, I suddenly thought about that: two people, one either side, being ever so physically close, but not any more…

I mean, I just wanted a gap from one side to the other. In the fly piece I had holes – four, like in a die. 'Cause I needed holes, and it was die-shaped, so with the holes cut in it, it looked like a dice. So then I went with it, 'OK, I'll have four.' Then I made another one: 'OK, I'll have two diagonally.' Like that. So it seems a bit scientific, the reasons for it.

In & Out of Love, 1991

Is there a floor in those things, a bottom?
No, they're a bit too heavy. But I like the fact of the gallery floor. Because then they just kind of take the space – they define the space; they don't enclose it completely. I've made one with a floor in, but it's a different piece altogether.

Are you angry?
No. Except when I'm angry. But looking at it on average, I'd say no. Confused, maybe.

There's a Gilbert and George photo–sculpture called Are You Angry or Are You Boring?
I don't think there'd be a problem with being either, really. Artistically.

What are the dangers of growing up in public?
Not being aware of it. I guess I am aware of it, but if I wasn't it might be a problem. People don't grow up in public anyway. I wouldn't do anything that I wasn't sure was going to work, publicly. But growing up isn't about that, is it? I think I make it kind of appear as if I am sometimes. But I always try out everything before I show it to some extent. And I'm always aware that, even if it doesn't work, it's going to be seen only in a good way; that at least I made the effort to make it work.

With the butterfly piece, was there any possibility of you falling flat on your face? That the butterflies wouldn't emerge when they were supposed to and the upper part of the installation would remain empty?
Well, I had them in my bedroom for ages. I mean, I tried it all out. I had a bedroom full of butterflies... Something could have gone wrong. But I had everything on hand. I mean, I had people I could buy live butterflies from at the last minute. Because obviously it's like everything – any kind of theatre, or anything.

Butterfly breeding's a bizarre thing. I think they might stop it quite soon. I just got the *Yellow Pages* out. I remembered somewhere when I was a kid where they had a butterfly house. And I went there and they gave me a load of addresses and I phoned them all up. 'Oh yeh, what d'you want? Two pound for giant, one pound fifty for medium, a pound for small.' For live butterflies. Pupae were a hundred quid for a hundred, something like that.

Everybody likes butterflies at the end of the day. It's like, you know: butterflies are beautiful; maybe the artwork isn't. Actually, doing the show made me realize butterflies aren't that beautiful really. The thing that terrified me was that my idea was as clumsy as anybody's idea of butterflies. Someone said to me about the show, 'It's a shame they've got the hairy bodies in the middle.' To me it seemed an *amazing* thing to say. And I kind of went: 'Yeh, I know what you mean.' My idea was basic: 'I'll do a show with butterflies in it.' You think about it in your mind; and then you have to see it in reality. You've got an insect living out a life cycle that only lasts four weeks. When I first thought of the show I thought of, you know, birthday cards. It's unavoidable. Pretty butterflies and pretty flowers and love. The image is so drenched in all that kind of stuff that the real thing doesn't exist. And when you see the real thing, it's hardly *Playschool*. Which I quite liked. Because I'd called it *In and Out of Love* and my ideas of love are really similar. I do have the birthday-card kind of idea, and then there's the harsh reality of life... I quite liked *In and Out of Love* being like on and off, or black and white, or life and death. It's *In and Out of Love*. And I never defined which installation was which. They were both *In and Out of Love*. Two installations.

after write about iconography of memento mori

29

How do you feel about the trappings that these days come with being an artist – promotion, publicity, openings...

I love all that. I do. I just like the fact that you've got art, and then you've got all this other stuff that goes with it. I see it as... transient. I don't see it as a solid thing you have to do, or that the artwork has to be involved in. But I quite like the idea that... I don't know. I just like it. I see it as the way the world is. I like the fact that there's all that kind of stuff going on. I like the free drink. You go to an opening. It's a really good way to have a party and not trash your own house.

You must be to some extent surprised that you can sell art, like the flies and the shark, that is so difficult to show and store. Preserving the shark when it's not being shown has to be a nightmare.

I think people always buy good art, and I think I've always been aware of that. It's like, in a time of crisis, people stop speculating. For me, as an art piece – and I didn't expect to sell it; I knew that it was a good idea and *maybe* I would; I made all the drawings so it existed inasmuch as it needed to exist, for minimum expenditure, for what I could afford.

I really enjoy finding a way to make things acceptably possible without affecting the work. For instance, Richard Wilson, who's done the oil piece at the Saatchi Gallery, which I think is brilliant, did another piece which really pissed me off. There was an old swimming pool with a gallery in it, and he had a jet of water blowing from outside in an arc to the other side of the gallery. It was a really good idea. But he said that he had real problems with the jet of water splitting and going all over the floor and he couldn't get it, like, the thirty feet or however far he wanted it to go. So he ended up putting a tray down, which *really* pissed me off. The tray, the drips... To me, I wish he'd really not done the thing. There must be a way. You can get a thirty-foot jet of water that doesn't drip everywhere, I'm sure you can. Anyway, maybe he'll do one that doesn't drip. Maybe he will. I doubt it.

How are you being affected by the recession?

Not at all. What recession? [*Laughter.*] True, that is. Absolutely not at all. I've sold more work in the recession than ever before, for more money as well. I've sold everything I've ever made...

People build you up. But, at the end of the day, if you're fashionable, you're going to be not fashionable. There's nothing you can do about it, no matter how good the work is. People go, 'Ooooh have you got a Damien Hirst?' They're going to be wearing flares next week. What I do is limited, so...

Being bought by Saatchi is fairly intimately connected with fashion and the boosting of reputations, to put it mildly.

Not as much as it used to be. And, like you say, if he sells it, I have a problem. And he will. He sells off everything. Tons and tons of stuff. Everybody. But that's what he does, you know. He's interested in money, and that's probably why he spent all that money on the shark piece. Because it's like: he's got all this work – he's got about six pieces, or more maybe – and then he thinks, 'If I can pay sixty thousand for one, all this goes up in value.' Then it gets to a point where you can't get it up any more, so he flogs it all off and finds another artist. I don't mind all that though.

I don't think of it in terms of the ideas. But because I'm aware of fashion, only in a way of being alive in the world today, I'll make work and it will be fashionable. It's unavoidable. It comes out in the work. The work looks fashionable, so he [Saatchi] buys it. But hopefully it can stand up to that. From my point

of view I just hope that I can kind of be like the Beatles and have no problems with having short hair at the beginning of the 1960s and long hair in the 1970s. I really like that as a model to look at. I like the fact that, without losing integrity, they can kind of change through fashion and not look back at the 1960s and vomit, and try and deny it; you know, their Beatle suits, or whatever...

It was sad that last interview John [Lennon] did with Radio 1, when they asked him about not being back to Liverpool for ten years and his response was: 'Where's Liverpool going? Liverpool's going to be there.' And he was dead twenty-four hours later.

I always think the Beatles' relationship with their past is a bit like turning round and telling your parents to fuck off, but you can't help loving them at the end of the day, can you? Like Leeds. I always kind of wish that it was there for me, but it just isn't. But I love it, 'cause I was brought up there.

I like Bradford. I spent two years living up there doing a book about the Yorkshire Ripper. I remember all that. I was still living there then. I've got a younger sister, and I remember massive arguments because she wasn't allowed out and I was. I walked past one of the bodies in the bush one night. The one in Canal Gardens. There's, like, a canal there and loads of flowers. It's called Canal Gardens. I actually walked through Canal Gardens where the body was found and the body must have been there and I never knew. With a friend. 'Cause we'd, like, climbed in; we used to go nicking fruit and messing around in the middle of the night. And the next morning about ten we went down on the bus and all the road was blocked off and they were bringing the body out. Terrifying. All my friends' dads got interviewed. They interviewed everybody.

What does your father do?

I don't know. I don't know who he is. My real father, I mean. That's why I was born in Bristol. My mum got pregnant. It was the first time she ever had sex with anyone and he didn't want to know, so she moved to Bristol. From Jersey. She was working in Jersey. She'd always lived in Leeds, and she moved back to Leeds when her parents found out about it. She had a year when she didn't dare tell them or anything. Then she married someone else when I was about two or three. Who I always thought of as my dad until he left when I was about thirteen, and then my mum told me. He was a car salesman. But my mum's quite artistic. She used to have a florist shop, so... But now she works for the Citizens' Advice Bureau in Leeds. She always drew. She always used to, like, make me draw. I remember I used to say: 'I'm bored, what can I draw?' And she used to go *mad* with me: 'What d'you mean, you're bored?' And she'd come out with these lists. I remember grabbing little bits of paper and drawing stuff, and when I'd say I'd run out of paper she'd come and Sellotape an extra bit on here, and when that was full she'd Sellotape another extra bit on here...

DH, Gabbie, Bradley Hirst, 1975

So I learned that and then I forgot it until foundation, when they showed you the same thing. Squares are a bit overpowering anyway, I think.

Were you ever chippy? Did you arrive in London thinking you were in some way better because of your northern working-class background?
No, worse. I was always embarrassed about it, if anything. I never thought I was better. OK, a little bit. But I had quite a lot of friends down here from Leeds. A lot of people I knew moved down a little bit after I moved down. It was a bit like a kind of Leeds scene. And they were all artists. I had a friend, who's still a really good friend from Leeds, Marcus Harvey, who went to Goldsmiths' before I did and never kind of got anywhere but was always sort of a hero to me. He's still working. He's got a studio near where I live now and I get a lot of ideas from him.

You say he hasn't got anywhere yet, but he can only be thirty. Not exactly over the hill. Isn't that a danger the way things currently are – if you haven't made it by the time you're twenty-five, you're considered past it?
No, not at all. He's the kind of person who carries on and carries on and carries on. And when the fashion changes, in however many years, he's got twenty years of it. Twenty years of work to draw on. And people like that always get discovered, I think.

For you at this point it's impossible to imagine feeling tired. Impossible to imagine being without ideas and shagged out.
I make a massive effort… Oh, you mean when you're a bit older? I can't imagine that at all. I just think about sitting down for, like, a year or something and working out enough sculptures on paper to last over a lifetime. But when you start to draw them down, they start to imply other things, and before you know where you are, you get three done in the year anyway. But you're right. I can't imagine not having ideas. At all. But I suppose you deal with it when it comes… Very difficult.

I'm aware that a lot of the things I make at the moment are kind of the same idea. I worry about that. I mean, I don't want to make 'Damien Hirsts'.

DH, Hugh Allan, Marcus Harvey, 1986

But you've already got them with the steel frames. The signature vitrines. The steel-and-glass cases.
I've thought about that in terms of the structure of the art world and what people are capable of receiving. I mean, I want to push people to thinking ahead; to think more than they might think they're capable of. I want to get them to the limit, but I don't want to get them beyond that. I mean, I don't want to start speaking a

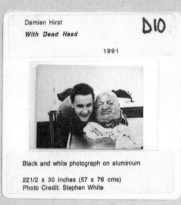

Damien Hirst
With Dead Head

1991

DIO

Black and white photograph on aluminium

221/2 x 30 inches (57 x 76 cms)
Photo Credit: Stephen White

language they *can't* understand. I want to speak a language they can understand and communicate things that they think they are probably not quite capable of receiving, but can with a bit of effort. Things they think they don't want to know about, but that I want to know about. Things that I think are important that they might not necessarily.

You talked about making a piece on instinct, without really knowing what it was about.
But that instinct can probably be broken down to a little bit of what people want, a little bit of what they don't want, a little bit of the way the world is today, a little bit of how I feel in my life at the moment, and a little bit of TV, advertising creeping in…

I don't think you can change people's minds without getting them listening to you. You can't tell people what to think, or what you think they should think, or what you think, unless they're listening to you. I mean, it's too easy for me to be dismissed by people going: 'Oh yeh, he just works on the sensational and animals.' If I can make some sculptures that are about the same kind of thing but don't actually have that in it, there must be a cultural reason for me to actually use dead heads, a social reason why people react to it. I mean, I think sensationalism is only an element in a composition, and I don't think if you're making a composition you should overlook it.

In the photo–sculpture called With Dead Head, is that an actual dead head? The head of a corpse?
It's me and a dead head. Severed head. In the morgue. Human. I'm sixteen. It's ten years old. If you look at my face, I'm actually going: 'Quick. Quick. Take the photo.' It's worry. I wanted to show my friends, but I couldn't take all my friends there, to the morgue in Leeds. I'm absolutely terrified. I'm grinning, but I'm expecting the eyes to open and for it to go: *'Grrrrraaaaagh!'*

I was doing anatomy drawing. I took some photos when I shouldn't have done. It was ten years ago. But I just suddenly thought… To me, the smile and everything seemed to sum up this problem between life and death. It was such a ridiculous way of, like, being at the point of trying to come to terms with it, especially being sixteen and everything: this is life and this is death. And I'm trying to work it out.

Was that a standard thing, for the teacher there to take students to make drawings in the morgue?
No, I didn't do it with the college. I had a friend who was in microbiology and… I had a massive collection of pathology books, burns and all kinds of horrible books that I'd collected.

When you were sixteen?

Yeh. I used to steal them in Leeds.

You lived with them? You lived with them in the house where you lived with your mother?

Yeh, but I thought they were kind of like… I *really* liked Francis Bacon. So I was using them to do paintings from. I was painting all these burned people and stuff. I'd read all those David Sylvester interviews [with Bacon]. I just thought he was really cool. So I'd gone out and got loads of books. But I'd always had a morbid fascination with it anyway for some reason.

I went out and bought about six a couple of weeks ago. Replicas of the books I'd had. Because eventually I couldn't bear them any longer and I gave them all away. But I've bought some more. Something that really intrigues me about them is the fact that, on the one hand, they can be really horrific visual things, and on the other hand it's a very beautiful, well-taken photograph. I think that's what the interest is in. Not in actual corpses. I mean, they're completely delicious, desirable images of completely undesirable, unacceptable things. They're like cookery books. The red's really red… I should get the catalogue [to the ICA show] out. Have you seen it? There's one piece I did in Paris, it's called *When Logics Die*. It uses two images out of one of the books I bought [the gaping throat wound of a suicide and a photograph of a bloody wrist]. That's a suicide, and that's done by a lorry, but I used it because I thought it was somebody who had committed suicide. I made a couple of pieces like that where suddenly the beauty of the photograph and these objects, rather than you looking at it and thinking, 'Oh my God, what's this artist trying to do?', you think, 'I shouldn't be in here.' This is only for the eyes of doctors and

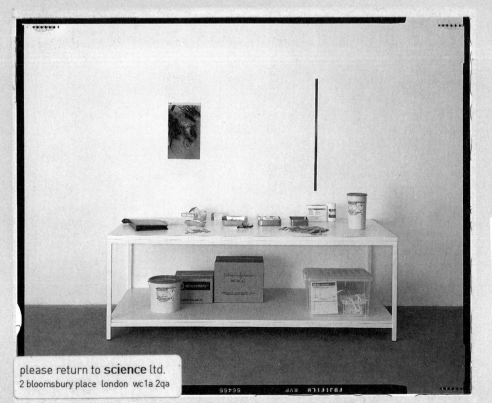

please return to **science** ltd.
2 bloomsbury place london wc1a 2qa

When Logics Die, (Fig. 151), 1991

please return to **science** ltd.
2 bloomsbury place london wc1a 2qa

surgeons. It's all medical, and they're using all this kind of stuff [swabs, scalpels, surgical instruments, laid out on a long white table under the photographs] to understand all this kind of stuff [the corpses, the wounds]. And that ridiculousness I find completely intriguing.

When I was really young, I wanted to know about death and I went to the morgue and I got these bodies and I felt sick and I thought I was going to die and it was all awful. And I went back and I went back and I drew them. And the point where death starts and life stops, for me, in my mind, before I saw them, was there. And then when I'd seen them and I'd dealt with them for a while, it was over there again. It's like, you know, I was holding them. And they just were dead bodies. Death was moved a bit further away.

You were holding dead bodies?
Yeh, you have to get them out of the tank and everything. They're for study. They're in formaldehyde. And I'm going: 'Have you got any gloves?' And the guy goes: 'Oh no, you don't need them. You're not going to catch anything.' I mean, I'm going to get a full torso, cut off here up to here; I'm getting him out of the cupboard to put him on the desk. And by the end of it, it was just… funny. They're all cut apart in particular ways.

That idea about death, you know, when you're actually confronted with that kind of thing – all these kind of images – it just gets relocated somewhere else. You can't… I look at those and I go: 'C'mon!' I don't mind it. I look at these images and I go: 'Oh.' It doesn't ring true. And then very occasionally,

after going through loads of scrambling thoughts, I get a twinge of it and I think, 'Oh yeh – *of course*.' And then it's gone as soon as I think it.

I want the world to be solid. But it's so fluid and there's absolutely nothing you can do about it. I mean I'm absolutely not interested in tying things down. Or having control, to any major extent. It's like: This is the way I make it because this is the way things are working now, but I don't expect them to be working like that tomorrow. Suddenly, like, Silk Cut can go off the market. Mercury gets into Silk Cut cigarettes and a thousand people die and there's nothing you can do about it. Boom! Gone. A worldwide brand. But I enjoy that. I don't want to tie the world down.

I always go through these logical things in my head where I kind of work out how you should live and how you should go about it. And I always work out that you should *just live*. I get to the end of it and I kind of go: 'Oh, you should just live. I've got it!' And then I kind of think, 'Well, fuck – that's what I've been doing all along, whatever I do.' And then it's: 'Oh, so it's like that, is it? Great.' Everybody… does… just… live.

I mean, I don't really believe in taste. At all. I can't believe in it. You can acquire a taste for anything. You acquire tastes. You know, if somebody served me up a dogshit, I'm sure if I made a big effort I could kind of go: 'Oh yeh, I see what you mean.' A good example of that is an olive or something. If you don't like olives, it's pretty near to a dogshit. It's got that same bitter kind of taste…

What does it all mean, though? I don't know. I'm not even sure I care.

Somebody told me you've already had a lot of approaches to show in America.
I've got a good show coming up in New York. I've got, like, six offers. But I haven't decided what to do.

You'll be corrupted. Another Basquiat. All that flattery. All the cocaine.
I get enough of that here… No, I doubt it.

Who do you think you will show with?
I think Barbara Gladstone. I got a really mad offer from Larry Gagosian. D'you know Gagosian?
Fuck knows why he's made an offer. It's very tempting, but…

What basis do you decide on? You get six offers; how do you decide which way to jump?
Well four are already cut out because of those two. The other four are no comparison, really. It's like, Danny Neuberg's one; Sonnabend…

I saw the Koons show [photographs and sculptures of Koons with the Italian porn star Cicciolina] at Sonnabend recently. I've never been a particular admirer of his work, but I thought it was really good.
He just left Sonnabend. I think he's going to Gagosian. He had a big fall-out with them.

I really liked the Italian glass sculptures, where you can see his cock up inside Cicciolina. I enjoyed watching the so-what reactions of the gallery-goers, with their kids and their strollers. That Woody Allen New York cool. Whereas I found it quite exciting… I always loved 42nd Street; 42nd Street as it was. The dirty atmosphere. The porno dens. It's got a lot of integrity somehow, hasn't it? Sex on that level. Especially personally and romantically.

Having a relationship, I always say to myself, 'So what if you fucking walk in and there's three black guys shagging your girlfriend?' I think if I can't come to terms with that, you know, I'm not alive. I have to believe that the kind of bit where she loves me is protected from that, and that no matter what kind of physical atrocities you can perform, it doesn't affect the love of someone else for you. Because I know what I'm capable of. So I have to admit that someone else can be capable of it as well, and is capable of it, and it won't affect what we've got. Dangerous stuff, though…

When I started off I tried to be a painter, and I couldn't do it, it was like: 'I've got this fucking white void.' And it used to screw me up. I had this idea that I wanted to *be* a painter. So I just tried everything to do it, and I could never do it. And then I started making little collages. If I could go round on the street and find little objects that were already organized, I could arrange them brilliantly. And I think that went on till when I did *Freeze*.

Rauschenberg used to do that a lot, didn't he, with the combine paintings of the early 1950s?

Yeh, the same thing as Rauschenberg or Schwitters. I think as soon as the elements are organized, I can arrange them in really poetic ways, and say what I want to say. But when I did a blue, and I had to say where it stopped, I couldn't do it. I thought there was something wrong with me… I can't make things up. But I think there's so much fiction involved in fact anyway that you don't have to. It's, like, what you make up in your mind, you go to yourself: 'Nah, that's just not real.' And then when it happens in real life, it's totally unbelievable – too tacky; too hammy; you'd never get away with it.

You don't have any impulse to make more consumer-friendly art? Something nice to hang over the mantelpiece?

I quite like it when someone puts a medicine cabinet in the bathroom. People have done it. I like that. The fish piece [*Isolated Elements Swimming in the Same Direction for the Purpose of Understanding*] is in the front room of a friend's [Daniel Moynihan's] house. And the weird thing is it makes the whole room look kind of Victorian. I love it.

I've seen pictures of Boltanskis in people's houses, the death-camp portraits, and they look ridiculous.

I don't mind them looking ridiculous. I mean, I always have my pieces define a space for themselves anyway. You know: you can do what you like… Jay [Jopling's] got a Boltanski in his house. Perhaps he should have built a box around it. That's what I always do if I think it's not going to stand up.

'When in doubt build a box around it.'

Well, that's what I feel like. But then maybe that's my own sort of paranoia. Maybe that's not a good thing. I kind of want to make sure… I feel a bit afraid about letting things out into the world somehow. Unless they're hard as nails – spatially, or something.

That piece you saw with the throat wound of the suicide [*When Logics Die*], that doesn't have a box around it. And there's a really complicated map with it, showing where things go on the table under the photo. And I kind of think, if you have that in your kitchen, next to your kitchen equipment, it loses it somehow. Whereas when there's a box around it, it… I quite like you being able to get hold of it mentally but not physically somehow.

DH at installation of *No Sense of Absolute Corruption*, Gagosian Gallery, New York, 1996

In spring 1996 Damien was preparing for his first major New York show at the Gagosian Gallery. The two cows sawn into twelve cow parts for a sculpture called Some Comfort Gained from the Acceptance of the Inherent Lies in Everything were being injected with formaldehyde round the clock in formaldehyde baths in DH's studio in Brixton.

A few months earlier he had been awarded the 1995 Turner Prize, having been first shortlisted in 1992. He was working on *Hanging Around*, a twenty-minute film for *Spellbound: Art and Film* at the Hayward Gallery. Quo Vadis, his restaurant collaboration with Marco Pierre White, was six months away from opening. And he was famous. The hooligan genius of Soho. A figure of contemporary London legend.

He had started a second existence in the features pages and media columns, the social diaries and op-ed-page cartoons. Not since the emergence of David Hockney in the early 1960s had a British artist's passage to fame been so rapid and so spectacular.

The period of neglect for an avant-garde artist has shrunk for each generation of artists in the last hundred years. It is no longer possible, or it seems no longer possible, for an important avant-garde artist to go unrecognized. But remarkably for somebody whose work would have seemed to place him in the avant-garde margins, Damien had been instrumental in defining the 1990s 'moment'.

'On a single day recently,' I wrote around this time. 'I was served a drink by a woman wearing a promotional T-shirt with the pattern of a Damien Hirst spot painting almost washed out of it; caught the same spots, this time turned into a high-fashion outfit by Rifat Ozbek, being worn by a girl singer on *Top of the Pops* on television; read a gossip item about his alleged goonish behaviour in some after-hours drinking dive; and spotted press and TV ads for the latest Ford saloon — one motor car sliced in half and placed in the kind of glass-and-steel cases that have slipped into the vernacular thanks to *Mother and Child Divided* and other notorious Hirst pieces.'

His career had a lot of heat under it. He was, as he would then have said, 'rocking'. The interview took place in the Hero of Switzerland, the nearest pub to DH's Minet Road studio, behind a breaker's yard in London SW9. The sound of horse-racing on the television and the bellowing of customers makes some parts of the tapes indecipherable.

INTERVIEW 2

THE HERO OF
SWITZERLAND.
BRIXTON
APRIL 1996

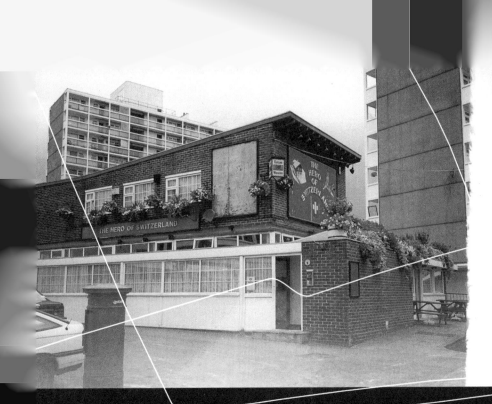

<Damien Hirst>[*Bringing drinks from the bar*] Fucking cunts. It's shit. You get shitty glasses, hardly any tonic, and you don't get a lot of ice...

<Gordon Burn>I've been thinking it's strange how quickly the shark became a kind of logo of the times – such a blank and yet peculiarly charged emblem..

I know what you're saying. But let me tell you: I realized two things, and they were happening at the same time. I was doing *Freeze* while I was working for this company called M.A.S. Research. Market research. And what I realized is you can get *anything* over the phone. And the shark was the culmination of all that.

It used to come up on the computer, and you had to say what it said on the screen. 'Hello. My name's Damien Hirst. I'm from M.A.S. Research and I'm doing a survey about electrical equipment in the home. Can I ask you a few short questions? It'll take about two minutes.' I used to do that, and it just gave me a ridiculous phone confidence. I can remember it all, because I used to love it. The nonsense of it. They *train* you how to do it. And it's idiotic. The whole thing's idiotic. 'Can you tell me, do you have a TV?' 'Yeh.' 'Do you have a hi-fi?' You'd go through the electricals in the house. And it just looked like you were a fucking burglar going to rip them off. And halfway through they'd always put the phone down. It was that stupid. It was a system called Random Sample Digit Plus-One. Some idiot who'd organized it hadn't worked out that it looked like you were casing the place. Absolute shite.

That was just before I did *Freeze* and got involved with Olympia and Yorke and the London Docklands Corporation. But what was brilliant was I always used to be intimidated by the telephone. I was horrified by phones. I couldn't do it. By doing this and having a laugh with all your mates, you suddenly realized that the person on the other end of the phone never gets any fucking visuals, so you have a *massive* amount of power, if you realize it. No one ever does. I just thought: Fuck! You can get anything over the phone. Anything.

DH, Glastonbury, 1998

We lived on Riverway, and we just used to send things out as 'Riverway Studios'. So we'd get all the invites to all the openings and everything. I'd be in bed, pissed out of my head from the night before, answering the phone. Still pissed, hung over. I was fucked, and I'd go, 'Riverway Studios, hello! Damien Hirst speaking!' Shit all over the room, fucking candles, puke and beer bottles everywhere. 'Yes, I'm sure we can arrange that for Thursday afternoon. Marvellous.' I mean, I got £10,000 out of Olympia and Yorke, £4,000 out of LDDC [London Docklands Development Corporation]... I lied like fuck.

Have you kept on doing it? Lying on that minor, white-lie sort of level?
I don't really think it's a lie. I don't think it's projecting a lie; I think it's projecting an image. I mean, I'm not afraid of meeting somebody and

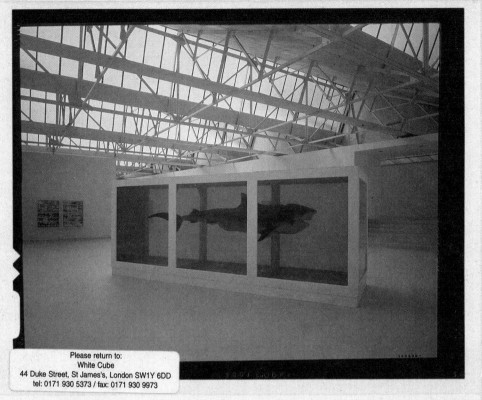

The Physical Impossibility of Death
in the Mind of Someone Living, 1991

them being shocked and going, 'Oh fuck, he's just a little twat from Leeds really.' It doesn't really matter, does it? I am who I am. The shark was, like, the end of that, and *Freeze* was the beginning of it.

The shark – I got an idea that you can get anything over the phone. That's all there is. It's like a screen to hide behind. When you're on the phone there's just so much *missing*. I just suddenly thought, Fuck it, you can get anything on the phone. I actually wondered if there was no limit to it. I wanted to do a shark and I thought, No, that's fucking impossible; you can't do that. I didn't go, 'Let's go out and get a big fucking fishing rod and go and catch a shark.' I thought, Shit, you can get it over the phone. With those sort of techniques. With the phone, you become totally international. You can go beyond continents. You can go anywhere in the world with a phone. That's the difference.

I mean, I went down to Billingsgate and I said to the guy, 'Oh, can you get me a shark?' And he said, 'Oh yeh, any size you want.' 'You can get me a twelve-foot shark?' 'Oh yeh.' He told me how much it was per pound an' I thought I'd worked it out. So when he told me he couldn't get it, it really fucked us up. It was, like, an extra cost. Which means we didn't make a lot of money on it.

Bernie Jacobson [a London dealer specializing in modern British art] told me he knew the guy who actually took the call from you in Australia to commission the shark.
Yeh, he's really well known. There are about thirty guys. But we chose him because he's, like, the really, really famous one. I read an article in a magazine about him afterwards. He's called Vic Hislop. Big shark-catcher. I got the map out and called up all the post offices and asked them to put a poster up. I got the map and looked all around the Great Australian Bight and I took the names down of all the towns on the

DH, Brixton, 1992

coast, got the numbers of the main post offices, and called them up. They stuck the posters up with my number on it and the phone never stopped ringing. Mad fucking crazy shark fishermen calling up. I did it like a system which I'd done with M.A.S. Research. It was like: 'Good... Maybe... Slightly possible... Idiot... Madman...' We'd mark them all. I think I put mine and Jay [Jopling]'s number on it as well. So I'd be at Jay's house drinking, four in the morning, getting drunk. And Jay'd go, 'It's a bloke from Australia.' We were narrowing it down and narrowing it down. And then Scott from Momart called me up and said he'd heard of this great guy in Australia who's got a museum, called Vic Hislop. So we got a load of information on him and he was the best, so we just chose him. Six thousand quid. Four to catch it, and two to ship it. I was having phone conversations with him where he was going, 'I had a fifteen-foot one yesterday. We were bringing it in. I shot it in the head and it got eaten by all the other fuckers.'

A lot of other people would have used that as part of the work, wouldn't they? Used the maps, the documentation, the posters, the long-distance calls and so on as part of the project, part of the concept. But it's integral to your work that you cut all that stuff away. I stuck with the original idea. And the original idea was that I wanted a shark. How you get it there isn't really that important.

But with an artist like Hamish Fulton, or Richard Long, say, it is precisely the process that is important. Not the arriving but the journey, as they say.
Well, what would be brilliant about Richard Long would be if he just went and did it and didn't tell anyone. I mean, I saw a documentary on him, that documentary where he's walking. And you get annoyed, because you know there's a fucking camera crew there and it really interferes with it. When it's on TV you don't mind. But when it's an artist making a sculpture, you don't want there to be a TV crew there. You want him to be out there on his own – a figure in a landscape, just doing it.

DH, Joan Collins at Elton John's birthday party, 2000

You like the research, the preparation, the steps that make the work possible. And then you like to jettison all that when a piece has been completed, so as to leave no trace.

I like the way it looks in the gallery at the end much more than I like anything else.

The fact that this messy and often time-consuming process, when it works, results in a single, clean, unencumbered statement in a gallery, with all the sweat and uncertainty of its making shorn away – this seems to say quite a lot about the way you are as a person.

That's what I mean about it being theatrical.

The most beautiful thing about the art world is that you get the chance to lose all the *baggage* of life. In a way that it's like somewhere else *from* life. I mean, I love all this stuff [the research, the preparation] but it's all towards the thing. It's like the ultimate in tarting up, or cleaning up, or presentation.

I mean, no one's interested in the shit of life. They're interested in how to live, or whatever… This is what it's like: it's like doing a magic trick for somebody. It's like: I'll do a magic trick, and I want it to be fucking *amazing*. But I can't resist showing you how to do it as well. Once I've got you amazed, I want to show you how to do it. It's not one or the other. It's the whole thing. But it's got to start with the magic trick.

That's how you see your life, isn't it? That's how you like to see yourself. As somebody who has been magicked from nothing. You cut away all the extraneous stuff, so you're floating there like the ping-pong ball or the coloured ball in *Loving in a World of Desire*, hovering on its jet of air. You see yourself hanging there in the media as 'Damien Hirst'.

Not true. It's what I said. When you look at me I maybe want you to think, Fuck him – how'd he do that? And then I want to show you *exactly* how I did it. I want you to be amazed twice. Once you're amazed because it seems impossible, and then you're amazed because it's fucking easy. That's what *I* like.

You've said that your idea of a perfect artwork is a sphere hanging in a gallery that you can walk around. Isn't it true that you would like to see yourself as coming from nothing,

connected to nothing, simply suspended there?

It's obvious why you think that. That's what you *want* to think. You're the kind of person that, if I showed you a magic trick and said, 'D'you want to see how to do it?', you'd say, 'No, I don't want to see how it's done.' That's why you see me like that. But I get frustrated. Because I want to show you how it's done as well.

Is that really true?

Yes. Because I know for sure you can't get a ball suspended on nothing. There's going to be a trick to it.

By now there's a lot of mythologizing around who Damien Hirst is.

There is not. Or, rather, there's a lot of mythologizing around who everyone is.

There is around every celebrity. That's what celebrity is. They just kind of hang there, suspended. That's why they all go fucking crazy.

D'you think a ping-pong ball's like a skull?

No, I think it's like a celebrity, hanging there in this media vacuum. It's a con, in a way. It's about celebrities, or famous people, or talented people, being different from – better than – other people.

But what I want to do is: I want to invert the whole fucking thing. I've said you have to get people listening to you before you can change their minds. And I believe that. You've got to *become* a celebrity before you can undermine it, and take it apart, and show people that there's no difference between celebrities and real life.

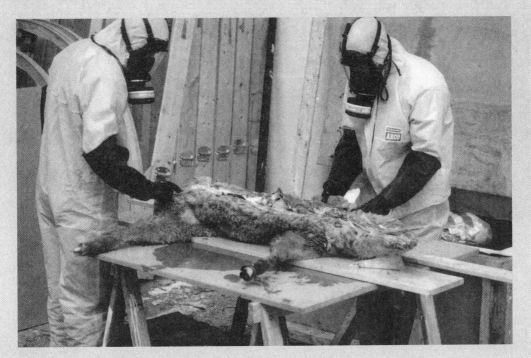

Studio assistant's making *Mother and Child Divided*, Minet Road Studio, Brixton, 1993

What is a celebrity? What would you say celebrity is?

It's a fucking lie. It's something to make rich people rich and poor people poor.

So doesn't that make for a certain tension? If celebrity is a lie, and being an artist, by definition, is being somebody who tells or reveals a truth.

Being an artist is an idea, for a start. And art is about life. Being a celebrity is a part of life. So art should be able to deal with that. And if it can't, then it doesn't exist.

Being a celebrity is about being *outside* of life. It's about closing down and shutting off. It's about becoming a person who is not like other people.

No, it's not. I had a desire when I was young to be famous. And I can either lie to myself and deny that, or I can accept it and realize that art is bigger than that.

Look, the problem is you've got a feeling about me, that's what it is. You're not prepared to let someone famous be your friend. And I'm not prepared to let you not. Because I'm not fucking famous. I just want to know I can do it. All I want to know is that I can do it, before I choose not to. I don't want to go, 'It's all shit,' when I can't do it. I want to go, 'It's all shit,' when I *can* do it. Because that is fucking fantastic.

The awful thing for me is when I get all this stuff, and I want to turn round to me mates and tell them about what it's like. And I want to go, 'Hey, Marcus, look, it's fucking easy, and they're all cunts. They're cunts at the bottom and they're cunts at the top.' But they won't have it. They won't listen. So I had to shut up. So I just do it really gradually, and quietly say a couple of things to Angus here and there, and Guy and Marcus and Hugh. Everything I go through, I feed out. But I can't tell it at the speed it happens

DH, *Mother and Child Divided*, Minet Road Studio, Brixton, 1993

to me. I'm a Gemini! I want to fucking share everything with everybody and have a party for the rest of my life.

[Deliberately garbling *I want to spend the rest of my life everywhere, with everyone, one to one, always, forever, now*] 'I want everybody to love me, everywhere, forever, now.' Is that a sculpture by you? No, your title is: 'I want to crawl back in the womb where it's warm, quiet, comfy, on my own.' I'm not going to let you leave me. Anyway, you haven't got the guts to leave me. You're trying to force me to leave you, and I won't.

Where did it come from, your desire to be famous?

It came from when you wanted to be the best drawer in the class. It came from when your parents said, 'I don't mind if you don't get a hundred out of a hundred, but do your best.' It wasn't being famous then, 'cause famous was something else. But it's the same thing, being best in the class. It means that you don't want to die. It boils down to immortality. I want to live for ever. And the best way to live for ever is to be better than everyone else. But it's fucking impossible. There's beautiful artists die every day, and never get recognized. The class just gets bigger, that's all.

Before I went to art school I came across the best artist ever in the history of the world, and that was Mr Barnes. And no one else saw it. The best *ever* artist you could ever hope to get. If you believe in the integrity of art and the belief of it coming from inside yourself and being a great thing, I found the best at the beginning. The absolute ultimate that no one saw. And I found it by chance. And I only realize now it was the ultimate. I didn't at the time. As many fucking Stings and Damien Hirsts as you like are just dead in comparison. Because he meant it, and he didn't give a fuck who saw it. It was just the most wonderful, brilliant fucking thing. And I don't know why I found it.

I used to live at number 7 Whitehart Lane, and Mr Barnes used to live next door at number 9. And I used to hear him through the wall. I could hear his telly. I used to see him going out with his shopping trolley empty and see him coming back with it full. A sort of mad man. I didn't think about him. And I was trying to paint in the room next door to him, and I couldn't do it. I just couldn't work out what to do.

And then we stopped hearing his telly. And we talked to everybody and we were worried about him. So we broke in there to have a look and find out and he'd been moved. We called the council and they said he'd been rehoused because his house was an unfit place to live in.

It was just sixty years of existence in one room. We live in boxes. A room is like an art gallery. And it takes sixty years to do that. It was a whole life in a room. There's no other way to do it. He lived there. It was a normal life of putting things on tables that just became obsessive behaviour in an environment. You start off putting things there for a function, but by the end of it there's no function. Sixty years of existence in a room. What was great was that in four weeks it was all thrown out the windows by the council. There was nothing left. I went in, and there was nothing left.

So at the beginning I found a man and I got to know a man I'd never met, through reading his letters, his life, every toothpaste tube he'd ever used, rolled up in a bag; heads from statues he'd found in graveyards; everything you could imagine, even money in parcels; boxes, tools, wood… Everything, but just collected into a… blob, like that scene in *Close Encounters of the Third Kind*. Absolutely no function whatsoever, at the top. And at the bottom, you find a man with beautiful handwriting, a collection of pens, a pipe collection, nice clothes… Desk height was normality. Under the desk, you'd find things that had been put there sixty years ago for normal use. And everything was dated: newspapers, magazines,

letters… And it just meant so much. And I was going back there and getting it, taking it to my house; going back, getting it, taking it to my house… And then I end up going there one day *and it's all gone*. Just all gone. And it's just rooms.

So what does all that mean then?
I'm still not sure. I don't know. But every time I do *anything*, it just isn't a patch on that, in terms of the art. It showed me that… It just means *everything* can be *nothing*. Immediately. It's, like, whatever you do – the impact of everything you can do – is nothing. I mean, if I hadn't seen it… How many times does that happen when no one sees it? It was like an Aladdin's cave to me for four weeks. I'd get up in the morning excited like it was Christmas and run next door; get in there. It was about five feet high in the room with stuff, and I was lying on top of it, digging holes in it, getting my arm in and just pulling things out and looking, finding, seeing what was there. Totally unbelievable.

You never felt it was a kind of desecration?
Not when I found out he'd been rehoused by the council. I did at the beginning, when I first went in. Completely. I got so freaked out, I said, 'Look, we've got to find out what's happened to him.' Because it all seemed like it was his, and so fragile and gorgeous.

 I made a collage when I was on foundation which was really like what was going on in his room. Like a Schwitters collage. One thing. And they never encouraged me to do anything else. But, you see, I was already doing that before. So then to find it in a room…

The only thing you've ever said to me which shocked me was when you talked about sneaking Jay [Jopling] into the mortuary in Leeds, and showing off to him by punching the corpses.
Same thing. Exactly. But in a way it's like getting aggressive with someone who's dead who you love, I should think. 'Get up!' You see, it wasn't shocking to me. I was annoyed when I dealt with those corpses. They just weren't corpses, d'you know what I mean? There's nothing behind the taboo; they didn't explain anything about death. It's, like, when I first got taken in there, all these guys who work in mortuaries, they all do that. They put the hand in your coat pocket on your first day, and it's all like that.

What's that about then?
It just means that death isn't there. In our lives, we're separated from corpses, so you think, Oh, that's where death is. And there's a sort of respect. And then when you get to the mortuary and you look at them… The people aren't there. There's just these *objects*, which look fuck all like real people. And everyone's putting their hands in each other's pockets and messing about, going *wheeeeeeyy!* with the head… It just *isn't there*. It just removes it further.

Damien Hirst
The Lovers

1991

Cabinets containing assorted jars of internal organs from eight cows in a 5% formaldehyde solution
Each cabinet 60 x 40 x 9 inches

Do you think death's going to get boring for you? That you'll have to find another subject?
I think there's something wrong. That's what's interesting about it.

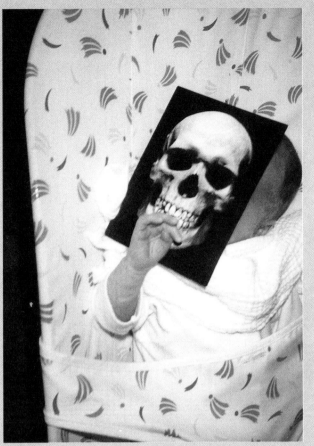

Cassius Hirst, baby-bouncer, 2000

Death being a violation?
No, death being a taboo subject...
'Fuck off. Have another drink.' All that's
to do with it. Smoking... It's all
whispers. And it's fucking stupid,
in the world we live in.

So why did you knock that
corpse about?
To frighten Jay. But because
I wasn't frightened...

It wasn't really to frighten him,
was it? It was to shock him. To
show him there are no limits.
I wanted him to wake up. I wanted
him to *wake up!*

It wasn't to demonstrate that
if you're an artist there aren't
any limits?
Not if you're an artist. If you're anyone.
There's not a different set of rules for
the artists than for other people. Artists
are *shit* compared to people. Art is the
coward's way out, I think. If you put
what you put into art into other people, you'd have a much fuller, more brilliant life. Like Mr Barnes. Life's
about living. It's not about making fucking art. Look at me and my life now. I've just called up Maia to say
I'm too busy, I can't come home... How fucking stupid, if art's about life. It's just ridiculous, to do that...
I'm giving up making art. It's shit. I can't be bothered with it. I can just buy you a nice present, y'know
what I mean? And you'd love it.

But if you weren't successful and doing what you're doing, you'd be a completely
screwed—up person, wouldn't you?
I don't know. I've told you: all I want to know is that I can do it, before I choose not to. I don't want to go,
'It's all shit,' when I can't do it. I want to go, 'It's all shit,' when I *can* do it... I'd like to stop making art.

Like Duchamp 'stopped' making art?
No. Fuck off. I don't mean stop making art as an effective piece of my art-making. He [Duchamp] never
stopped. He stopped making art as part of his art. I'd like to just stop and live. There's one thing I want
more than anything else, and I don't think I'll be able to get it, which is to just live in the present. *Live.*
To just fucking *be there*, and live. I don't need as much money as I can make in art. It's not about that.
It's just about living. Anyone can do it.

We live in the future, don't we? As a society. We don't live in the present. 'Ah, it'll all be better tomorrow. Don't worry...' 'I'll get these in, you get the next one...' It's all based on the future. Because we're afraid of dying. I don't think you should be afraid of dying. Because it's the only solid thing. I think you should go, 'Yeh, I'm going to die.' Without crying... I'm not really. I just got smoke in my eye. *Boo-hoo-hoo-hoo*...

[*He turns to the bar.*] See that bloke over there [a long-haired man with a guitar]. I used to live with him. Not live with him, but I stayed with him for a few weeks. That is weird. Oh, believe me, that is so weird.

Who is he?
It's a long, long story... I used to have this friend in Leeds who went to prison over that fraud. D'you remember the fraud I told you about? And that guy was a really good friend of his. When I first came down to London I stayed with him. I can't remember his name.

Didn't you feel guilty about the guy going to prison?
No. Well, yeh. But I shouldn't, because he grassed me up. And I denied it. He got caught, told on me, I denied it. We were both caught the same night, and I denied it and the charges were dropped. Anyway we can't talk about that. [*He remembers the man's name.*] Billy. He's called Billy. I went to art school with his son. Foundation. It's twelve years. He doesn't look any different. Believe me.

It's just so weird for me to look round and see him. Especially when we're talking about all this. My friend who went to prison used to live in the house with me next to Mr Barnes. And he used to live with him [Billy] before that. That is really... That is so weird... [*To the man with the long hair:*] Billy! Are you Billy? I know you... Damien. I didn't know you came in here... My studio's on Minet Road. The shithole with all the broken cars outside...

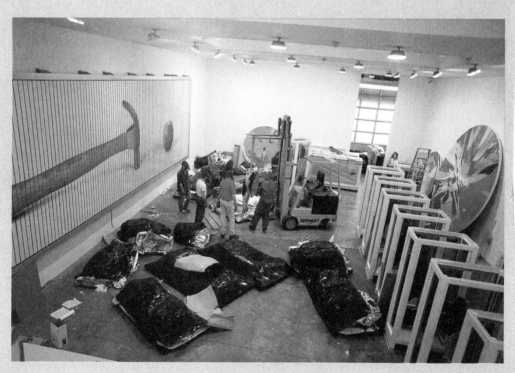

Installation of *No Sense of Absolute Corruption*, Gagosian Gallery, New York, 1996

[Damien spends a few minutes talking to Billy, and then comes back to where we have been sitting.]

And your friend did time?

He got caught pushing a tramp down Oxford Street in a fruit cart. Pissed out of his head with one of the stolen cheque books stuffed in his pocket and his own student ID card. We'd found the cheque books together. And the agreement was that we don't go out unless we go out together. We'd tossed to see who signed the cheque card, and he'd won the toss. We both wanted to sign it, because that meant you had the power. And then he started going mental and fucking off and I didn't know where he was and had no control. Then the next thing, he's got arrested. Then the next thing you know he's grassing me up. I get hauled in and deny it and say he's mad, and it was all fine. Then he really tried to get me to go down with him because he thought he'd get less of a sentence. When he went to prison he realized what a cunt he'd been to me. He came to live with me after. I felt so guilty I'd moved him into my house. But he'd get pissed and just try and fucking beat me up. Then tell me he loved me, and beat me up again. Then tell me he loved me... Basically, he was just in this horrible situation where he hated himself for grassing me up, and he hated me for getting away with it... But isn't that weird? That was a bit of a wild card, seeing Billy in here. That really freaked me out... *[Lowers his voice:]* I only spoke to him because I thought that when he'd gone you might have thought I was the devil and I made it up.

The work for the new show [*No Sense of Absolute Corruption*, Gagosian Gallery, 4 May–15 June 1996] is about to be shipped to New York. What will success in America mean to you?

It means I can relax. It means I can do it. If I can do it in America without moving to America, a lot of people who are looking at me will realize what that means. I hope that people do realize that if you can make it there you can make it anywhere. I hope that Angus [Fairhurst] realizes that; I hope that Sarah [Lucas] realizes it. I hope everyone realizes it. 'Cause I've just bought a house in Devon!

There's an easy way to make it worldwide: move to America. Look at Malcolm Morley and how he did it in the 1980s, for fucksake. Move to America, embrace it, they accept it, and... Malcolm Morley would have been *shit* if he'd stayed in England. I can't help thinking if Gilbert and George were American, they'd be much more significant. But because they're not American, they're not. Where d'you want to live? That's the question.

Angus, and I think Sarah as well, said that you always had a completely different career pattern in mind to them. They say they're not looking for instant hits or tabloid notoriety. They're in it for the long haul.

What fucking 'career pattern'? What do they mean? Me, Angus and Sarah are all working in McDonald's, talking about a *career pattern*? When you're fucking living your life and enjoying your life and being good to the people around you who you love – fine. It doesn't matter where you fucking work. There's no difference between being in the art world and working at McDonald's. How much money do you need? I'm capable of earning more money than I need at the moment. And that's good. Because it makes you realize it's not *about* fucking money. What do I want? I want to live for ever, and I can't have that.

I think they were saying that you wanted the kind of fame normally associated with pop stars, and that they weren't necessarily looking for that.

No, I didn't. No, I didn't. I just realized that I was listening to pop music and watching television more

than anything else. My whole fucking view of art is based on pop music and films and TV. 'Did you watch that thing on Picasso on the telly tonight?' 'Did you see that commercial by Tony Kaye the other day?' 'See *Top of the Pops* last night?' It's all you ever talk about when you're at fucking art school in my generation. I always wanted to meet the Beatles, d'you know what I mean? John Lennon! Fantastic! John Lennon's my only hero.

I know that. But why?
Because he refused to compromise. He tried to compromise, but he couldn't. That's why I love him.

And he's dead. What does that mean?
It means he's better, I guess. It means it's a shame... You've got to admit that you're a boring cunt at some point. D'you know what I mean? You're supposed to be a radical, top-notch, I'm-going-to-change-the-world fucking artist. And you're just a lad from Leeds with childish ambitions... I dunno. You've got to admit you're a star-fucker at the start, and that you want to be famous. Then you can move forward. You get to a point when you run out of people to be more famous than. Then what happens?

What does happen?
You buy a house in Devon and realize what you *really* want. For me, after Gagosian, there's nowhere to go. In terms of the art world.

You've got the book [I want to spend the rest of my life everywhere, with everyone, one to one, always, forever, now.] coming out. You've got the restaurant [Quo Vadis] opening...
Yeh, there's all that stuff. But not in terms of when I was a kid and I thought it was *fucking great* and all

Sarah Lucas, Angus Fairhurst, DH, 1990

I ever wanted. Gagosian's the end of it for me. You do it all in England, then it has to work in America. And after that…

Bertrand Russell said he wanted to live a life of intellect tempered by flippancy, or a life of flippancy tempered by intellect.
It just means he doesn't want to die, lying cunt. He's a coward. No, I tell you what – Jacques Brel said it, and Scott Walker sang it: [*Sings:*]

If I could be for only one hour,
If I could be for an hour every day
If I could be for just one little hour
A cute-cute in a stupid-arsed way.

It's, like, what arrogant cunts! D'you know what I mean? That I'm just so intellectual I wish I could be flippant. 'Oh, I wish I could be flippant.'

Let me read you this: 'Psychoanalysis attempts to restore to the neurotic patient the freedom to be uninteresting that he lost somewhere along the way.' It seems to me that it's your gift in a way that you cannot stand boringness either in yourself or in other people. But isn't it also a burden that you can't let yourself be uninteresting?
I think you're always the same. Jarvis [Cocker] said to me, 'I can't write songs about what's happening to me *now*. I can only do it afterwards.' And I said, 'If you can't write songs about what's happening to you now, then you can't sing.' It's, like, you know, John Lennon can have a baby in the middle of fame and madness and write a song like 'Beautiful Boy'. Or, even better, 'Two of Us'.
'Two of Us' is a great song. It's about him and Paul McCartney. Their relationship. It sounds like a love song. That's what's fucking weird.
[*Sings:*] Two of us going nowhere,
Driving no place,
Spending someone's hard-earned pay.
You and me Sunday-driving,
Not arriving
On our way.
We're on our way home…
D'you know what I mean? It could be a love song. It could be about him and Paul. But it could be about any two people. That's what genius is, if it exists. Which I don't believe. To be able to be in the middle of all that shit and still sing about it is fucking brilliant. *And* to be able to sing about it in a way that people can dance to it and anyone else can hear it. It's fantastic.

What was Jarvis's reaction when you said he should be writing about what was happening to him now, not two years down the road?
He said, 'I can't.' I said to him, 'If you did a song called "I Can't Write Songs about What's Happening to Me Now", it could be a fucking belter of a song.' Know what I mean? It's the truth.

It's like that great thing you once told an interviewer: 'I sometimes feel I have nothing to say; I often want to communicate this.' You have to be very confident in yourself and

totally inside what you're doing to say something that astute.

No, you don't. You have to dare embarrassment and not be afraid of failure. I know I'm all I've got.

I've got a quote from Winston Churchill for you: 'I suppose that it is one of the principal criteria of success to believe in yourself so strongly that you are the epicentre of all that is happening.'

I tell you what: I think that every single person living on earth thinks that, all the fucking time. Even if you're a psychomaniac and you kill yourself. Even if you hate yourself so much. Everyone believes that. And it's nothing to do with success. It's *life*. It's what life is.

OK. Here's one from me: 'You have to be aware that everyone else is thinking far too hard about themselves to be thinking about you, whoever you are.' If you want it, you can have it. Once you know that, you can be free.

Tell me about your friend in Leeds that you mentioned to me once, and his mum. You don't have to mention names.

It's just a big story. They're all big fucking stories… OK. So I had a friend when I was at school and his mum was an alcoholic. And knowing them was probably the first time I realized there wasn't a difference between parents and children. Maybe. He said all these things about his mum that were, like, weird. I used to get into trouble at school. We used to break into the school, used to drink a lot, he had a girlfriend who was Polish. He was older than I was. And I always used to get into trouble for what we did and he always got off with it, because of his mum. He used to always tell me this stuff about his mum, which the school knew about, which was that she was a maniac, alcoholic, mad… I think she was mad. And I used to tell *my* mum about it. But my mum used to say, 'He's lying for attention and it's not true.' And I used to believe my mum, and think he was lying.

Oh God, I've got thousands of stories about him. Did I tell you about the night we went out and fucked all these girls? I went to bed with this girl. It was the first time I ever had sex. I was fourteen or something; she was thirteen and I was supposed to fuck her and I couldn't do it. I was, like, using my thumb, trying to get my dick inside her. And he was in bed fucking this pregnant woman whose husband was away. And I was worried about this girl getting pregnant and I couldn't even get my dick in. I said to her, 'What if you get pregnant?' And she said, 'Oh, I won't; I haven't started my periods yet.' And I couldn't fuck her or anything. We all stayed the whole night. There was a guy called Scottie in the bath. And I called my dad to say I wasn't coming home, and he said I had to because he was babysitting and my mum was out. And I didn't go home. And the next day when I saw this friend, he had an 'X' cut in him in scissors by his mum. Two red slashed lines. And she said, 'If you ever fucking stay out like that again, I'm going to stab you to death.'

I told my mum that, and she said, 'He's lying.' So I never knew whether he was lying or telling the truth. Because I was at the point where I believed my mum and I didn't believe him. But I saw the 'X'. So I used to go round to his mum, and she used to be pissed out of her head with tights on and flowery knickers on top, lying on the sofa. She smoked hash. And she'd go, 'I've got some hash. Someone, go

get me some Rizlas.' And he'd go get Rizlas and I'd stay in the house with her lying in the front room, whisky bottles everywhere. He always said he hated his mum. I'd sit and talk with her and she'd go, 'Ah, Damien, you don't know fucking anything about this world. They're all fucking cunts; never tell you anything.' I used to get sexy, 'cause I was fourteen and she only had her pants on. And I used to wank about her.

I borrowed an airgun off him once. And I shot the whole house up – my house – with the airgun. Shooting ornaments and into the sofa, into the ceiling, the doors, the wall – everywhere, all over the house. I did about two hundred pellets. I've got no idea why. Like I've got no idea why once when I was really young and I was coming downstairs and the house was in a mess, I grabbed everything in the room and threw it all in different places and I made a different mess. It was still a mess and no one ever noticed. I don't know why I did that, and the airgun was the same.

Two hours before my mum came home, I suddenly realized. *Fucking hell!* Because it gradually built up through the day. I was knocking off school and I suddenly realized I'd done all this fucking shit and I was going to get done. I started off shooting things where it wouldn't be noticed, like into the corner where the wall meets the floor. Then I'd go in the ceiling, by where the light bulb is. Then I'd think, I want to do the light bulb. And I'd do that. Then I'd shoot the door. Then I'd shoot the sofa – fire about five shots into the sofa… Spent a whole day just shooting things in the house. I'd shoot an ornament, and then I'd throw it away. Straight into a bag and out into the back garden and I'd hide it so they'd never find it. And then I suddenly realized at the end of the day that I'd actually left this trail of discovery and that I'd shot all these things and that I was gonna be fucked. I went round and tried to put it right. I got, like, boot polish and, where anything was brown, I filled in the holes. Teased out the fabric in the sofa so there wasn't a hole… No one noticed. And then about three weeks later my mum found out. She went mad with me, and I denied it. So she went round his house; took the gun back and said, 'Damien's shot the whole house up.' And my mate's mum went mental with him and beat him up.

Then one day he said his mum tried to commit suicide. He said she lit the chip pan in the kitchen, locked all the doors, set fire to the curtains… But the neighbours had come round and anyway it was all fine. He told me this story and I didn't believe him. He said, 'She tried to burn the house down.' And I went, 'Fuck off.' I told me mum and she said, 'He's lying.' And then, after that, I think it was at school, he said, 'My mum tried to kill me last night. She came in, she'd got a Colt 45 an' she put it to my head. She said, "I'm going to fucking kill you," and she was really drunk.' And he said, 'Don't you dare go in my sister's room. Don't you dare fucking go in there, or I'll fucking kill *you*.' And the next thing he knew,

the police arrived and took his mum off. And I told my mum that night what he had said that morning, and my mum went, 'He's lying again.' The next thing I know, she's showing me a picture of two Territorial Army guys in the *Evening Post*, and my mate's mum. The story was that she'd gone out drinking with them and nicked their gun off them.

Then about a week later I was going down the street with him and he said, 'I can smell burning.' And he went, 'Fucking bitch.' Halfway down the street, I went, 'What?' He went, 'That fucking woman. Why does she have to take the fucking house with her?' He ran down the street and I ran after him. The dog's barking and there's smoke coming out the house. He kicks the door down and tries to run in. Then the fire brigade arrive and he's in the car with the police and I got put in the car with him and the policeman says to me 'Don't let him do anything stupid.' But before the police arrived, they brought her out on a stretcher and the head fell out as they walked past, and I saw her head then. She was a corpse. Black lips and no hair; fucking suntan. And all he kept saying in the police car was, 'Why'd she have to take the house? The fucking bitch.' Roman Avenue… I often think about where he is.

I've got this quote from you about Jeff Koons: 'He's given up his whole life to become his own idea of himself.'
It's true. But I'm not prepared to do that. I agree with John Lennon: it's shit, and you can't do it. But I admire Jeff Koons, because he actually made a concerted effort to do it as part of his art. Which is fine. It started with *The New Jeff Koons*, that self-portrait with the crayons. It was called *The New Jeff Koons,* and he did it, and he said it, and he made it public. He let everyone know. Like I said to Ashley Bickerton, 'Do you ever talk to Jeff any more?' An' he said, 'Yeh, I do; as long as I talk about Jeff.' An' all his friends know. He's just said to everybody, 'Look, you used to know this guy Jeff Koons who'd hang around with you and have a beer with you. But now I'm Jeff Koons, the Artist, and I've become this.' And he said it at the beginning, and Cicciolina's a part of that, and you have to admire him for doing that. At some point, he gave up his life to become his own idea of himself. What I hate is that a hell of a lot of artists who I know, who are alive, have done that and won't admit it. And pop stars. I mean, I can imagine David Bowie going to his son, 'Have you any idea who you're talking to?'

There's one thing that you don't understand, which is that all these people – Bowie, Sting – they get this thing on a plate. You don't create this thing, being famous. You get it on a plate. And a lot of people look at this thing they've been given on a plate, and they choose it, rather than stick with what they've got. But it's something that they don't *control*, d'you know what I mean? Whereas Jeff Koons controlled it.

Well, obviously, after Andy Warhol…
But Andy Warhol was a shy, fucked-up person who never felt he was any good himself. He never felt he was that good himself, really. Except secretly inside he was an ego-power-maniac.

He's probably the most significant artist since Picasso.
Duchamp and Picasso I'm interested in… What about [Richard] Hamilton? Don't you think he should be important? It just seems a little bit weird to me that they're all fucking American. The big ones. Throughout history, recent history. Except Bacon. It seems a bit of… an *imbalance*, d'you know what I mean?

But to go back to what we were just saying about choosing fame. I've got no one I can turn round and talk to that much, for advice and stuff. It started when my mum decided she understood my work when Saatchi bought it. And I had a choice. I could have either gone: 'Well, that's my mum. She understood my

Cassius, DH, Connor Hirst, Combe Martin, 2000

work because she understood it at that point.' Or: 'She understood it because Saatchi bought it.' That's what people do. So it was either: 'All right, I'll become "Damien Hirst".' Or I'd carry on being a child and try and question it.

You have a thing ahead of you in the future, what you're going to become. You have this thing. You've always got it; you've always had it. Well, I don't have it any more. And I don't know anybody who doesn't have it any more. No one.

I mean, you're secure in a fucking hole; it's your world; it's perfect. And then you move out, and you slum it; and you don't mind because you've always got this thing you're striving for in the future. And I've got rid of mine. I don't have anything to strive for in the future that is outside of myself. Or inside myself.

I just think everyone's famous, but not me. I mean, I think every fucking person who's famous must think that everyone else is famous except them.

You know, I used to tell people what I felt like. And now they ask what I feel like, and I go, 'I can't tell you about what I feel like. Because if I do, you're not going to like it.' It's not easy. I wanted to be stopped. Gordon, get this: I wanted to be stopped. I wanted to find somebody. I wanted to find a father figure.

How did you come to be working at d'Offay?

I wrote a letter. While I was at Goldsmiths'. I did Thursday, Friday, Saturday, three days a week for a year or summat. Hanging pictures. Packing pictures.

What was the most important lesson you learned from working there?

I remember I had a dream to be able to afford a roll of bubble-wrap. So I could wrap up my work... I got to see the artists, but more like as a voyeur. Cause the person who hangs the work is nobody. I used to work in an office where you hang all the pictures, and there used to be the viewing room with Anthony [d'Offay] and the people, and there was an eye-hole in the door. Because you used to have to check whether there was anyone in there having an important meeting. So I used to watch. I couldn't hear anything. Which is the antithesis of the phone thing, where you hear everything and see nothing.

Were Beuys and Gilbert and George and Bruce Nauman and people coming around then?

Yeh a little bit... I went to a lecture of Beuys at the university. Leeds University. Absolute fucking gibberish. I tried so hard to understand it, but it was just fucking gibberish... I remember Anselm Kieffer coming in and looking at one of the galvanized dustbins in the workroom and going, 'Oh, they're great! Wow!' And after he left, somebody from the gallery came rushing and said, '[*Camp American voice:*] Damien, can you rush over to John Lewis and get two galvanized dustbins?' I knew of course that d'Offay was in love with Kieffer and wanted him. So, 'Wow, they're great.' That's all he had to say.

That's the best thing, that just this fucking *shit* that d'Offay created was absolutely convincingly delicious. Just unbelievable. This space. It was like the most perfect white piece of paper. It was totally anal. But fucking fantastic, if you're an artist. But for anyone else who worked there... All these people were there to serve artists in a way that you just wouldn't fucking believe. A door would squeak and I would spend three days messing with it so that it closed without Anthony hearing anything. Three fucking days. And then I used to regularly drive round in a cab all over London, sixty-quid cabs, picking something up. [*Sings:*] 'Search for the hero inside yourself...'

I never had to light anything, or anything like that. Except I remember once when things were busy being given a Carl Andre sculpture and being told to lay it out in the viewing room and light it. It was six squares, and they matched the size of the squares on the floor. Sheet metal, about a foot by a foot. I spent ages laying it out. And I was thinking about what it meant, and what it was. They give you the shape and they give you the plates, and they're all numbered. You can't do anything. But I lit it. I've got all the ladders and I'm changing all the lights, and I lit it. I spent ages. And I got it looking absolutely fucking gorgeous. There was about four other things on the wall in the room that the guy was also coming to look at. And he bought the Andre. And it was a fucking fortune. When I went in there it looked like shit. And I knew – and I still know – that he would not have bought the Andre if I hadn't lit it. There's no way he would have bought it, because it looked like crap. It's not a great Andre but he bought it. He bought my one.

And Andre came out of the woodwork at d'Offay after that. When you work in a gallery, there's a lot of fashion shit to be dealing with. You're at the beck and call of your clients. It's all about selling. They don't realize that there is anything that is genuinely fucking good. And Carl Andre is genuinely good. But he was in the basement. And I was unwrapping Richters and walking off with the fucking bubble-wrap and thinking I'd made it. Fucking great. You'd really made it when you did that.

Did you change the lighting on the other things in the room to make them look *less* good?
It started off, there was a light on something else that I needed on mine. I mean, it was their mistake for being so busy they had to give the job to me. It was like a stolen job. It only happened once. But I made everything look good together. It was the first time I realized that light could affect anything. Everything looked great. Maybe that's where I got the feeling for doing group shows.

I feel I haven't even started yet.

With your work, you mean?
With my art. There's a difference between my art and my work. I mean, I don't think anybody feels like they've started yet. Angus, Sarah, all those people… I just feel like everybody's getting a glimpse of… that it's getting equal now. Like, everything's going a bit moody and a bit knowing. Everybody realizes they know more than a lot of the people who are out there. And we're very fucking young to know that. I know artists in their sixties who don't know that. [Lucian] Freud never knew it, at this point. It's like everybody's got the choice of going the way everybody in the past has gone. But when I was an art student I looked at it and I thought, This is not what I want. With the exception of my own generation of artists, who are friends, there's not a living artist that I know that I respect.

What is art?
It's a fucking poor excuse for life, innit, eh?! Art-schmart, God-schmod, Jesus-schmeesus… I have proved it to myself that art is about life and the art world's about money. And I'm the only one who fucking knows that. Everyone lies to themselves to make it *seem* like it's the other way. But it isn't.

You've got to fucking enjoy yourself, Gordon, haven't you? Don't I look like I'm enjoying myself?… It gets close sometimes.

If you don't like my show at Gagosian, I'll be fucking worried. If you don't like my show in New York I'm going to be *really* upset.

Installation of *No Sense of Absolute Corruption*, Gagosian Gallery, New York, 1996

By the summer of 1999, Damien was still a year away from his second major show at Gagosian. The opening had already been postponed a number of times. He had been experiencing what he called 'a difficulty with art'. This dated back two years to a show at Gallery Bruno Bischofberger in Zurich in 1997. The show, by Damien's own reckoning, had been a failure: 'I lost sleep over it. Fucking nearly died... I'd run out of ideas. Run out of everything.'

DH, 1990

Sensation, which had opened at the Royal Academy in London in October 1997, had been a kind of mini-retrospective: all his major work was in it. It was still touring the world. But Damien had been concentrating his energies in the commercial arena. He directed a video for Blur; he got involved in a record label.

And then he opened Pharmacy, a bar and restaurant, with Matthew Freud and others at the beginning of 1998.

Over the past fifty years the vocabulary of art has expanded towards the inclusion of everything. Everything seen in a certain way becomes art, is art. Damien believes this. He did believe it. But when he opened a London office to deal with his proliferating outside involvements – the restaurants, the videos, the record label, album covers, books, films, TV commercials, interviews, litigation: everything that wasn't Art, in other words – he called it 'Science'. It says it on a brass plaque fixed to the wall, next to the plaques of the other strictly whitebread businesses in Bloomsbury who share the building: 'Science'.

It's what you hear a voice announce every time you phone: 'Hello, Science.'

He was sort of thinking about a piece that would be called The History of Fame. In it, an ectoplasmically white inflated ball would be suspended on a jet of air above several dozen fiercely sharpened Sabatier knives. The History of Fame would have an audience soundtrack – rumbles of anticipation and applause when the ball dropped close to the knives and appeared to be in danger of bursting; groans of disappointment when it floated clear of the daggers and the carvers waiting to go to work.

By 1999 he had come round to the view that if his adventures in the catering trade and his other excursions had taught him anything it was that if he's not an artist, he's nothing. But he believed he had been hearing the grinding of knives for some time.

The interviews took place in a converted hayloft at his house in Devon fitted out with two leather armchairs, a steamer trunk cum table, and hot and a wet bar made out of a cardboard box.

INTERVIEW 3

OUTBUILDING.
COMBE MARTIN
SATURDAY.
28.08.99

<Damien Hirst>[*Assuming interviewer persona:*] 'So… Did any priests come to your birth, bringing myrrh and frankincense or owt like that? Tell me a little bit about yourself.' Shall we have a line?
<Gordon Burn> No.

OK. [*Camp voice:*] Tell me when you do… Shall we have quarter of an e?
No.

[*Camp voice:*] Tell me when you do… Can I just start by saying: 'So… Whistling. How'd you first learn to whistle? You've got this cheeky, drinking, you know, *cheeky* personality. Tell me a little bit about that.' [*Laughter.*] C'mon. It'll wear off in a minute.

Talk a bit more about Francis Bacon. Why you think he's good.

He's the best. There's these two different things, painters and sculptors. And Bacon is a painter. He doesn't… It's not about your ability; it's about your guts, on some level. And Bacon's got the guts to fuck in hell.

You see it in the 1940s paintings. I remember looking at a newsreader painting at that exhibition he had in Venice. It was just a head, like a newsreader. You go up to it and it's, like, the ear is made of oil paint, but it's almost like a fucking relief. It's almost three-dimensional. You've only got to get oil paint and do an ear, and you paint over it three or four times and it starts to be raised off the canvas. It's like you managed to stick a fucking ear on.

Auerbach…

Fuck Auerbach. They're shit. Bacon's not that. Bacon's like: it's a doorway, it's a window; it's two-dimensional, it's three-dimensional; he's thinking about the glass reflecting… It's his guts. Absolutely. It's, like, he can't paint, and he admits it. And it's the most powerful position you can ever have.

Did he ever admit to that?

I think he has. It's like, there's a painting he's done of a guy cross-legged, and he can't paint fucking baseball boots. But he doesn't pretend he can. That's why he's brilliant. He paints a baseball boot to the best of his ability, and it's totally fucking naked and clean, and it's right there in your face, and you go, 'This is a painting by a geezer who totally believes, and it's everything he says it is, and whatever his aim is, he's achieving much more than that.' It's totally laid out in front of you: no lies, no doubt, nothing.

And he's a different kind of painter, and he came from nowhere. It's like… Richard Wentworth does a thing called *Making Do and Getting By*, and it's strange that he uses a shoe in a doorway. But Francis Bacon paints a fucking umbrella, and you shit yourself. An umbrella's scary for ever after that.

He's an artist, a sculptor, a painter. He's about the last bastion of painting. When I was growing up I wanted to paint. And all I wanted to do was paint like Bacon. And, before that, painting seems dead. It's totally dead.

People don't talk about painting any more. They don't even say they hate it. It's like they just don't give it any thought.

It's, like, what is it? What's the point that it's arguing? And it all boils down to painting. There's one kind of art, and it's painting. Everything else is a step away from that, and it all points back to that.

It comes top of your list. 'Painter: the king.'

Because I think art's kind of foolish. And painting, like, incorporates its own bullshit before it starts. Its own lies. You start out by going, 'There's a two-dimensional space and I'm going to treat it as a three-dimensional space, and I'm going to fucking fool you.' Y'know, you paint your wall white, and it's a wall. But as soon as you start to treat it as three-dimensional, and you can, there's this massive delusion built into it, which is great.

The Hockney–Caulfield generation of English painters grew up reacting against what they saw as the horrible dull greys and sludgy browns of Sickert, and against everything Sickert stood for. The references were always painters and painting, weren't they, until

about twenty-five years ago? Have you always reacted *against* a painter?

Well, you're always reacting against something. I grew up in a situation where painting was considered dead. But I had a massive desire to be a painter. Not an artist. Not a sculptor. I wanted to be a *painter*. Not a collagist. The idea of a painter is so much greater than the idea of a sculptor or an artist. You know: 'I'm a painter.' It's one on one, *mano a mano*, you on yourself. But the thing is painting is dead. It didn't work. For me, Bacon is the last result of the great painters. He's the last painter. It's all sculpture after that.

Was what he did about expression? Was it about 'expressing' himself? Or was it about something else?

I think artists have always had this dilemma, which is to move forward. But you always want to be great in terms of what went just before. I don't know what it's like for other people, but... I mean, I personally absolutely totally love colour. What got me into art is colour. Absolutely nothing else. It's like, you know, I'd gasp at fucking daffodils. I think blossom should have a public warning sign before you walk around the corner. I would physically sort of gasp at colour.

I love *colour* more than [I do] most *people*. So I can totally understand it. I'm a fantastic phenomenal fucking colourist. It's like, I'm a Bonnard, a Turner, a Matisse... Like I say, if you give me colour, I *gasp* at colour. Whereas a lot of people don't. And you get colour in painting in a more powerful way, I think.

Sculpture used to be carving things out of fucking rock, and painting was, like, grinding up rock and smearing it on canvas. They're both illusions. They're both a fucking lie. Photography, I think, caned it. But the desire of the painter... You know, Turner strapped to the fucking mast.

When did the focus in painting and sculpture move from the artwork to the artist – the 'art star'? When did personality start to loom as being if not more then equally important?

I don't give a shit about that. I grew up in a world where what I inherited was fucking Carl Andre and bricks at the Tate. That media kind of fame thing.

I remember being in the art library and looking at all the books and thinking, I've got to read all this shit. You know, I've got to read it all before I can even start to say I want to be a great artist. My whole view of great artists wasn't out of museums and artworks. It was out of books and artworks reproduced in a small way. I was eating up not artworks but images of artworks. I changed my mind about which artists I loved. But I devoured art *books*, not art exhibitions.

I went to see the Bonnard exhibition at the Pompidou. Bonnard–de Kooning at the Pompidou. I made a big effort to go over there. But I grew up in a generation where everything – the kind of information you get – is just so easy. You don't realize it, but the whole history of art came out of books and reproduced images.

[Reacting to noises below in the yard] Shut it, you slag! I'm fucking working. Abbie, get your tits out, let's have a look, go on. Get them out for me an' Gordy; we're doing an interview. Just pull 'em out. Go on… No, pull 'em out, nipples an' everything…

Is that bruises?
<Abigail>[Fallis, an artist friend] Yeh.

What from, rough sex?
Yeh, very rough.

[DH to GB] Oh, you bastard. You're fucking filthy as hell, you dirty cunt. 'Are they bruises?' 'Been having rough sex?' She's only four years old. 'Talking about bruises, have you been having dirty fucking awful sex?' 'Have you been slashed about?' 'Nice bruises. How rough *was* it?' [*Laughter.*]

I'll leave all this in.
You haven't got the guts.

So you were saying…
I was saying that my whole history of art came out of books. It was, like, inherited information, information gathered from pages in books. My whole idea of art, and everybody's idea of art, is the world you grow up in. Then there's the big media thing attached to it.

Art works. It exists. It seems like every other medium – like music, like writing – has been caned into shape by other people. But art, still, even today, has been left running riot. There's a massive amount of freedom in art. Still. You can get away with murder.

It seems that artists are quite like doctors or surgeons. People impute the same kinds of powers to them. Artists and surgeons are allowed to look where nobody else is allowed to look.
Artists are more important now than they've ever been. Or *as* important as they've ever been. When I came into it, that would have sounded incredible. It was kind of like a joke. It's not a joke any more.

The *Mona Lisa*'s a fantastic example. Which makes the most money? The *Mona Lisa*, or the T-shirts, the earrings, the mugs, the postcards, the souvenir pens? If somebody said to you, 'You have a choice:

I'll give you the actual *Mona Lisa* itself, or the merchandising rights.' What would you take? In terms of *art*, what would you take?

It's like, if you've got the *Mona Lisa* on your wall, all you'd get is people coming in your house and going, 'Fuck off! Is it fuck!' Know what I mean? Nothing against the artist. It's been kicked up its own arse, the *Mona Lisa*. It's destroyed. It's been destroyed as an image.

Is that what Duchamp was saying when he painted a moustache on it?
I think it's what Duchamp was saying all the time.

As an artist, you have a desire to communicate an idea to a hell of a lot of people on a massive scale. And you can do it with an individual artwork sometimes, and you can do it with a mass-produced work. What we've got available today is so massive; there's so many fucking angles you can hit it from. I mean, Duchamp didn't do it, quite. But to put a fucking toilet in a gallery is fantastic.

It's, like, if a tree falls down on your land, or in your street, it looks... *bigger*. You drive to work every day, everything's the same, you know where you are. Then one day you drive to work and a tree's fallen down and you go, 'Fucking hell!' You look at the tree and it's massive. You never notice it until it falls down. Artists do that. They take things and they place them in front of you, but out of context. Things you *know*.

It's like I was saying about Bacon. You go, 'Fucking hell, look at this. Check this out. Umbrellas are really frightening; they look like bats, and they're dark, and they're black.' And they're not. But it's just, like, you're pulled up; you're made to think about yourself.

A lot of your work has a mass-produced gloss. It has become common to talk about it combining the surface sheen of pop with the elegance of minimalism. In fact, anybody could make a spot painting. Anybody could make a steel vitrine and put a modern office desk in it.

Jay Jopling

DH, Larry Gagosian, 1996

Yeh, but anybody can remake it after you've made it, after the fact. You can make an exact copy of the *Mona Lisa*. You can make a copy of the *Mona Lisa better*. But it's not the *Mona Lisa*. You look at Coca-Cola cans and they're all fucking different, but they're not. But they are. There's this big battle going on.

You know what it all boils down to: What is the role of art today? [*Laughter.*] But it is what it boils down to. It's fucking difficult to work out what its role is, there's so much there. It's like: 'Oh, so you're an artist.' What the fuck is that, eh? What is that that you are? It's just totally fucking changed.

Do you still look at art?
Yeh. Less. I stopped for a long time. But now I look at it. I look at the world.

I tell you what: art is fucking unusual. It's just fucking unusual. But it's like… I know the rules. And the rules aren't so fucking mad. The rules of art aren't so mad. I'm torn at the moment between… You know, if there's anything wrong with the art world, I blame the artists, I don't blame anyone else. There are no rules.

There's the fifty–fifty bollocks which, like, canes everyone's head. I mean, look at all the great artists, they're not on fifty–fifty. [It is the general rule of contemporary dealers to take a 50 per cent commission on everything they sell.] But no one tells anyone nothing. And it's a real fucking shame that no one tells anybody nothing. Like, I'm on sixty–forty with Jay, percentage-wise. I could be on ninety–ten if I totally fucking martyred myself, which would make it great for the people behind me. It is like a kind of relay race.

I mean, Rachel Whiteread went from sixty–forty with Karsten [Schubert] to fifty–fifty with d'Offay, which fucking slaughtered me. It just so upset me. Artists are an easy target. Basically, artists are fucking stupid. You get a fifty–fifty deal and you get cuddles. You get promised a cuddle. Which is really all you want. For me, it's fucking horrible being an artist who has to think about money. I'm too young. You're thirty-four,

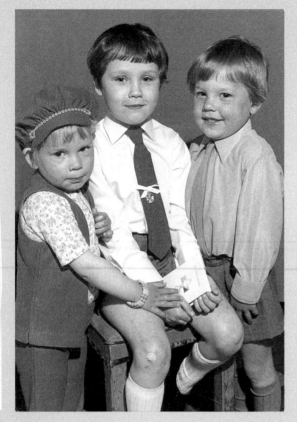

Gabbie, DH, Bradley at DH's Holy Communion, 1971

and you just start seeing all kinds of fucking bullshit. But all you want is a fucking hug. Weak fucking business people dived on the backs of it and went, 'Oh yeh, it's fifty–fifty.'

The thing is, *art* is about fifty–fifty. The whole idea of art is about fifty–fifty. You and me equal together. Viewer and object. So fifty–fifty makes total fucking sense to artists. But it's totally fucking wrong.

You end up being an artist in the art world: 'I can't talk to you tonight because I'm a bit worried about my show.' You can't have that. Because a person who's an artist is just a person who's around in your life who brightens your fucking life up. Who just makes a bit more of an effort that way, visually. Anybody who makes an effort.

Anybody who complicates your view of the world instead of simplifying it. I went in there and I wanted to make art in terms that I knew existed, which came out of fucking books. And I wanted to be famous. I wanted to be a *famous* artist.

Art's more important than money. But we need a hell of a lot more power through money than we've fucking got.

When other kids were in their bedrooms practising air guitar, I've got the feeling you were in yours growing your aura.
Look, I can't hear you if you're going to mumble. [*Laughter.*]

You get this thing in science, all right, which divides and dissolves the whole body into a thing; an object. You walk in there and you might as well be anybody. It's like: 'You've got three weeks to live. You need these pills, those pills, these other pills, goodbye.' They reduce you to this kind of nothingness that exists. It's like there's only one song, and everybody's born to sing that song and give it their all. 'Leaving on a Jet Plane…' It would be a totally different song every time if you didn't take the pills. [*Laughter.*]

You can't believe in art if you don't believe in God. And I don't believe in God in those terms. When I was a Catholic – I was brought up a Catholic – and it's, like, bullshit; it's like fucking nonsense. My mum left my dad because my dad was a cunt. My dad fucked the babysitter. This is, like, the real world. He got married, fucked the babysitter, me mum threw him out, they left each other. My mum came up to me and she said, 'Look, Damien, I really need the Church now more than I've ever needed it in my life.' Getting divorced, this big sex fucking weird thing, this guy you've been with, you've got three kids, it's really difficult. So I said, 'Look, go talk to the priest and tell him that you're going to get divorced but that you need the Church.' So she did. And he went, 'Sorry, mate.' And, to me, it just totally nullified the idea of

getting married. 'Cause I saw it like this fucking twelve-year-old kid, which I was. I saw my mum doing that, I saw she needed the Church, and the Church just went, 'Fuck you.' They'll marry you, but they won't fucking divorce you, in the real world.

What is the takeover of Pharmacy going to mean to you? [It had just been announced that Pharmacy had been bought by the Hartford Group.]
Mean to me financially? It means the worst thing in the world for me emotionally and personally and I wish I'd never got fucking involved and I've devoted too much fucking time to it. Everybody looks at me and thinks I only care about money. It's, like, you dive into money, and you question money and you find out you can't rely on money. When you get involved with people in money situations and you start competing with them and you win, it looks like you're winning because you're only interested in money. But you're only winning because you don't give a *fuck* about money, and you dive in there.

What it means to me financially… *apparently* – and I only say 'apparently' because basically I've got fuck all out of Pharmacy so far… And I put a hell of a lot into it – a year's work – when I could have made art. I just want to make art. I can't be fucking arsed with it. But *apparently* it's worth 3 million, my shares. I refused to sell my shares. They tried to get me to sell them shares. They basically merged with a larger company.

I did Pharmacy because I wanted to make a great place for people to be. It's really simple. And Matthew Freud comes up to me and goes, 'There's two ways of doing this next move. One way of doing it is to wait, make the profits, and with the profits that you make you maybe open another. Or if you're

Pharmacy (detail), 1992, installation, Cohen Gallery, New York

bold enough and confident enough, what you do is you sell half of it as a going concern in order to get the money to open others.'

And respect to the geezer, he did put a lot of money into Pharmacy to enable me to do what I wanted. Too much money. We wasted a lot of money. But it's a fucking achievement, as an idea. Whether it's a hang-out in Notting Hill, or whether it's a world-class restaurant, it doesn't matter. It's the idea. And it works. Definitely. And I love it.

Anyway, he says, 'There's two ways of doing it, which do you want to do?' So I said, 'I want to make the profits.' Because that's where I'm from. I'm from Leeds. And everybody disagrees with me, and we've got all the partners, and they say we'll free it up. So fair enough. I disagreed, but me on my own can't do anything. So, all right, we go that route. But that route's got absolutely fuck all to do with me. That route's just about: Let's bullshit our way into larger amounts of cash.

Jonathan Kennedy's the only reason I got involved in it. He came at me in a very emotional way. He goes, 'I want to make great restaurants for people to be in.' And I believed him. I never really got to know Matthew. And I've always been totally fucking paranoid all along that Matthew and Jonathan are pulling a fast one on me. I refused to sell my shares. Matthew's kept his, I've refused to sell mine, and Jonathan's out of the picture.

Do you still have an involvement with the restaurant?

I have a thing in my contract which is really fantastic, which I love. Which is that they can't ever do a Pharmacy anywhere in the world without me. And it's just a real fucking shame, because I put more than a year's work into it. I've had to sign a thing which says I won't sell my shares for another year and six months. But apparently they're worth 3 million pounds now. But in a way I wish I could've driven it into the ground. It was an incredible amount of work, for an incredible place, and then there's these…

Do you still own the installation?

Yeh, I still own the art. It's hard to define. I still worry about it.

I want to do another restaurant. I really want to do a restaurant. I want to do one down here [in Devon]. But I want to do a restaurant because they're just fucking beautiful things. Every time in my life since I was a child, I've always celebrated through food, through good dinners, through meals, nice rooms.

PHARMACY
INTERIOR (BAR)

Damien Hirst
Pharmacy

1998

Notting Hill Gate, London

Photo Credit: Stephen White

Patrick Caulfield always says how much he likes restaurants. He can't be bothered with the food, but he enjoys them for the rooms, and the human traffic, and the social transaction.
I love 'em. I'm really proud of Pharmacy, and I'm ashamed of it at the same time. I'm totally fucking ashamed of it. I met Matthew Freud the other day, and he said, 'Damien, I'm not into money.' So I'm like: 'What the fuck *are* you into?' But Pharmacy's dead. It just fucking died. It had such great possibilities.

It was amazing recently that *Pharmacy* was up at the Tate, and the restaurant was operating at the same time. They looked identical. What was the difference between the two?
There was a *massive* difference. Massive difference. They're two totally different things. Completely. One's alive, one's dead.

Which one's alive?
The fucking restaurant. The restaurant's totally alive.

I actually wasn't sure what your answer to that was going to be. You feel the restaurant is more alive because of the more successful blurring of the line there between art and life?
I love art. Pharmacy's a restaurant. All I did was put paintings over the sofas so people could eat their dinner in a nice room. Nothing else.
 There's this thing which is called 'high art'. I'm not sure about galleries, but I love art. It's like, if you're living in a squat and you do a big fucking monochrome painting and you bring someone round to have a look at it, and there's shit everywhere and cups of tea with all mould in them, spilling over, and duvets everywhere – you can't look at the fucking painting. But you can take a big fucking square of red, and there's only one place you can put it: in a gallery. You put it in a gallery and it's fantastic. The whole nonsense and craziness of life is cut away. It's out of this world.

That's why I thought you might be going to say that the Pharmacy installation in the Tate was the living one. Because it will go on existing beyond death, carefully protected and preserved. Beyond you.
No, it's death. You can only get that in art. You can only get that in art galleries. Death. It's totally fucking dead.

Because of the set-up? The silent white room?
Because of everything; the whole thing. It's dead. You know it's dead. Because if you don't fucking paint your windows the plants are going to grow through the fucking windows and grow into your fucking soul. Because if you leave the doors open the leaves are going to blow in, and the rot's going to set in, and the filth's going to come. Because that's life. That's a life. The dogs are going to come in and the bread's going to go mouldy and the whole thing's fucking chaos. And in an art gallery... Art's *dead*. The art world's dead. Life is alive. Pharmacy's alive. It's like: Eat your dinner, complain about the food, wash the plates... It's alive. It lives. It fucking lives. Whereas *Pharmacy*'s dead. A hundred years from now, Pharmacy's going to be alive – the restaurant. It's going to live. You can still have dinner there in a hundred years' time.
 There's no way I'm saying to people, 'Well, that was an old idea, Pharmacy. So can we order, like, 2 billion tons of food from contemporary times to deliver to people that haven't been born yet the

experience of eating at Pharmacy now.' Freeze time. I'm not doing that. You can't do it. Whereas *Pharmacy*'s going to be old. It's dead. It was a statement. It's an old idea. It was important, then it's gone. The moment you do it: bang! Old. You know: 'Old Masters'. The *Mona Lisa*.

Art's for people who want to possess it, d'you know what I mean? It's like: You eat your dinner, you shit it out, it's gone. You can always go back to Pharmacy and have your dinner. But to *possess* art; to possess these objects that… There was a moment when I did *Pharmacy* in New York [Cohen Gallery, winter 1992–93], which was the best show I'd done in my life at that point, when I felt it said a fuck of a lot about the times.

Where I showed it, there was an elevator that was tiny that opened straight into the gallery. The gates open and you have the desk of the gallery and the *back* of the desk of the pharmacy; a cup of tea on it and a sandwich and the phone on and loads of stuff. So you walk behind the desk and you go, 'Oh fuck.' You're suddenly behind the desk at a pharmacy. You're in the wrong fucking place. Totally. Everyone went back in the lift. You walk in and you walk out. 'Oh no. It's a pharmacy.' You're behind the counter. Everyone goes back in the lift. Pushing the button in the fucking lift. Down in the lift. Then they come back up and go, 'Where's the Damien Hirst exhibition?… That's it?… Fucking hell, it's art.' I love it. That's how it should work. It didn't work at the Tate. It didn't work very well.

But the thing is, the moment you do that… I did it there and then. And that's what it was. It was the most contemporary thing you could ever fucking do – that *I* could ever do at the time. But the moment you do it… It's, like, you put all those drugs in there, and twenty minutes later they're redesigning the drug packages, they're all going out of fashion, and so it becomes a museum. It's fucked, d'you know what I mean?

But it really worked. It really, really definitely worked. I mean, what it was trying to say, I don't fucking know. It's one thing if you put a medicine cabinet on the wall… My dentist's got a fucking medicine

cabinet in his surgery. He's got it on his wall. The reason *why* he's got it on the wall in the surgery is because his wife won't have it in the fucking house, because she thinks it's shite. But the fact that it's a dentist and it's on the wall means that if he goes, 'This is a piece of artwork,' no one believes him.

Nicholas Logsdail [of the Lisson Gallery] came to my studio and he said to me, 'Have [the medicine cabinets] got any drugs in? It would be great if they did.' I said, 'Well, the whole point is they don't.' He said, 'Give me a call if they do.'

The whole point is they're empty fucking vessels. It's the fucking packaging.

The difference between Pharmacy *in a gallery and Pharmacy as a restaurant is that, in the restaurant, you see the art almost out of the corner of your eye, in the same way that the words of a song on a jukebox can intrude themselves into your mind. The awareness happens without you hardly being aware of it.*

Art's exciting. It's a phenomenal fucking position to be in where you can put art into a gallery and you can make people go back in the fucking lift. You can put art into a gallery in the way that it has always been put into galleries, and you make people go, 'I'm in the wrong place.' It's *fan–tastic*. It's like I said about the tree falling down: you can change fucking everything. You can change it all the time.

The thing is… all the packaging and all that is, like, colour for me. I arranged it all, colourwise. Beautiful colours. Minimalist fucking delicious colours. 'Can you move that red box down there by that green box?' That's the disgusting thing about me. Nice colours. Pretty. You know: Hans Hofmann, anything you want. Still lives. It's got all that as well.

Would you agree that art can be more meaningful, more memorable, half looked at in a social situation like Pharmacy than confronted head–on in a gallery?

It boils down to death. I mean, we're fucking dying. It's a shambles. Total fucking shambles. What the fuck are we doing, dying? It's so delicious, it's so beautiful, it's so fabulous. You don't have to buy a fucking microscope to see how fabulous it is. The real gear, the stuff that we're living in, rots. And things that rot are so fucking colourful. It's amazing on absolutely every level. And we're dying. It doesn't make sense. So everything's about celebrating, and about living. It's about living.

The moment you suddenly go uh–oh and grab the hand of the man in front, you start getting fucking moody. Everybody gets moody. There's nothing you can do about it. But, like, listen to the fucking birds. Just walk out your door and grab a piece of grass and buy a microscope and fucking look at it under the microscope. Get a more powerful microscope and look at it. And a more powerful microscope… It's real. It exists. You've got everything you want, all the fucking time.

What about the point of not setting out to seek an experience deliberately, but just letting it happen?

What about if you're an artist? And what about realizing that you're not a brilliant architect and you're not a brilliant comedian? But you are a brilliant artist. What if you accept it in your own eyes, that being an artist is what you are? That the thing that you put into the fucking world is art. It's like someone's crying on the floor, and you give them a fucking cuddle. Someone's sitting in a house and it's really empty and barren, and you rearrange the furniture and it's suddenly great. What if that's just the fucking thing that you do? 'It's going to be OK.' That's what art is. One of the most powerful things in the world. It just exists.

INTERVIEW 4

OUTBUILDING.
COMBE MARTIN
MONDAY.
30.08.99

Spot studio, 1995

<Gordon Burn>It seems part of your aesthetic to have somebody else between you and the art. The spot paintings are the obvious example.

<Damien Hirst>The dots are boring [to make]. And I love other people.

It isn't to do with a hands-off approach to the work?
No. Not at all.

I always say artists are the people who would *rather* make birthday cards for people than buy them. I mean, we live in a world where you go up to somebody and say, 'I really care about you. I bought you this from a shop.' It says 'Happy birthday' with a poem in it that means fuck-all. *Making* it is the thing. Not fucking buying it. 'Cause it means much more than anything in the world if somebody gives you something really personal that they've made an effort over. They're embarrassed about it, and they shouldn't be.

I was hitching in France when I did the *vendange*. And an estate car, a Citroën of some kind, pulled up with the whole family in. I couldn't speak French and they couldn't speak English. And there was no way I could fit into the fucking car. I don't know if you've ever tried hitching in France, but you can never get a lift; it's impossible. Anyway, this car pulled up and it had, like, mum, dad, kids, grandparents – the whole family. Fucking packed. And they leaned out of the car and said things to me in French, and I spoke things back to them in English. And in the end they gave me a tomato. Just handed me a tomato out of the fucking car. It was one of the most beautiful things I've ever got given in my life. They didn't pull up to give me a lift. I didn't know what the fuck was going on. But they gave me this tomato. And they drove off. And I was left on the side of the road with a tomato. What was going on there? If they'd given me a can of Coke, I would've thought, thank you, and I would have drunk it, and it would have been fine; I wouldn't have been thirsty any more. But they gave me a tomato. I swear to you. The most delicious thing I ever tasted.

So how does that sit with the fact that in your own work you resist the handmade?
I don't. It is handmade.

But by other hands. Not yours.
I had an argument with an assistant who used to paint my spots. A fantastic argument. Because it's, like, nothing comes out of my studio unless I say it comes out of the studio. You've got loads of people working. You've got people you care about that you've known for long periods of time. When she was leaving, and she was nervous, she said, 'Well. I want a spot painting. I've painted loads for you. I've painted these spot paintings for a year, and I want one.' A year in the studio, getting paid a fiver, a tenner an hour, whatever it is. So I said, 'I'll give you a cheque for seventy thousand quid if you like. Why don't I just do that? Because you know you're going to sell it straight away. You know how to do it. Just make one of your own.' And she said, 'No, I want one of yours.' But the only difference between one painted by her and one of mine is the money.

I've got really upset by Dominic. A lot of my friends have sold. I got really hurt. It still disturbs me. It's not about money. I gave Dominic a painting because I fucking love him. I gave him a painting because he gave me a thousand pounds to make the fly piece when he had the money and I didn't. So did Angus [Fairhurst]. It's backwards and forwards, y'know what I mean? No matter how big I get, it's still backwards and forwards. You do that. It all boils down to the fact that, as an artist, it's not *about* fucking money. But if it's not about money, then you should be able to handle the idea of money. You should be better than money.

Hugh [Allan, DH's studio manager and business partner in *Science*] knows. Ask Hugh. I get *really* upset when I give people things and they sell them. I get really upset. If you give someone a painting and their

kid's dying of cancer and they need some kind of treatment and they sell the painting, absolutely fine. I feel like I've done a good thing. Glad I could be of service. But when someone wants an extension on their fucking house and they sell my painting, I get really fucking upset. If they buy it, fair enough. I don't mind. But if I give it to them, I... I get *too* upset. I shouldn't get upset, and I'm just getting over it at the moment.

And that was the argument I had with her. You have to be a hard bastard. You can learn to be a fucking hard bastard.

Could she see it? Could she see your point?
Yeh, she could. But she's a liar. She's a lying shit. Everyone's a lying shit, d'you know? Because it's: 'I want a Damien Hirst.' Like, at Christmas I gave a spot painting to my brother, and my sister and my mum. I left it too fucking long. You give them a spot painting, and it's like... What I want when I make a spot painting is I want to put it on a wall and I want people to look at it and look at the colours and think, 'Wow – what a great object.' And I really don't want them to think about anything else. I definitely don't want them to think about 'Damien Hirst'. Whatever they've got in their life, I want this to enhance it and make it better. I want it to be on the wall and to brighten their fucking rooms up. Beyond belief. I want them every day to walk downstairs and just go, 'Wow.' Every day, till they fucking die. I never want it to stop. That's what art is. That's what I want.

And I took money for it in order to do that. And by taking money I suddenly got this thing where you can't fucking see the paintings because of the fucking money. You can't see the colours. I've failed, a bit. I'm still working on it. They look at the painting and go, 'It's a Damien Hirst. How much is that worth?' People don't look at it any more. And the spot paintings are actually so fucking *fabulous*. I feel I'm actually in a fucking flea market of ideas. They're just phenomenally fucking delicious. And they ain't nothing to do with money. But because I took money, they stopped brightening your rooms up, and started being the bane of my fucking life. People who've got them are suddenly walking past the Damien Hirst on the wall and they're going, 'Forty thousand quid. Kitchen extension.' And it's, like, somehow art didn't work for me on that fucking level. And I thought it would.

When Dominic sold the painting I got really upset. It's really easy to just shut the fuck up and hide and not take it on. But I dived into it. So when a studio assistant says, 'I want a spot painting,' I understand it totally, and go, '*Fuck off!* If I give you seventy thousand quid, would you buy one? *No!* So make your own.'

For me, I'd rather fucking starve to death with no money and have an artwork. Personally I just would. I'd rather have a beautiful thing and die starving than sell that beautiful thing and die bored. I can say that.

I remember you told me once many years ago that you loved the idea of turning paint and canvas and other materials into a commodity. That you got a kick out of the money aspect of the work being part of its life.
All right, let's talk about money. The thing I remember as a kid is that the Tate Gallery bought a pile of bricks. And I remember at the time thinking, 'Fucking hell, that's weird.' I thought, 'I'm not a modern artist; I'm a traditional artist. So fuck that; that's shit. It's daylight robbery.' I was just like everyone else. I believed the nonsense, if you read the papers. But then I discovered Carl Andre at the Tate, and I went, 'That's not a fucking pile of bricks. It's a beautiful fucking object. It's a phenomenal object. It's clinical, and it's fabulous.' So I suddenly went, 'Oh yeh, it's all bollocks what I read in the papers.' All this fucking media thing.

You get this *fucking* thing with *fucking* money. 'Fifty thousand quid for a pile of bricks!' 'What, a hundred thousand quid for a fucking sheep in formaldehyde?' The biggest fucking shambles of all is money. It used to be that you'd get a hundred quid's worth of gold and you'd make it into a hundred coins called sovereigns that were worth a hundred quid . And that was out the window in no time. They kept the gold, and gave you shitty bits of paper with a print on it. And now artists are accused of doing that.

I'm one of the few people in the world who can say, 'I know what everything is worth.' I definitely know what everything in the whole world's worth. *Everything*. From the bottom to the top. I know that. It's obvious. Everything in the whole world is worth what anyone else is prepared to pay for it. And that's it. Simple.

I remember in Biarritz at the casino, you commented on how different it was putting plastic chips on the table than it would be playing with real cash money.

I had an idea. There's two farmers in two fields. One of them's got a field of wheat, the other one's got a field of lambs. And every night they go home to the missus and look at each other's field, and one of them eats a load of bread and the other one eats a load of lamb. And there's got to be one day that they meet together and lamb sandwiches occur. They swap a couple of lambs for a few loaves, and they've all got lamb sandwiches. D'you know what I mean? But then some cunt sees what's going on, someone in the government, or the Queen, and goes, 'Less of that! Less of that swapping lambs for sarnies! D'you know what this is called? It's called a ten-pound note. "I promise to pay the bearer…".'

Money. Don't talk to me about putting fucking bricks in the Tate. Talk to me about money. You know what they use? Art. They use the oldest tricks in the book. Artists, drawing, printing, images, paper… That's what money is: 'Less of that swapping lambs for bread.'

Is that why Andy did the hundred-dollar bills?

Oh, I don't know about Andy. I like Andy Warhol. Again, it's honest. Honest fucking geezer. He just went, 'I'm into stars and fame and I'm insecure and paralysed and I like flowers…' You know: 'Don't expect nothing off me.'

You walk in there and you go, 'I'm brilliant. I'm going to really impress you. I'm going to be the best in my class.' You fail. No one's going to like you. But you walk in there and you go, 'I'm shit and proud of it.' You win. That's Warhol. It's any great artist. It's Bacon. Shit and proud of it. And not just proud of it; prepared to die for it. Give you his all.

Damien Hirst
Away From the Flock
1994

Steel, glass, formaldehyde solution and lamb
37 3/4 x 58 5/8 x 20 in. (96 x 149 x 51 cm)
Photo Credit: Courtesy Jay Jopling (London)

Warhol is supposed to have turned to friends like Henry Geldzahler for ideas about what to paint: 'Oh, Henry, tell me what to paint.' He sent a lookalike out on a lecture tour. Is there any connection between that and you liking to use intermediaries to source and make and install the work?

You keep going back to this 'carrying out the work' business. It's bullshit.

You've got an idea, or you've got a vision, and you've got to see that vision through. It's like thinking, 'I'm an artist; I've got to paint my own paintings.' And the logical extension of that is 'Yeh, but who's making my paints?' I mean, I once burnt bone to make black – burnt bone mixed with lard to make black paint. It's a load of shit. And Franz Klein did it years before. It's nothing to do with that. What it is to do with is: What do you want to say? There's so much out there. *So* much out there. What do you want to say?

Most of the people who I work with I've worked with for a very long time. And they start to know how you work and start to give you what you want. You start to involve them and your relationship with them. There's this thing about being an artist that I'm totally tired of, and I think everybody is. It's supposed to be this fucking phenomenal thing. Like: 'My God that's a Hirst...' 'God, is that a real Rembrandt?' 'Is that a Warhol?' They're dead. But I'm thirty-fucking-four and it's happening younger and younger and younger. I've got the shit attached to dead artists *while I'm alive*. Something's fucking wrong.

It's like: 'What do I want? Do I want to be dead?' No. I'm alive. But I make one-offs. And then Koons makes, like, three-offs and four-offs and keeps APs [artist's proofs]... If you make something and you're alive and a thousand people want it, why not make a fucking thousand?

If you lose that side of it, where the artist is like the travelling minstrel who wanders into the village with his skill... if you lose that, then you also gain this thing where you brighten people's lives up. And that's where I'm lost. That's where I'm totally fucking lost. It's just the choices are so massive now. There are some things where the idea means you have to make *one*. If you do a sculpture called *Saint Sebastian*, there *can* only be one, because there was only the one saint. Whereas if you do one called *Chicken*, and it's a chicken in formaldehyde, it can be mass-produced.

Today... I mean, artists are high and mighty in my mind, and in the books. But I think that if art works, then maybe artists *are* high and mighty. D'you know what I mean?

No, I don't know what you mean.

It's, like, I'm Damien. I'm thirty-four fucking years old. And people go, 'I had dinner with Damien Hirst

Damien Hirst
Away From the Flock (second version)
1994

Steel, glass, formaldehyde solution & lamb.
37 3/4 x 58 2/3 x 20 in. (96 x 149 x 51 cm)
Photo Credit: Courtesy Jay Jopling/White
Cube, London

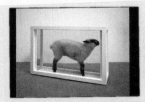

Damien Hirst
Away From the Flock (third version)
1994

Steel, glass, formaldehyde solution & lamb.
96 x 149 x 51 cm
Photo Credit: Courtesy Jay Jopling/White
Cube, London

the other night.' Like I'm dead. I'm sat here, I'm curious, I'm interested in art, I hate all this shit and I'm trying to take it forward.

I wanted to be a famous artist. Artists do everything better. Artists do *everything* better. A great accountant's an artist; a great bricklayer's an artist; a great plasterer who signs the fucking wall before you paint it... Artists. They're the greatest things in the fucking world.

When you're doing art you can do what you want. The fucking walls fall down, and the whole fucking thing... Do what you want. There's no idea too mad for art. That's why people are frightened of it and think it's weird. I remember Angus [Fairhurst] giving T-shirts away at the Tate. Giving them away, and no one would have them.

The thing is art's fucking popular. And I grew up when it wasn't popular. If that means art becomes tacky, but you can still achieve what you want to achieve as an artist, then who cares? I definitely don't care. Art's about looking. People don't look. Artists make people look: look at what you know; question what you know. Art's magic. I'm an artist. Let's get one thing fucking straight here: I'm an artist.

The worst question I ever asked was 'What if?' Or the best. There is no answer.

Right at the beginning. I've asked it ever since. I wish I'd never fucking asked it sometimes. 'What if I went and pissed on the floor? What if I stood on the table and pissed on you?'

[*Affecting upper-class accent:*] Well, to be honest with you, I do like to think of myself as a little bit more traditional than Andy. I mean, these Americans have had it all their own way for far too long. [*Own voice:*] I love this fucking room.

What the fuck do you think? Absolutely. Nothing's changed. But I need other people. I've always needed other people. But absolutely nothing's changed. I haven't changed. I definitely haven't changed. I'm exactly the same person. I'm older, and I kind of feel I've fannied about with it. That I'd like to forget about it. I feel I've opened a can of worms in my own head.

No. Definitely not. Because it gets truer and truer and truer. It's, like, sitting in business meetings talking to fucking Matthew Freud, who thinks you're interested in money. It's like, by being an artist, I turned out to be a fucking businessman. But I'm not. I'm a fucking artist. And if art fails me, I'll be a miserable cunt. I won't even be doing these fucking interviews.

It's life, Gordon. It comes down to fucking God. I always think that art, God and love are really connected. I've already said I don't believe in God. At all. I don't want to believe in God. But I suddenly realized that my belief in art is really fucking similar to believing in God. And I'm having difficulties

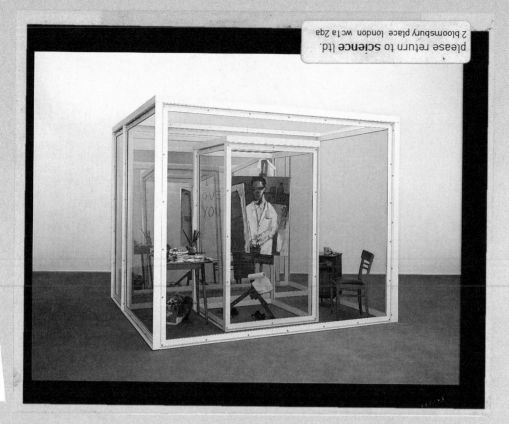

please return to science ltd.
2 bloomsbury place london wc1a 2qa

Contemplating a Self-Portrait
as a Pharmacist, 1998

believing in art without believing in God. And it's, like, if I don't believe in God, I can't believe in art. You can't put your finger on it. It's a fucking dream state. It's a fucking mad thing. It's a weird thing. I'm hanging on to art. I've got fame. I've had that. It's shit. It's bollocks. I've got this thing which is called art, right. Which I love. And I'm finding myself getting absorbed by all the other stuff.

It all comes from asking, 'What if... what if... what if...' You know, *why not?* I said to myself at one point, 'If anybody tells me anything, instead of just taking it for granted, I'm going to go, "Why?"' And you find out, unfortunately, that there is no fucking reason why. And then you find yourself in a right old tight spot where you're responsible for your discoveries and where all the people who told you you were a cunt in the beginning are going, 'Maaahvellous, daahling!' And you kind of stand up there for it. Because I've definitely advanced art. To the point where I don't understand. But I don't... I do not want it to go back.

How much of that was intentional?
None of it.

Did you ever feel that other people's perception of what was happening was beyond yours?
Listen: you grow up, you dive in there, you're looking at what's just behind you about a millimetre away, and you go, 'You're bollocks; you're shit. Punk rock? *Fuck off!*' You tell your parents to fuck off; you tell your teachers to fuck off; you tell your contemporaries to fuck off. You tell everyone to fuck off. And before you know where you are, everyone's going, 'Maaahvellous, daahling, we always knew you'd be successful.' Jeezuschrist.

I'm not, like, a little innocent wonderbeing. I went in there to accumulate. I went in there to find out. I went in there to kick the shit out of what existed before. To be told off and smacked around and live on the sidelines going, 'You're all wankers.' I was totally unprepared for having to succeed. I was telling people to fuck off and I got away with it.

But at the same time they were sending motorbikes and taxis round to ferry people like Norman Rosenthal, and critics and curators, to the early student shows.
It's a tiny thing. But I know what you're saying. That is me. It's throughout everything I've ever done. You have to get people to see it.

You have the ability to say 'fuck off' with charm. Other people would say it and it would come out in an ugly way.
Look, the Sex Pistols did a song called 'Anarchy in the UK', and you listen to it now and it sounds like the Beatles' 'She Loves You'. It's music. It's a celebration. It's impossible to sing about anarchy. It's absolutely impossible. It just doesn't make sense: 'Hey, let's get a band together and tell everyone everything's shit.' You can't. You've got to get people listening to you before you can change their minds.
I tell you what: if I had a load of work in my studio that was shit, there's no way I'd send a cab for anyone to come down and have a look. You send a cab when you think you've got something fucking phenomenal.
I worked at d'Offay, and I was at Goldsmiths'. I went between the two. And I suddenly went, 'Fucking hell, what's going on? Everything's shit in the art world at the moment. My college is infinitely better than what's happening in the galleries.' But you don't think beyond that. OK, you want to be a famous artist. But you want to be a famous artist in everybody else's terms. It's a bit like a pain. You start off going, 'Fuck off. It's all shit, an' I know better than you lot.' But all you really want is a fucking cuddle. Then you get it, and you become responsible for it, and then what the fuck d'you do?
I've got a child who draws fucking superb. Scared the hell out of me. Scared the shite out of me, Connor drawing.

Because it's so good?
Just 'cause it's so good, 'cause it's so shit, 'cause it's so natural, 'cause I ain't got fucking time…
It's better than me because it's meaningless, and it's meaning*ful*, and it's just so fucking *natural*. It's without effort. Like I've been looking at paintings in the second-hand shops, and they're shit, and they're great. We've got a painting upstairs in Connor's bedroom, fuck knows who made it, and it's brilliant. No one's got one. Except Connor.
You go to the shoemaker and go, 'Mek us a pair of shoes,' and it costs you a fortune. And you come out of the shop and you're bound to bump into somebody wearing the same fucking thing. But you can still go in an art school and pick a painting and no one ever in the history of the fucking planet can have one.

So is a spot painting painted by you better, or worth more, or in any way different from a spot painting painted by a studio assistant? Does it have any added 'aura'?
Listen: Who designed the Guggenheim?

Frank Lloyd Wright.

Right. And he can't build. He's a fucking architect. Can't build walls. So if you live in a Frank Lloyd Wright house that he built himself, knowing he can't build walls, is that better than a Frank Lloyd Wright house that he just designed and got other people to build for him? Which is the best Frank Lloyd Wright house?

It's not quite the same...

It's exactly the fucking same. I only ever made five spot paintings myself. Personally, I can paint spots. But when I started painting the spots I knew exactly where it was going, I knew exactly what was going to happen, and I couldn't be fucking arsed doing it. And I employed people. And my spots I painted are shite. They're shit. I did them on the wrong background, there's the pin-holes [from the compass] in the middle of the spots which at the time I said I wanted, because I wanted a kind of truth to it. Under close scrutiny, you can see the process by which they were made. They're shit compared to... The best person who ever painted spots for me was Rachel [Howard]. She's brilliant. Absolutely fucking brilliant. The best spot painting you can have by me is one painted by Rachel.

You once said to me that the other people painting them would worry about imperfections – runs and so on – but that you liked them and told them to keep them.

I'm a painter. I was terrified of going into this machine mode. I wanted to leave remnants. That's why the ones I did are shit. The people who are doing them for me took them beyond that. I hired people who started saying, 'Yeh yeh yeh, Damien, I know what you're saying, but fuck off.' It's a bit like your work talking back to you, and you go, 'Well, OK.'

Each spot has a compass hole at the centre which has been filled and sanded down so it disappears? I never knew that. I find it weirdly exciting. I see those paintings, just in that second, completely differently now. The act of making them seems much more conscious. They seem much more... made. Less 'accidental'; less flat.

Yeh, but here you go, you see. This is the fucking point. The thing is they're fucking gorgeous; they're fucking delicious; they don't keep still, they'll live for ever. They're absolutely fantastic. They're colour. They're as good as flowers, and they're just fucking paintings.

I still feel that getting rid of the compass holes in that way seems to say quite a lot about you.

I just love the idea that you live in a fucking shithole and you've got no money and it's depressing, and you just suddenly get up on your feet and go, 'Hang on a minute.' And you rearrange the furniture and you mix jam with emulsion to get pink and you paint the walls and you go, 'That's better!' I totally mean that. I *totally* mean it. You just take what you've got and rearrange it and you've got something better. I love that. I just fucking love it more than anything.

 You're depressed, just rearrange the room. Smash the windows out. Go mental, and swap sides in bed... The most terrifying thing to me in the whole world is ending up in separate beds.

But wouldn't that be changing things in the same kind of way?

You're born alone and you die alone; you're alone in the middle. We want parent figures to come in and take us away from all that bollocks. But you have to work hard at it. It's a fucking nightmare. You'll be

please return to **science** ltd.
2 bloomsbury place london wc1a 2qa

Contemplating a Self-Portrait
as a Pharmacist (detail), 1998

shagging an old woman if you fall in love. And there's nothing you can do about it. That's the best you're going to fucking get. But let's not get in separate beds. Let's not get lonely.

There's something fundamentally wrong with the world. And unfortunately I've glimpsed it. And I don't like it.

There's a load of fucking scumbag cunts hanging around, making shitloads of money out of people with no money. Out of frightened people. It's terrible. And I've glimpsed it, and I'm right on the edge of it. And there's an 'I'm all right, Jack' attitude to it which *really* doesn't fit with artists. It really doesn't fucking fit with it.

That's why other artists would say that you probably shouldn't have got involved with those 'scumbags' in the first place.
If you don't get involved with those sorts of scumbags you can't change the world. 'You're there and I'm there. You're the goalie; I'm the footballer.' I hate it. 'Cause all I want to do is make art. I don't want to make a political fucking bollocks stance, on anything.

But you already have done, from what you're saying.
All I said was: 'What if?' And, now I've found something out, I feel really responsible. I'd love to just shut the fuck up and be I'm all right, Jack: 'Fuck you, I've got me farm in Devon. I don't care.' It's so easy... How much is a can of Coca-Cola worth?

Depends how thirsty you are.

Exactly. What about if you go round someone's house and they've got a really beautiful chair and you go, 'I love that chair.' And they say, 'Well, you know you've got that bed that I've always loved when I've stayed round your house? I'll swap the chair for the bed.' And you go, 'Bang in that new kettle you've just bought, and it's a deal.' Know what I'm saying? It's, like, two people can make a deal like that, and walk away with more than they came to the table with. That's the beauty of it. That's how it should work: 'I'll give you this if you give me that.' And you both walk away with more. That's how it should work. That's what you look at under the microscope when you look at a fucking blade of grass.

Richard Wentworth, who was your tutor at Goldsmiths', used to make a point of encouraging his students to familiarize themselves with places like Asprey and other ruling-class hold-outs on Bond Street, on the basis that ideas can spring from unlikely sources. Isn't this similar to you getting involved with boardrooms and investment analysts and City types?

I'll say this to you, because it's absolutely meaningless. Because I don't have the time, I don't have the energy, I don't have the power to back it up. But I'm an artist, OK, and I'm bored with business situations. I don't give a fuck. But I win hands down every time in every business situation. As an artist.

Because it's confusing, isn't it?

No, it's not.

To them, I mean.

Yeh yeh yeh. 'Cause you don't get people who walk into a board meeting and go, 'I genuinely don't give

Raphael Jablonka, Jay Jopling, DH, Bruno Bischofberger Gallery, Zurich, 1996

a fuck.' And people who genuinely don't give a fuck can generally get what they want. Because they're prepared to lose. The men in suits go, 'Oh, I see what you're doing.' But they don't fucking see what you're doing. 'You're going for a bigger percentage.' Because I don't give a shit about money, I am coming at it from a totally other angle. So the position I get into is where they think I'm a really sort of powerful manipulator, financially. These so-called big money men. Big fucking powerful money men. Into money. 'Oh, I see.' But they don't fucking see. They just think I'm a really smart businessman, and they start to fucking hate me in terms of business. They don't realize I'm really going, 'I don't give a fucking shit if I drive this thing into the ground. I'd rather have nothing than something shit.' They think it's a big fucking game or something. But it isn't.

Can they be touched by art, those money-minded people? Can art get to them?
Art can get to anyone. Everyone. Absolutely. Art stops you in your tracks, no matter who you are. I'm talking about great art. You can't avoid it.

You can. Many people avoid it for most of their lives.
I'm talking about great art. I'm not talking about mediocre art.

What is great art?
Great art is when you just walk round a corner and go, 'Fucking hell! What's *that*!' Great art is when you come across an object and you have a fundamental, personal, one-on-one relationship with it, and you understand something you didn't already understand about what it means to be alive. That's why people with loads of money want to possess it. That's why it's worth so much fucking money. But it isn't. They want to possess it. But they can't. Throw money at art, you get *nothing* back. You die. Then where does it go? Fantastic! Henry Moore.

Do you feel there are parallel universes? That every day you rub up against people who are so different in their outlook and priorities that they could be from another planet?
I just think that you've got your fucking wardrobe, you've got your fucking shelf, you've got your fucking toybox, you've got all your stuff. And then one day somebody gives you something weird that you want to keep. Like a pebble. You keep it through your fucking life and then it goes somewhere else…
I'm really romantic in that. I can't help it.
 I wrote down on that list I made for you, 'Picasso and Matisse'. Picasso-stroke-Matisse. It's two totally different fields of thought. Picasso was a star-fucking cunt. Can't be arsed with him. Very fucking talented. But too busy looking at himself on the telly to get on with it. Fuck Picasso. Whereas Matisse is just like… awesome colour. Bang. Cut-outs. Karamba! D'you know what I mean? Just, like, fucking delightful. I'm up there with Matisse and colour.

Most people would see you in the Picasso mould of artist, in terms of personality, promotion and all that kind of stuff.
I don't give a fuck how other people see me. I'm thirty-four and I'm totally surrounded by people in the art world that are telling me to shut the fuck up. I haven't even started, I'm curious as fucking hell, and I'm in the situation where I'm surrounded by every fucking gallery in the world telling me to shut the fuck up and churn it out. It's, like, *for chrissake!*

Damien Hirst
Mother and Child Divided
1993

UTHER WAY ROUND.

Steel, GRP composites, glass, silicone
sealants, cow,
calf, formaldehyde solution

I've not aimed higher than I'm capable of. And I've not bullshitted. I've demanded. And needed.
I've gone in there, and I'm amazed at my success. *I* never thought I was brilliant.

I haven't done an exhibition for three years, and I'm doing an exhibition at the moment. And I think
it's going to be the best exhibition I've ever made. I think you'll go in that exhibition and you're just going
to enjoy the objects. I don't think you'll think about me for a fucking second. But meanwhile I've been
caught in the media. It's really tempting to shy away from it. But I'm not shying away from it, because
I think art's better than all that bollocks, and the only way to do it is to hit it head on. In a load of ways,
I wish I'd never done it. On the other hand, I've got this house and everything.

But I really think it's the best exhibition. I reckon you'll go in there and you'll have a one-on-one
experience with every fucking object, so you won't even think about me until after you leave. I think
you'll be fundamentally, like, knocked over sideways, leftways, backwards, forwards; with horror and
enjoyment all mixed in, like in a funzone, like in a fairground. I think you'll fucking love it. You'll just
totally like it. You won't be able to not like it. You won't be able to question it and worry about it.
It'll brighten your evening up. It'll brighten your life up. And the fucking things are for sale.

Will it brighten your life up in the same way as the last Gagosian show? Does it have
the same raucous, carnival-like atmosphere?
You get a bike seat, you get some handlebars, you stick them on top of each other and you call it *Bull*.
There's nothing else you can do. Once it's done, it's the way it is. Artists don't make depressing work.
If it's depressing, it doesn't work.

The last Gagosian show was more to do with making it in America – making an impact in America.
But also it was a celebration. There's a lot of fear involved in going to another country. After I'd done
Pharmacy in New York, uptown, I'd earned my wings. You know, been careful, career-minded…
But then eventually I just went 'bollocks' to everything I'd ever heard, to everything everybody had ever
told me. You just see it very clearly. That [Gagosian] is a fucking brilliant space; the best space in New
York. I'm going to do a show in that space. And to focus on the show while also going through the
really complicated fucking nonsense of the career-minded stuff…

I took loads of drugs. Took loads of coke. Got into loads of situations and took loads of those things
and I've doubted everything in my fucking life, absolutely everything. Except art. And it will never come
to it. I've really fucking hammered it. I've hammered it to fuck. But I've never doubted art. The possibilities
of it. The weirdnesses of it. The badness of it. But I was brought into it in a really fucking mad way.
You can do anything with art. It's fundamental to my fucking being. Art's my thing. It's the structure

of who I am. And you can't unwind that. Because if you unwind that, you unwind me.

I love objects; I love colour; I love images. I give art a very fucking hard time. But I love making a go of it. I can say things better that way than I can any other fucking way. The fame thing makes it a bit complicated at times. But I've done the fame thing at thirty-four, and the art thing you can never do. Throughout your whole fucking life, you never do it. And I'm under no illusions with art.

The working title we've been using for this book is 'What you lose on the sandwiches, you make on the rooms'. We should talk a bit about how we arrived at that.
The reason I love it as a title is because there is a kind of martyr element where you sacrifice part of yourself. But what you lose emotionally and personally, you gain… I don't know, historically. I mean, I definitely already know that if I died tomorrow the contribution I've made is important. I'm not comparing myself to Warhol and those guys, but I already know I've dented that thing. So *What you lose on the sandwiches, you make on the rooms* is your personal life set off against this kind of afterlife you have as a famous artist. It's all the same thing. Because you own the fucking hotel, d'you know what I mean?

If all the people you love need you to be an artist, you give up everything of your own. The harder you do it, the more you get, and then you're dead. You make art for people who haven't been born yet.

So that's why I like the title.

You know the Bacon book, which talks about how he makes his paintings: 'How do you begin a painting?' 'How do you know when a painting's finished?' I really wanted this book to be like that, but it can't be. With me it's really got to be about the personal life and the art and the fame and how it connects, because that's what it's about with me.

What have you lost?
What have I lost, or what am I prepared to lose?

Both.
What have I lost? I remember headbutting the walls when I was at Simon Browne's [a friend's] house with Maia, and Maia and Simon were saying to me that I had to write back to this young student who'd written me a letter. I remember headbutting the wall, and smashing a hole in the wall, and going, 'I inhabit a world you don't even know exists, you cunts!'

I thought I'd developed an ability to deal with it and not care. But something had changed, and I admitted it. I was still hanging out with all my old friends in the old way that I always did. But suddenly I was on the lookout for people taking advantage of me. Whereas before I just trusted everybody. I was very on the defensive, and starting to understand that I was a commodity on some level. I was getting all these letters to my studio and to the gallery after I won the Turner Prize, asking, requesting. So the first thing I worked out was that across the board you say, 'Sorry, but no.' It wasn't in my nature. My nature is to talk to everybody. But it just sort of piled up too much, and one letter had got back to the house and Maia was on at me to reply to it, like you do in a normal life. But I'd created this abnormal life and I was having to live with it. Anyway, Maia started giving me this hard time, about how I'd changed, dah-di-dah. And I remember I went up to the wall at a friend's house and headbutted the wall with all the fucking might I could muster. And I smashed a fucking huge hole in the plasterboard. It was the first time I ever realized that anything had actually happened at all. 'Look, you *fuckers*, I inhabit a world you don't even know exists.' It was the first time I realized that I did.

It had started with Marcus. I'd go through stuff with Marcus [Harvey] that really was upsetting. We used to always go out together, to openings. We used to go to this pub in Brixton. And I didn't want to go to the pub in Brixton; I wanted to go to the Groucho Club. And I kept taking Marcus to the Groucho Club, and buying him drinks. And he just turned round to me one day and said, 'Look, I don't want you taking me out and buying me drinks; I can't handle it.' That was before I headbutted the wall. He'd call me up and he'd say, 'I want you to come to the Prince Albert in Brixton.' So I was going to the Prince Albert, but I didn't want to be in the Prince Albert; I wanted to go to the Groucho Club. And that was when we sort of went our separate ways. Because I was a curious fucker.

It's, like, Dominic lends me a thousand quid; Angus lends me a thousand quid. And you lend them money back, and you lend them money back. And I've always thought – I always will think – that the balance will tip backwards and forwards. Definitely backwards and forwards. But everybody's kind of turned round to me and gone, 'Well, mate, you've made it.' But none of us really believed that. Headbutting the wall was the first time I knew it was true. I 'fessed up to it. 'I inhabit a world you don't even know exists.' But I didn't know it till I said it. It's, like, arrogant as hell.

You meant an interior world?

In a normal world, you go, 'If a fucking bird with a broken leg turns up on my doorstep, I'll try and mend its leg.' And then suddenly you inhabit this world where everybody's out to get you and you become a bit cynical and you've got to watch out. 'All right, mate? Can you do me a drawing?' The cunts start to infiltrate your friends. Because you're a pushover, if you don't change. People who you've never met write you letters asking you for things. I try to protect the people I love from it. So: 'I inhabit a world you don't even know exists!'

What did you think about that the next morning? Did you still think it was true?

Absolutely. I still think it's true now. But Maia somehow inhabits that world now, too.

I definitely believe that there's, like, an eggshell surface round things. You don't have to do very much to be a famous artist. You don't have to do much to make art. And when you get to the eggshell surface, to the point where you've always wanted to be, everybody always goes, 'Leave – it – alone'. Because your body's against you, everything's against you, if you go through it. And I just smashed it open, I couldn't handle it.

How defined do you feel now by the first work you did – the flies, the shark, et cetera?

I still think the fly piece is the best piece I ever made.

I think it probably is.

I've got a belief in art, right. And I don't know – in fact I don't care – whether it's right or not. I've got a really hard-to-beat, hard-to-believe, really hard idea about what I think art is. It's very romantic; it's very fucking childish, and it's really weird. But it's, like, without that, I've got nothing.

And I've definitely always treated it, and I always will treat it, as an all-or-nothing situation. There's no way I'm going to settle for half. So I asked a really big question, and I asked a really dumb question, and I've been into all sorts of areas that I don't really understand. And I've always been faced with the situation where, if I take a half, and shut the fuck up, I'm going to be fine. But it's definitely an all-or-nothing situation. Because that's the nature of the thing that I believe in.

But it's very difficult. It's very difficult when you settle down, and you've got a fucking ego. I mean, everyone's got an ego. 'Hands up who's got the biggest ego!' And my hand's straight up there. But it's not that. It's about how hard it is to totally believe in art. It's about curiosity; it's about childhood; it's about questioning things. But it's also about getting older and having a house. I find myself being... I feel like I'm split between two people at the moment. There's a really quiet me who doesn't have friends... I have friends, but I don't have friends like I used to have friends.

What did Maia mean last night when she said that if you had a phobia, your phobia would be being afraid of people?
You become responsible for other people. The position I'm in now, I'm responsible for a hell of a lot of things to do with the art world. What I do affects the course of art. I don't mean it in an arrogant way.

DH, 1999

Doesn't Maia mean being afraid of an intimacy with other people?
I don't think so. I don't know what she means. The thing is, I agreed. I don't know what Maia thinks.

The fame thing is a barrier, isn't it? It's setting yourself off in a chamber that can't be penetrated by very many people: 'I am a rock. I am an island.'
It's like you're a child, and you grow up. You kind of look people over who you admire, and you learn from them. Everybody I've ever met, always. I suppose it's about looking for a father figure. You kind of go under people's wings. I feel like I've always spent my whole life going under people's wings.

The kind of people I like are, like, big hard fucking people. They don't go under people's wings. They just go, 'This is the way it is.' I've looked at them with a kind of awe. I've never felt the need to compete.

But I've somehow, along the way, got to this position where I'm something else. Where there's nowhere to hide, if you like. You can't get under the wings any more. You're, like, a big man. You become a big man. A lot of it's to do with Maia. It's like, suddenly, through no fault of your own, you move into this situation where you're responsible for a whole load of fucking shit. And a load of these people are going, 'Get out from under my fucking wing, you cunt.' Because it's like you've lucked out. And it's all come up trumps.

But I'm definitely not very good at standing on my own two feet. I need other people. So when Maia said I'm afraid of other people, maybe the reason I kind of agreed with it is something to do with that. D'you now what I mean? No, not really.

Kind of. I was thinking it was maybe a bit more deep-seated than that.
I'm a Gemini, which doesn't mean anything. But I need other people.

It's a cliché, but a lot of people escape into fame, don't they? They find it easier to perform in front of twelve thousand people in a crowd than to talk to one person in a room.
I thrive off other people.

In a way, this is a formalized conversation we're having. A formalized relationship. It's much easier to do it this way, it seems to me, than it is to see you in a pub, or at the Groucho, or even over dinner. Easier to talk like this in a formal way, with the tape-recorder running, than in an informal way, as friends.
But for me to explain how I really feel, I have absolutely no fucking idea. It's why you take drugs; it's why you fanny round; it's why you run around. You question it all the time. It's, like, I keep thinking, 'Right, what do I do? Do I give up smoking? Do I give up drinking? Do I give up drugs? Do I give up drugs and drink? Do I give up smoking and drink? Do I give up smoking and drugs?' It's like you said before: 'Life is what fucking hits you when you're busy making other plans.' And I've got myself into that sort of situation.

I keep saying to myself, 'What do I want? What do I want? What do I want?' And what I basically don't like is… I tell you what: Growing old is difficult. Growing up is difficult. It's really difficult. But that combined with fame is incredibly fucking difficult. They're two separate things, but they just fucking hit you both at once. There's a lot of tempting things get offered along the way. And it's really difficult to work out how to deal with it. Because it's, like, your fears as a human being growing up…

The 'Damien Hirst' that people think they know – it's a convenient screen to hide behind in a way.
Not for me. Not at all. People'll fucking force you to hide behind it but I never will. That's my problem.

In the list of topics to be covered that you drew up before we started this, you wrote, 'Drugs – a big one.' Do you want to talk about that?
Smack, I won't do it. That's why I said drugs is a big one. Because it's, like, all of my generation, all of us… I mean, art's about life, and drugs are not. They're about getting out of it. People say, 'Out of it.' It's about 'getting out of it'. It just seems fucking mad that… There's no, like, 'love and peace' with it any more. Not even any war and hate. It's about 'getting out of it'.

As an artist you're faced with a blank canvas and it's the worst thing in the world. But fuck addiction. It's banging at the window. But it's not that. It's just…

You love dosing yourself, don't you? And knowing what the next ingredient required at this point – substance 'A' to balance out substance 'B' – is.

I think I have a problem about death. But I don't like dosing myself at all. I like taking drugs; I like getting out of it, definitely. But I do it, I definitely take drugs, when it's getting difficult.

It's a losing battle, and you go through it. But at the start of it, the start of when you do it, it's: 'I'm an artist, and I fucking love being sober. I *love* being straight. It's the most brilliant thing in the world.' And you sit there, and you're doing it straight. But it's, like, things come into your fucking head – or my head, and I know it happens to a lot of other people – when you're straight.

I mean, all us lot, we fucking caned the fucking art world. Absolutely totally phenomenal. We caned the art world as fucking *kids*. And we didn't know what the fuck to do with it. You sober up, and you're looking at it, and you don't like the look of it. And the moment you don't like the look of it, you go, 'Fuck it, let's get pissed. Let's have a line. Let's have a pint. Let's have an e. *Then* I'll have a look at it.' D'you know what I mean? It's, like, getting on something just stopping that fucking nonsense. And you're growing up as well.

It's a frightening situation. Sometimes I feel responsible for a fucking massive generation of other people. It's a big high point of life. But it's, like, there are no fucking answers. I would love to travel through life going, 'I don't give a fuck. Bollocks! Follow me! C'mon! We don't care!' But then you suddenly start caring. So you have a line. But then it wears off. So you have another line. But it just doesn't work after a while. Because you suddenly go, 'I'm boring.' You do care. But it's very difficult to go through that transition.

You try and work out what you want. And Maia's driven me with this thing. Maia made me into such a fucking strong man. She does know it, but she won't ever admit it. She demands strength out of people. The strength was there, but she shat all over me when we first met. She's shown ten years of incredible fucking strength as a human being. An individual human being. Maia said this great thing. She's always said to me, 'No total abstinence.' And I totally agree with her. It's a concept; it's an idea. Addiction does creep into it. But, as an artist, you can't have abstinence. You can't *give up* anything. But then you have to focus on what you want.

I mean, can you imagine what it was fucking like? There you are at art school, your second year, you do a fucking show, you turn the art world on its head, you leave, and you become the same old shit you tried to fight. All you've ever wanted is to be famous on everybody else's terms. You've never really wanted to be out there in this isolated fucking lonely place which is the future. But because you're so young, you can fucking see it. Because you haven't got cynical and you're not fucked up, you can see it. How brilliant it is. And you've got these people behind you that are brilliant. And you've somehow got to fucking hand it over.

I never wanted it. I never wanted to be responsible for art. It's like, as a kid, you're asking really challenging fucking questions. And if it happens that while you're asking those challenging questions you become incredibly successful, then you can't stop asking the challenging questions. It's, like, if I was sixty and I got success, it would be great. I'd just shut the fuck up and *bathe* in it. But at thirty-four… It's the same for Mat [Collishaw], the same for Sarah [Lucas]; it's the same for Rachel Whiteread. They put a fucking full-stop right in front of you, and a tick next to you. A big red fucking tick. 'Well done!'

You're on this fucking line of exploration, and they give you the big tick. And the tick says, 'Shut up. You've arrived.' And then you're fucked.

DH at installation of *Young British Artists 1*, Saatchi Gallery, London, 1992

You can't rebel in a culture of rebellion. To quote George Melly quoting Thom Gunn, 'Revolt always turns into a style.'

Either what's gone before you is shit, and you have to offer an alternative, or you live in a culture of rebellion. And I think a lot of what went before was shit. And if you don't say anything, you go along with it, delivering another culture of shit to the people coming along behind you. And you can't fucking do that. You just can't do that. Can we?

But you've made it clear that you're aware that people are already trying to reabsorb you into the mainstream: 'Maaahvellous, daahling!'

Fuck them all. Fuck them all. I'll die before art will let me down. Fantastic! From every angle. I've hammered it. It's just an absolutely totally fundamental thing, basic to people. This fucking joy. This absolute fucking joy.

It's, like, I'm a bit twisted and mixed up within the art world at the moment. Because I've taken on too much. The things I've got to play around with are kind of big, and have become unwieldy. But I *have* to hang on to them. Because if I let them go it's a waste of time me doing it in the first place. Like retreating. And maybe that's what growing up's all about.

Does it make you feel sad that there are people willing you to fail at this point?

I don't give a shit. Gordon, listen to me. I haven't done a show for three fucking years. I've spent a long time working on this show. I've put it off. But when I've done great shows, and I do great things, I've always known. I'm totally on top of it; I have no doubts whatsoever. And it's, like, I'm doing this show

and I have absolutely no doubts whatsoever. I'm totally on top of this show. It's fucking brilliant, and I'm incredibly excited about it, and everyone's going to love it.

I used to get joy out of people going, 'Wow!' And now I feel totally isolated in a different fucking realm where I can't talk to people. And I *know* what's going to happen. I'm going to do this show and everybody's going to go, 'Brilliant.' And it's, like, *dead* for me. It's fucking just totally dead for me. And I have no doubts about it. A lot of people will go in there, friends like you, and people off the street, and they'll love the show, and it's really great. And it'll be dead for me. But I know it's going to be the best show I've ever done. The *best* show I've ever done.

But what if it's not?

No, Gordon, I'm telling you. I wouldn't be doing it. I'm telling you. I know for sure. It's a totally different thing. It's really personal. I'm not diving about in the unknown. Can you understand that? Can you understand that position?

It's, like, I doubt the art world. D'you know what I mean? It's probably the last… I can't think of a way… I can't carry on like this. I did the '96 Gagosian show; I dragged it out the bag. Now I'm doing this. It's back in the gallery. And it's, like, I fucking hate the art world. I hate galleries.

I'm a right old moaning bastard. I should just shut up and stop moaning. But I don't know exactly where to go next. But I can't carry on like this in the art world. It's, like, I really dragged this out. But you drag it out and you end up back in the same old slot that you were fucking in when you were a second-

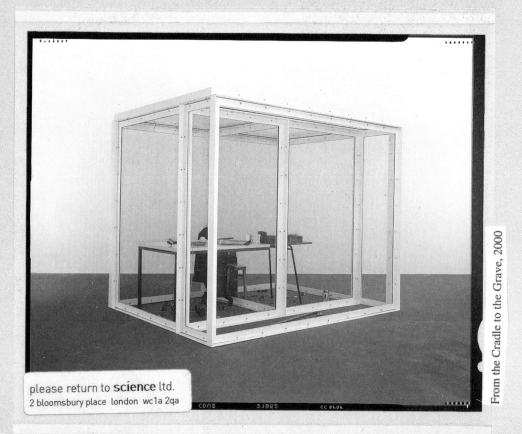

please return to **science** ltd.
2 bloomsbury place london wc1a 2qa

From the Cradle to the Grave, 2000

year art student. You knew it was wrong. I mean, I knew the art world was fucked when we did *Freeze*. It was *fucked*. But it's, like, I make art; I don't fucking make the art world.

Haven't you said it before, that your next show is going to be your last gallery show?
I didn't. I stopped. I did Bischofberger [in Zurich] after Gagosian, and it was shit. It was a really shit show. I made a mistake. I failed.

Did other people think it was shit as well?
No, they all thought it was great. But they know it's shit now, if they look back.

In an artwork… It's a visual language which is nothing to do with you or I. It doesn't matter who's there. It just exists. It's like a universe; like people. There's definitely a visual language that exists.

Didn't you hate yourself, doing that? Putting on a show that wasn't as good as it could be, or perhaps not very good at all?
Yeh. It made me not make art for three years. I stopped. Immediately. The moment that started happening, I stopped immediately. I lost sleep over it. Fucking nearly died. Just that there was nowhere to go. I'd run out of ideas. Run out of everything.

But I'd agreed to it before I agreed to Gagosian. I knew it was shit. Not only did I not have the ideas, I didn't have the energy to follow them through. I was making art in the outer world. Like a nomad. I felt I didn't need a personal space. It was, like: 'I survive against all odds! Give me the date of the opening. I'll fucking stay up all night, take coke, get drunk, deliver it on the day, and it'll be brilliant!' I did that with no studio. I did it all out on my feet. All out there. And it just, like, worked up to a point. And then it didn't work any more. And suddenly I didn't care. That was the worst thing. 'Fuck it.' You know: 'Aah, fuck it.'

You went on a two-year lost weekend after winning the Turner Prize [in 1995], didn't you? And you said you loved it.
I've never been on a lost weekend in my life.

I had the best two years of my life taking drugs and drinking with Keith [Allen]. The *best* two years. It was all part of art, and everything. It was the biggest celebration. The biggest jaunt. It was like: '*C'mon*. If you take drugs you can have a *fucking* great time. Take drugs, you can have a brilliant time.' Then they can become a habit, or whatever. But you know, what works works.

I mean, I used to like Black Sabbath. It used to just be me in a life. Just me. I used to go out, have a laugh, drink till I'd vomit, and go home. Now it's not just me. It's me and Maia and Connor. I used to wear flares, for fucksake.

What was so good about that period after the Turner Prize? What did you learn from it? What were you getting out of it?
When drugs wear off, things get really pear-shaped and odd and weird. When you take drugs, it's like you borrow from the back of the car. When you party hard, you pay for it, d'you know what I mean? It comes back. It's a double-edged sword.

You take drugs because they give you a high. It's not a real high. It's a drug-induced high. It's not real, but it's great. You take drugs and you go up and it's great and it's a high. It's brilliant. But then there's another great aspect of taking drugs, which is you get a low. But that's not real either. And it's just as

good. It's good to feel bad, when it's not real. It's good to feel bad in a drug-induced way, because it prepares you for when you feel bad in a real way. But a lot of people, they take drugs for the high and then they deny the badness and the tears when it's real badness.

The best thing for me with Keith and the drugs was that, when they were wearing off, me and Keith got together and went, 'We're not going to bed.' It's like: 'I go to bed on my own and feel like shit, and you're going to go to bed on your own and feel like shit.' So when it was wearing off and getting really ugly and horrible, and you feel like shit and you want to commit suicide and you hate yourself, we'd sit together and go, 'This is the best bit!' And force ourselves through it and fight it out. It used to be great. And there's no one I know who takes drugs who ever did that comfortably.

Didn't you take more drugs to get over it?
No, because they ran out. We went, 'C'mon. Just ride it. Just ride the horror and the filth, the dirt, the shit. The drugs are wearing off; let's ride this.' 'I feel like shit.' 'So do I.'

It's brilliant to have other people there when you feel like that. There's loads of other people there who'd be going, 'Have you got any more drugs?' And we'd go, 'No.' And we used to love it. They'd go, 'Well, I'm going home.' 'Well, fucking go home then. We're not. We're staying out. 'Cause we love this bit.' The best bit. Our favourite bit. The drugs wearing off. You fucking hate yourself. It's fucking awful. But I'd rather be awful with my mates than be fucking awful on my own in bed.

We used to really seriously – especially with Keith – talk through it. Everything. But to experience really bad emotional paranoid states like that... fucking hell... Drug-induced *bad* times. You take the

drugs; you have a great high time. You go incredibly high up. As a payback you go incredibly low down. And then you get back to normal.

It's fantastic to feel that bad and to realize there's nothing to feel bad about. To feel all those bad things and then to know it's totally unreal. It's drug-induced.

It's also in a strange way the traditional romantic idea of what people think artists are like. I did it without thinking, Gordon. I did it *without* thinking. That's why I had the best two years of my life. Because I had the high, and I had the dirt. D'you know what I mean?

But you must have been aware to some extent of building a mythology, of creating an image of the kind of person you were, and how you lived. The 'hooligan genius' of Soho. Oh no. C'mon. Artists have always... Look. I'm a fucking alcoholic. I'm an artist. It doesn't matter.

It's good for business.
Bollocks. Forget business. Business is irrelevant. If you make great fucking art, then fuck business. Fuck what they want. They'll buy what you fucking give them. If you're great, they'll buy it.

In the romantic tradition the two go together. For the art to be great, the artist has to more or less destroy himself.
If you're making great art, you don't have to think about the punters...

Bez [of the Happy Mondays] said the best thing to me about drugs. He said, 'It don't fucking matter, whatever drug you do, if it's heroin or anything, you're only doing one of two things: you're either

DH, Keith Allen, Alex James, Fat Les photo call, Devon, 1998

celebrating, or you're fucking hiding. If you're celebrating, good; carry on with it. If you're escaping, jack it in.' I think that's absolutely brilliant. The best fucking piece of advice.

But the thing is you dive in anyway. You don't give a fuck. You go, 'C'mon, we're having a laugh. Let's get pissed; who cares?' Like you're a child with parents. But if you carry on doing the same thing, suddenly at some point you can't carry on doing it. Because it doesn't work. The celebrating goes out the window. And then you do pick up a bit of a habit. Addiction, if you like, if you wanted to take it on further.

It's like at mid-life you want to be a child again. I mean, thirty-four. It's the middle of your fucking life, isn't it? *If* you live to be sixty-eight.

In the art world you get to do whatever you want, and play around. Especially when you're selling it. You don't give a fuck. But each individual moment, and every piece you make, you're building up a fucking history which is totally solid, which you can't fucking change. And you suddenly get to a point where you've got less time in front of you than you have behind you. And all that punk bollocks – '*I don't give a shit*' – doesn't work any more.

Can you feel walled in by what you've made in the past? Because at this point you no longer have a completely free mind; it's already furnished with stuff that is impossible to throw out.

There's a thing in art about truth. You've got to be who you are. You can't be a good artist and lie. You can't be a liar. Whatever's happening to you is what's happening to you. And whatever's happening to you, you've got to communicate. You can't lie. When you start lying, you're shit.

You've got to be true. You can be a shit person, you can be a fucking scumbag; you can be anything you want. But as long as you remain true, then you're fine. I mean, I've definitely skirted around and flirted with this idea of, like, 'Damien Hirst'. But it's not the fucking half of it. So you remain true.

Isn't this house, and the life you've got here, more important than art?

To me? No. I maybe thought so for a while. But I am nothing unless I make art. I'm a great geezer if I make art. I used to think that if I put into my life what I put into my art , I'd have a much better life. But it's not true. There's no fucking way out. You think you're an artist? Well, get on with it. I'm a great artist because it's, like, that's the way things work for me. It's the *best* way I can do things. And I'm infinitely better doing that than I am if I don't.

DAMIEN HIRST
Happy fun
1994

Oil on canvas
119 x 84.5 cm

Photo : Steve White

Oil on canvas
119 x 84.5 cm
Photo Credit: Courtesy Jay Jopling/White Cube

Damien Hirst
Totally Happy
1994-1995

DAMIEN HIRST
Fun Fun Fun
1994

Oil on canvas
119 x 84.5 cm

How's that going to go down in print: 'I'm a great artist'? Aren't you going to look a bit up yourself?

I don't know. I don't care. All right: I'm a better artist than I am anything else I could possibly be. I'm not saying I'm a great artist in terms of Picasso or any other artist. I'm definitely not saying that. I'm just saying that, for me, given my way of communicating and saying things, I'm better at art than I am at anything else.

I am an artist. It's a really strange fucking thing. And there's nothing you can do about it. I'm a better artist than I am a bricklayer. I'm a better artist than I am a stage designer. I'm a better artist than I am an athlete. I did high jump at school. When I say I'm a great artist, I just mean in my terms.

I mean, 'artist' is a dumb word for it. It's, like, I always do things. I make people mad fucking birthday cards, and believe in them. Big birthday cards, little birthday cards, carve your name in an apple on your birthday… But weird shit, just things, just objects, make people happy. Make people happy *cheaply*. And I don't mean in terms of money. Just take a bit of this and a bit of that… You walk into someone's house and you move this away from that, or take this and put it next to that, and it's just much better.

When I was at Jacob Kramer in Leeds, I did these abstract paintings and they were just like blobs of colour, like those *Visual Candy* things [DH paintings, 1992-94]. I was doing those, and I was sticking patterns on them. I thought I was doing, like, fucking de Koonings. And there was this guy called John, who was my tutor, and he was looking at them, and in front of everybody he goes, 'Making curtains?' And I was slaughtered, but I didn't show it. 'Great curtain designs.' And I just went, 'D'you really think so? Tell you what, you could be right. Yeh, maybe I'll print them out.' And he moved on to another person's space.

And my mum used to have a flower shop. And I remember a guy who used to teach me, when he first saw my work at Goldsmiths', said, '[*American accent:*] Hey, Damien. A lot of flower-arranging going on here.' And it was like negative things, d'you know what I mean? Curtain designs. Flower-arranging. So: 'What-if-what-if-what-if?' I just suddenly went… You know, if you want to be a famous painter, you've got to be like de Kooning; you've got to make important paintings that change people's lives. As soon as somebody tells you it looks like fucking curtains or flower-arranging, you get pissed off with it. And I went, 'Why?' And I realized there's no fucking reason why. What's wrong with a beauty pair of fucking curtains? What's wrong with flowers?

I thought the interesting part of that conversation…
Rant. Can we call it a rant?

… was that you were determined not to show it: 'I was slaughtered, but I didn't show it.' You wouldn't let him see that what he said to you had any effect. That he had any power over you to make you feel bad.
But that's the curiosity. That's the 'What if?' It's like: one minute you're upset; the next minute you're not. You're beyond it. It's lost the madness. But that leaves you in this fucking boat: 'Perhaps I will make curtains with it.' And if you follow it through, it's like: 'I can do anything. I can do fucking anything.' You end up with another mess on your hands.

Everything I've ever discovered in art – here's a beauty! – has happened twenty, fifty, a hundred, two hundred years ago. Everything I've ever discovered in art has all happened before, on a massive level somewhere else. It's fantastic. You're changing the world. You make this massive huge leap into fucking

curtains. And then you go, 'Hang on a minute. What about those drapes that so-and-so painted? What about those windows that Kounellis filled in?' It's all been done. It's all there. The most important thing about me is Mr Barnes.

I met him again the other day.

Mr Barnes?
Yeh. I met him again the other day.

He's dead.
He's not dead. He'll never die. He's all over the planet. He's a… thing.

Where'd you meet him then?
There's this reclamation centre: 'Chris's Crackers' it's called. Chris is crackers. I met him. It's near here. It's full of junk. It looks brilliant, like an Aladdin's cave of fabulous things. You look at it, and just as you go 'Wow!' you see that every fucking single thing is totally fucking useless. Every thing. There's nothing you want.

He's done a brilliant thing. Everything's rusty as fuck. Everything's rained on and is, like, shit. He's a Mr Barnes sort of figure. And I worked out what he did. He occasionally gets bargains. He hunts around. But he *lives* this thing. It's nothing to do with the shop. Everybody looks around it and there's fuck all to get. He lives in this *thing*. It's fucking organic. He *loves* being in it. More than anything in the world. Everyone's in it with him. He's a powerful man. And occasionally he gets three or four, five or six things that are worth summat, and he puts them in the middle of this *shit*. And people come in and buy them, and that's how he makes his money.

Last week we went there for slates, and he ignores us. Shit everywhere you go. Fields full of shit. Bits of wood and metal. A whole garden like you wouldn't believe, just massive piles of junk. Useless junk. And in his shop everything's, like, a hundred and fifty quid, three hundred quid. It's totally worthless. But it's a great place, the way it's built as a thing. Like Mr Barnes's house was a fucking thing. It's not the things it's made up of; it's the *thing* itself. It's absolutely brilliant.

Would he ever own up to it? That he needs to surround himself and pack his life out with all this crap?
I've gone there to buy slates, and he's battered fucking holes in them. 'Two hundred quid, that. Be five hundred if it didn't have a hole in it.' Everything you touch falls apart.

It's the action of the world on things. Things are fucking great. Things are just fucking brilliant. It's the clutter of the world. It's the way it should be. None of this fucking 'wash yourself, get your suit on' bollocks. *Things*, man. I'm telling you: you plant a tree; it changes and grows; it grows with you. You put a thing somewhere; it decays and you don't. Well, you do. But it decays faster than you.

You live in a fucking scrapheap like Chris's Crackers, and it decays faster than you. It's fantastic. I know exactly. I saw it happening. I looked in the cab of his truck, and the cab of the truck is just, like, a load of fucking shite. Balls of wire and shit. All across the dashboard. Fucking everywhere. Bits of wire and metal. He's driving this truck and it's just this fucking shitheap full of shit. Then we go up to the top of this lane and there's a field. And it's everywhere in the field: big pile of fucking fridges, big pile of cookers, big pile of wood – rotting wood, numbered, all lined up.

If you just met this man, away from all that stuff, would he strike you as a normal person, or somebody mental?

Yeh, mental. Definitely a mental person. But the thing is, I understand, because of Mr Barnes, that this thing is nothing to do with the things. Nothing to do with the bits and pieces. It's like, if you want a bit of wire, he goes, 'Yeh, yeh, under the cookers, by the lawnmowers, down the field there's just a little bit of wire…' I talked to him about slate, right. And he goes, 'Ooh, it's like rocking-horse shit, slate these days.'

He's the king. Chris is crackers. But he's the king. He's better than me. I was in his house, and everywhere I went it was him. The king. Forget about the world. This is the new world. This is about *his* world. Fantastic.

I love this room. This room will always have a force field round it. Always.

Copgrove Road, Leeds, 1985

INTERVIEW 5

DH'S OFFICE.
COMBE MARTIN
THURSDAY.
23.09

Two years after it opened in London, *Sensation* is finally about to open in New York. It has become international news because of the furore caused by NY Mayor Giuliani, in part motivated by the fact that he is still in the race for the Senate seat against Hillary Clinton. CNN are coming to interview DH live in a few hours. Most of the US networks and media outlets have been trying to get through for a quote.

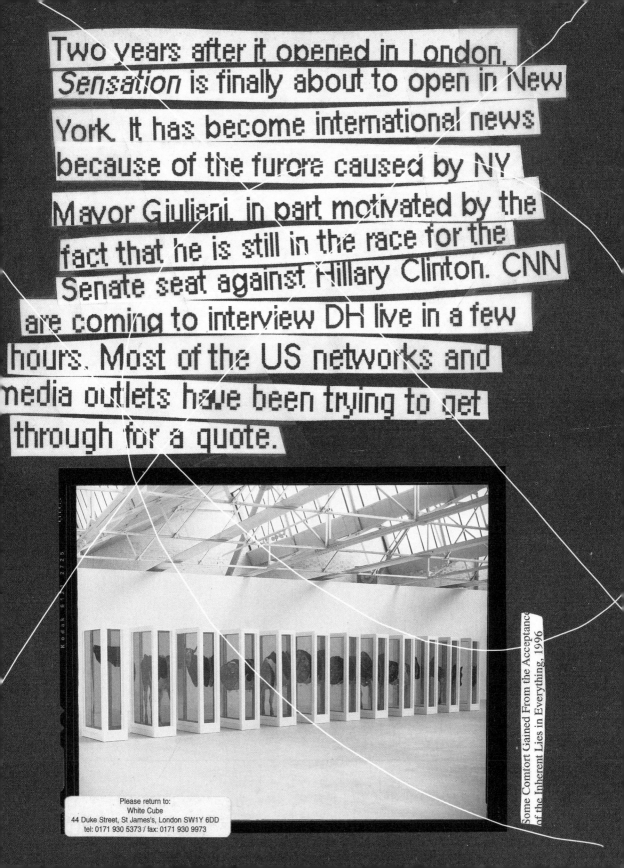

Some Comfort Gained From the Acceptance of the Inherent Lies in Everything, 1996

<Damien Hirst>… and then we got to my third birthday, and all hell started breaking loose… I love it when it all kicks off.

<Gordon Burn>Why do you like it? The noise and chaos that you thrive on is the opposite of what people tend to think artistic activity consists of. You know: contemplation and quiet.
Bollocks. That's all dead in the water.

I'm definitely into minimum effort, maximum effect. It's, like, you leap off in some direction, into the unknown. And you get in a situation where, with very little input, you get a massive effect. To me it's refreshing the way it's kicking off.

What about the warning that I've just been reading the Brooklyn Museum has put out, saying don't come if you're of a nervous disposition, worried about being offended, all of that.
I think Charles [Saatchi] is probably behind that, isn't he? Or somebody. I think it's a bit over the top, and courting the idea of sensation.

Even that in itself is interesting. Why should PR people be involved in art?
PR used to be about promotion, but now it's about selling shit to cunts, d'you know what I mean? It's ridiculous. There's a whole debate according to Jonathan Kennedy: Is Coca-Cola a brown fizzy liquid, or does it taste good? And I think it tastes good. But, you know. You get two people come together in any walk of life and it's: 'You make it; I'll sell it.' It should be a harmony. It should harmonize. But you get a situation pretty quickly where people start to think: Well, I'm the one who's *really* doing the work here, because I'm the one that's making people buy it.

Art always boils down to the fucking objects. There's no way round it. If you're an artist and making one-off objects, it doesn't need promoting. If you've got the time. But you can speed it up. The days of van Gogh have gone, y'know. I mean, Bacon was doing it. Bacon was PR-ing himself. There's a level of spiel and talk you can do beforehand that doesn't take away from the impact of the piece when it eventually gets seen.

Bacon and van Gogh would work by themselves on the edge of possibility. And the edge of possibility was always discovered in the course of working. They could surprise themselves in the course of putting on the paint. Looked at from the outside, it would appear that the element of instinct and surprise has no place in your work, because of the amount of pre-planning involved, and the part played by assistants.
The element of surprise is still there. But I feel that the level I make things at, you pick up a kind of disease, which makes you want to go bigger and bolder. In a way, it's kind of like you want to throw money away. So it's like you've always got to keep that under wraps, and you work within your means. And it's fine to work within your means when you haven't got any money. But then it gets really complicated working within your means if you have got a lot of money. At some point you've got to find a happy medium somewhere.

I try to surround myself with people that… If I work with someone once and I like it, I go back to them.

DH, Provence, 1996

You've touched on this before, when we were talking about the spot paintings. You said that the studio assistants you took on could make a better job of them than you. You like their mistakes.

Well, sometimes I do and sometimes I don't. And if you don't, then you get rid of the person. They work against you. It means it's more hard work for you. You've got to keep your eye on the ball. And that's the same in a painting as in life.

But when you're constantly surrounded by people it's very difficult to think about the deeper levels of it. Which is why I always say I'd rather be a painter. When there's just you and it, it's very simple. When you've got other people there it's, like, you're interacting with other people and at some points it becomes… I mean, painting's like the most fabulous illusion, because there's nothing at stake. Except yourself. And when you start building up a group of people who are making things for you, then it's very difficult if you were thinking of going in a completely different direction. You build up a relationship with them. You're a human being. It's very difficult then to behave as an artist like you can do when you're a painter.

It seems like the edge of possibility for you is somewhere quite different to where it is in normal art practice. It happens outside the work.

I don't think so. At the end of the day, if everything's going well, nothing goes out there without my say-so. And that's enough. It doesn't matter which route you take to get to the finished product. As long as the finished product is what I want, it doesn't matter what has happened along the way. We're OK. That's the hardest thing to keep under control when it's so sort of out of your hands. But the thing is it's always in your hands. At the moment, that's what I'm trying to work out.

It has to go in the bin a lot of the time, d'you know what I mean? You're spending a large amount of money, and you've got people chewing your ear off all over the place...

I think what I'm trying to get to is where the work comes from. It seems to me that the accidental happening, or joke, or brink, is the thing you're constantly looking for. Which is why you're restless as a person, and as an artist. It couldn't be further from solitary studio practice; being in a studio on your own.

Sometimes it is, and sometimes it isn't. The noise and distraction you've talked about can be isolating in itself.

I think I'm always looking for a *thing* to describe a feeling. And that thing can take on all sorts of forms. It's like with anything used to describe a feeling, sometimes it gets personal, and sometimes it doesn't. As an artist, in your life you have two things. I mean, all artists kick against what you just did before. A lot of it starts off like that. You explore. You go out there and you're totally encouraged to break down the boundaries, find new ground. It's only the same idea. But you've been charging through to bring it up to date.

And then there seems to be a change that you go through in your life, when you suddenly realize you've picked up these techniques and these tools, and that by picking them up you're not getting any further ahead. It becomes your visual language, this stuff that you've picked up. By kicking against everything, you develop a visual language which is your own. And suddenly, instead of discarding what everybody did before, you start discarding what you've actually picked up yourself, which is your own.

Infinity, 2001

And you can't discard that. So you have to go, 'Well, I've got the tools to say what I want, and I better use them.' You don't have the *energy* to discover any more.

Do you always work slowly towards an idea or a piece? It seems to me you work retroactively: something happens quickly – in a flash or a glance – and then you work backwards to give it a solid shape or form.

I remember when I was in New York, staying at Gagosian's house, going over this show, I was really worried that I was getting into a situation where I was turning out 'Damien Hirsts'. You spend so much time, if you like, *playing the game*. I mean, I don't mind playing the game. But there's always got to be this fucking thing behind it, which is art. Which totally frees you; it's your escape route. It's the thing that saves you when you're in that situation of playing the game called 'the art world'.

I suppose in a way it's like poker, or any sort of gambling game. I've said there's not a living artist I respect that isn't of my generation. But I remember when I was in New York just now, at Larry's, going over the show, on paper everything works out really well. There's a sort of *magic* to things, which has to be there. And it's, like, you struggle for it. And if it's not there, you try to convince yourself that the little knick-knacks you're making along the way are magic. But they never are, y'know.

All the time I'm speaking to Larry on the phone over here about the show and what it was going to look like and what it's about. I'm very confident, you know. You're surrounded by people, and it's easy to be confident, 'cause they're all telling you it's going to be great. But it's your arse that's on the line. And when I got to Larry's, I just got hit by an incredible doubt. And it didn't mean the pieces were bad. They're in progress; everything's building up. But it just didn't have that… oomph.

You kind of think, Well, I've got a kid; I've got a house in Devon; I don't have to try as hard. But if you don't try as hard, then you're not a fucking artist. And I remember I was lying in the bed at Larry's house, not on drugs, not drinking, nothing. And I suddenly woke up panicking, just going, 'It doesn't have that oomph. It doesn't have that oomph. It doesn't have that oomph.'

I was lying in bed thinking. And I was struggling incredibly hard through all the ideas, all the sculptures, all the titles, everything that was going on in my head, trying to find something that would not just, like, back up this situation, but bypass it – beyond belief. And I kept going through it. And I came up with that sculpture. I got out of bed and I drew it down. *Standing on the Precipice and Overlooking the Arctic Wastelands of Pure Terror* [eventually titled *The Void*]. The one with all the pills in it. That piece came out of that situation. It's fifteen by seven feet. It's just an awesome sculpture. But I worked it out, in and out of sleep, lying in bed, unsure, trying to convince myself, not being convinced… But it actually happened at Larry's house, in bed, on my own. I remember waking up like that. Bang!

In that situation – and you don't know at the time; you can't say it's 'genius' or anything like that – but in that situation, that thing occurred. That idea occurred. It was crystal fucking clear: the size; the title; everything. I was just struggling out of what I had. And it didn't come from any of the things that I had, but it came from *everything* I had.

Did you get some feedback from Larry Gagosian that the show was lacking oomph?

I didn't even talk to him. I didn't talk to him about it [*The Void*]. If people buy it, it's great. That's all that happens on that level. If people buy it, then you're great. If people don't buy it, then you're shit. But it's not a great show – though people will tell you you're great – there's something annoying about it, if you fail. I mean, I feel I failed with my Bischofberger show.

There's a direct link between the piece you're describing [*The Void*] and a small, very early piece of yours that was put up for sale recently at Sotheby's, that had white caplet pills embedded in a white surface.

Well, of course you say that. But I just think this piece will be… I think it's, like, the best piece I've ever made.

How big are the pills?

Actual size. It's one big huge cabinet with a polished stainless-steel mirrored back and it's got sixteen thousand different pills in it on these shelves, and glass locked doors. It's an awesome-sized reflection.

They're synthetic pills?

They look like real pills; that's all that matters. Real pills decay. They rot. They're made to dissolve in your body. Plus they're full of toxic substances. It's impossible to get them. I've been through every route. And even if I managed to get them, within a couple of years they'd be rotting, and it'd be fucked. I've had problems with formaldehyde.

Isn't that a curatorial problem, rather than an artistic one? You once said this: 'They told me formaldehyde is not a perfect form of preservation, these fish won't last… They actually thought I was using formaldehyde to preserve an artwork for posterity, when in reality I use it to communicate an idea.'

I've been a curator, and I've been an artist. I'm involved in both. But art's not real life. I'm into theatre. I'm totally not into 'truth to materials'. As long as you can convince people. As long as they are 100 per cent convinced, if there's a way to do it which is less hassle for me, then I'll definitely do it. I'm into entertainment and theatre. As long as it's that convincing, it doesn't matter. You know, you've got a cow's head that looks convincing from a few feet, it's got flies all over it, it doesn't matter whether it's real or not. Because the whole dilemma is: Is it real or isn't it? It's like: Are you real? What the fuck's going on?

Isn't it frustrating that, as soon as he has done two or three substantial pieces, an artist has effectively defined himself?

You've always got infinite possibilities. But you can't escape your own history. You have a responsibility towards your own history. The more you carry on making art… I mean, there's something very personal about art. It's, like, I have personal favourites that aren't the personal favourites of other people. You can't avoid it. You are who you are.

Your interests change through time. But they change a hell of a lot more when you're a child, and less and less as you get older. But then you've got to avoid having someone churning out 'Damien Hirsts' when there's a demand. Because it's not about that. Basically, at the end of your life, people should be able to look back at it and go, 'Well, that is the fucking map of a man's life.' It has to be that. It's from life to death.

How aware were you when you were doing the fly piece and the butterfly piece and the shark and the cows that you were bringing something new that was going to make the world – the art world, at least – sit up and take notice?

Only the fly piece. *Only* the fly piece.

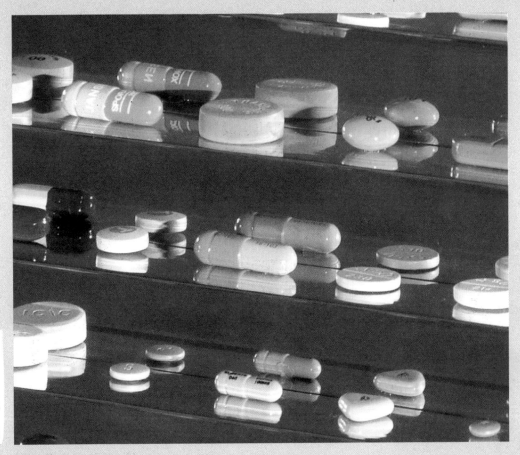

Infinity, (detail), 2001

It's all about being an artist and a curator, and people saying you have to decide whether you're one or the other. It happened to me very fast. I was also making things that I personally considered shit, like these collages that were *so* out of date, and I was in this very modern college and I was trying to bring it up to date by gloss-painting these fucking cornflake boxes and sticking them on the wall, thinking at the same time, Well, Tony Cragg's done that. And everywhere I tried to bring this Kurt Schwitters idea in I was failing miserably.

I mean, for me to come from the cornflake boxes to that [*A Hundred Years*, the cow's head and flies] was a massive leap. It was incredibly difficult. And I'm my own worst critic. And I'm surrounded by Gary Hume and all these people making these brilliant, really up-to-date, perfect things. So I'm curating this show [*Freeze*, 1988]; I'm doing that, and I'm just trying to drag this sort of Kurt Schwitters mentality from the past into the future. So it's really tempting for me to be a curator, 'cause I didn't succeed in what I was trying to do.

I believed in what I was doing when I was doing the collages. But it was very difficult to keep that belief and bring it forward. And every time you attempted it, you ended up with fucking *Blue Peter* cardboard boxes on the wall. And they just looked like shit. And Tony Cragg's done it years before. So all that was going on. And then I did the spots. That was the only point where it settled down. And I don't know where the fuck that came from.

Kodachrome SLIDE — PROCESSED BY Kodak

Kodachrome SLIDE — PROCESSED BY Kodak

↑ TOP
25 × 35 cm

65 × 70 cm
↑ TOP

Kodachrome SLIDE — PROCESSED BY Kodak

Kodachrome SLIDE — PROCESSED BY Kodak

TOP

Kodachrome SLIDE — PROCESSED BY Kodak

↑ TOP
43 × 34 cm

DIA. 36 cm

Kodachrome SLIDE — PROCESSED BY Kodak

50 × 42 cm
↑ TOP

↑ TOP
30 × 42 cm

I hadn't realized until recently that *Freeze* was like a rolling show, that the work changed, and it was only in the last part of it that you did the two spot paintings straight on to the wall.

When I got those, I thought, OK, great. That was the first point when I thought I'd brought it up to the present day. But I was also in my own head, going… I was looking at a lot of contemporary art and thinking it was shit, because of the way I was taught in school. I was thinking that all the beautiful art always existed in the past. But you go through college, and I just suddenly realized that I'm walking round with my fucking head on the ground. I mean *literally*. Looking for bits of old wood and rubbish. You're just suddenly going, 'Hang on a minute. I'm living in this world and I am actually physically looking at the world with my head turned to the ground.' And if you pick your head up, there's fucking advertising billboards and TV and magazine images and fashion and design and film… And I just went, 'There's no way you can do it. If you stay like that, you're fucked. You can't do it; it just won't work.'

I think that by doing *Freeze*, and curating an exhibition of other people's work, it did that. But the spots was, like, the position where I calmed down and went, 'OK, well, it can be done.' It was great.

You really don't know where they came from?

I was always a colourist. We've already talked a lot, I think, about always having a phenomenal love of colour. About being a complete colourist. I sometimes think I'm the best fucking colourist that exists at the moment. I mean, I just move colour around on its own. So that's what the spot paintings came from – to create that structure to do those colours, and do *nothing*. I suddenly got what I wanted. It was just a way of pinning down the joy of colour.

I didn't ever, ever, ever actually let go of the handmade and the found element. It's why I left the pin-holes – the holes made by the compass point – in the first spot paintings, the ones painted by me. You can see them. But in terms of the joy of the colour, they take away from it. And ever since then, I completely see the two things as different. It's, like, an involvement with death and decay, and ideas and life: the action of the world on things exists somewhere, and the colour exists somewhere else. And it's fantastic.

When did you start naming them after drugs? Is it really connected with you and Bradley [DH's brother] having your stomachs pumped as children after mistaking coloured pills for Smarties?

That's a true story. But I think that was sort of added in an interview to make it make sense, because I was asked so many times. I did the medicine cabinets as well, so I was interested in that sort of connection.

But it's, like, unfailing. It's totally unfailing. The spin paintings are shit in comparison. The spot paintings are an unfailing formula for brightening up people's fucking lives.

You've talked about the spot paintings being metaphors for many things. If you look at things in the real world under the microscope, you find that they are made up of cells. 'I sometimes imagine that the spot paintings are what my art looks like under the microscope,' you've said. Also: 'I see every spot within each painting as being alone and yet together with all the other spots; I can find the pieces sad or happy or even dumb.' Were these thoughts you had before you made them, or thoughts suggested by the completed work?

These are discoveries along the way. That's what you do as an artist. You do a certain amount of working out beforehand, but then – Omigod! – something happens, a billion times more. It's just totally out of your hands. And that's what the spot paintings are. The spin paintings are probably an example of expecting that to happen again when it doesn't.

I was talked into making the spot paintings perfect – filling the pin-holes and rubbing them down and making them look *perfect*. In a hundred years' time from now, all that's going to show. So don't put it in at the beginning was the lesson. Because it's going to be there anyway.

Apart from the spot paintings, most people wouldn't associate your work with colour.
I can draw, but I never thought I was a great drawer. I can paint, but I never thought I was a great painter. But in terms of colour, I can fucking do it. When it comes to colour, I can tell you what's wrong with anything.

Mathematically, with the spot paintings, I probably discovered the most fundamentally important thing in any kind of art. Which is the harmony of where colour can exist on its own, interacting with other colours in a perfect format, whatever you do with the colour. It's, like, they don't go wrong. They just don't fucking go wrong. It's equal gaps, equal dots. People talk about the 'golden triangle' and things like that. It would be really interesting to know what Bonnard or Hans Hofmann would think of my spot paintings.

What happened at the time of Freeze, when, say, Gary Hume was showing those doors, which are brilliant pieces? Did something happen to push you on from what you were doing, to the spots?
Actually, d'you know what did happen? I'll tell you exactly what happened. When I was on foundation at Leeds, at the Jacob Kramer, I went on this trip to the Tate Gallery with everyone, with the tutors and students, to see a show called something like *New Art* or *Art Now* or *New Art Now*, which was a big thing. The whole lot of us all went down there, and we all got a big kick out of it, and the tutors just basically said it was shit, 'cause they kind of lived in the 1950s and 1960s. They all said, 'This is shit. This is not what it's about. It's about colour, and it's about painting, and it's about form. Art died about 1960. It all went to pot, and art died.' And I agreed.

I took art really seriously, and as a challenge then. I thought, Well, OK, everything that's happened in art in the last twenty years is shit and something's gone wrong with art and I have to put it right. What I was getting was basically: 'Well, look. Now you've seen what's going on. It's all a pile of shit. This is what's good. Get on with it.' That was the sort of background I came from. And so I got on with it. I went on being taught about this very romantic view, basically of colourists and abstract expressionists – de Kooning and all that sort of stuff. Peter Lanyon. Patrick Heron. All that was great. And then something had gone wrong, it didn't matter why. I didn't doubt that at all. I just knew everything since the 1950s was all shit. So I carried on, and that's when Mr Barnes came into my life.

So I went from those collages to a very full-on, real kind of Schwitters character. I actually discovered one along the way. And after that I realized you can't walk around with your fucking head on the ground; you've got to look around. As soon as I lifted my head up off the ground, that's when I realized that all the stuff I saw wasn't shit.

I don't see the relevance of the visit to the Tate show.
The Tate show kicked in when I went to Goldsmiths'. Because all the people at Goldsmiths' were actually

Work in progress, Goldsmiths' College, 1986

making work which was very similar – at least on similar lines – to the work in the Tate show. So I had the same aversion to what was going on at Goldsmiths' as I did to what I'd seen at the Tate. I arrived at Goldsmiths' and went, 'This is all shit. And these fucking little collages of mine are brilliant.'

And then, through having conversations with people and realizing what I was doing, and what my objective was, which was to go back to a time before it was all crap… through doing all that, I gradually realized that art hadn't lost it. I realized that here was me with my head on the ground, and here was they with their heads in the air.

Art's always about the world. And then I had a doubt about Schwitters. I thought, When he made these things, did they look brand new? Because I was looking for *old* bus tickets, and *old* phone books with *old* covers. I bought all *old* gloss paint, from all *old* paint shops, 'cause all the old colours were totally different. I was looking for *old* things, and was having an aversion to plastic. It was like I couldn't get myself dragged out of this. It was *Blue Peter*-ed out its arse. And I just suddenly thought, God, when Schwitters did it, was this, like, the most shocking, modern bus ticket that he stuck on here?

I suddenly realized that what I was into was this fucking nostalgia that had been accumulated through age.

Did Schwitters use new bus tickets?
I still don't know. I really still don't know. I mean, I don't quite believe it. But I think, relatively, yeh.

I think Schwitters was definitely nostalgic somehow, but not the way that I thought. I mean, I think I'm definitely nostalgic.

As a person, or in the work that you do?
In the work that I do. I think in the way that Kurt Schwitters's work looks nostalgic now, mine will when

a similar amount of time has passed. In fifty years' time, I think people will go, 'Oh God, he got *Vogue* magazine, he didn't go and get the most modern thing out' There's not a newness to it. All the elements of all the sculptures are tried and tested. You know, solid stuff that we've got lying around.

Why did you paint the first spot paintings straight on to the wall, rather than on to canvas?
I *had* to do it on the wall because I couldn't paint. I couldn't paint. I don't know where the idea came from.

I used to do these little collages, and then I used to try and paint them. And that used to fuck me up. As soon as I painted on to them, I destroyed them; I fucked them up. I used to have to be really careful: get in there, and get out.

Like Schnabel painting on broken cups and plates?
That's what mine always ended up like, and I didn't like that.

On foundation, I'd collect a pile of rubbish and I'd go in there and I'd move it all around and stick it together and I'd go, 'I need a blue, I need a blue…' And if I didn't have a blue that I wanted, I'd have to change another colour. So I'd change an orange, and then the blue that I did have would work. 'Cause I'd always work within what existed. And then somebody said, 'Why don't you paint on them if you haven't got the blue you wanted?' And as soon as I paint on them when I haven't got the blue that I wanted, the whole thing fucks up. Completely.

What were you painting on to them? Was it something figurative, a recognizable image? Or just paint?
Just colour. It was nothing. I got a bit into figurative stuff. I remember there was one point with Jon Thompson [head of the Fine Art department at Goldsmiths'] when I was doing this thing where I just opened a book which was an encyclopedia and flicked through it to find a page I liked. Then I nailed the book down with 'Romance' written on it across the top of the page. And then I had an old vanity mirror, so I nailed that into the book.

And I had a tutorial where Jon Thompson said to me, 'Oh, you are aware that in *Hamlet*, the Shakespeare play, the vanity mirror and "romance" means duh-duh-duh…' And I went, 'No.' And he said, 'Well, you can't get away with this. You can't get away with this sort of behaviour.'

And was he right?
He was dead right. You can't put this on a wall and exhibit it to somebody if you're not aware of the associations you are making with these objects. You can't be unaware of the obvious. You can't say that it's a happy accident that you liked the word 'romance'.

There's a visual language that exists; it's tried and tested; it's worked for thousands of years. It's, like, if you're a musician, there are rules; there are notes. And I think in art it's the same thing. Like, you can't make a wig out of snakes and stick it on a manikin without being aware of Medusa. You're dead in the water. You can't do that. Because the moment you're told about it, it totally changes it. It's not finished unless you know about it.

When you made the decision to do the spots, you obviously knew about Richter and his colour charts. Was it a related idea?
I'd had this problem with colour. All along. I used colour to solve formal problems. I always used colour

Work in progress, Goldsmiths' College, 1986

to solve two- and three-dimensional problems. That's why they look like curtains. I dealt with the surface. I took away the three dimensions and I just messed about with the paint until the colours all butted up against each other, like the *Visual Candy* things. And it is a curtain design, and it is a painting.

So then I was doing the collages, and I started adding colour to the collages to solve my problems, which made my problems greater. So I was completely torn then between *painting* on a green and going out on the fucking street and hunting around in the gutters to find the green I wanted. Now I end up getting in situations where I was painting on them so much that all the found objects got completely covered with paint. So then I pulled them apart and threw them in a pile with all the other stuff. They got tumbled around with the other stuff and became things in their own right. When I walked around on top of them they became like these things that I'd found. So my whole studio became like this fucking… I was getting complaints from people for banging – hammering – when they were trying to paint. Fantastic! People used to come in for a tutorial, and I'd be in this pile of fucking shit, really like Mr Barnes. Basically, it was Mr Barnes. It was *after* Mr Barnes. So I'd become Mr Barnes. I suddenly realized I'd become Mr Barnes, and I'd created this thing.

At the end of my first year at Goldsmiths' we had an exhibition where everybody had to exhibit what they'd been doing. And I ended up, I just smashed it all up, and I swept it all into a big pile in the middle of my room and that was it. That was my exhibition. And I didn't know what the fuck I was doing. And I hated it.

Shortly after that, somehow, *Freeze* came up. I'd found I could work with already organized elements. And I suppose in *Freeze* the artists were kind of already organized elements in themselves, and I arranged them.

It seems to me that we're back to where we started a couple of hours ago. We're back to talking about making the world interact with the work – about making the world *become* the work, in fact. The difference now is that, instead of looking for bits of rubbish or old wood

in the gutter, you're looking for an experience, or a joke, or a person, or a place to take back with you to the studio.

The thing is, I was a romantic fucking shit in those days. But I'm still a romantic shit.

One of the best things ever said to me was said to me in my second year at Goldsmiths' by Jon Thompson. I'd done something which was a real mess. I'd got a pair of very formal cupboard doors and hacked these kind of moose-antler, blobby weird shapes out of them, screwed them on to bits of metal and screwed painted pans onto them, and I had this monster just hanging on the wall. This was all I had. And he asked me how I'd got the curves and talked about how in nature, if you look at a flower, it's not a random curve, it's a perfectly formed curve, and there are so many curves mathematically, and so on. And I go, 'Yeh, but that's the point.' And he said, 'But it looks like shit.' And I said, 'That's what I'm trying to say.' And he's going, 'But it just looks like a cupboard door that you've gone like that with.' And I go, 'Yeh, but that's what I've done.' And eventually he turned round to me and he went, 'Well, all right, Damien. The bottom line is, the people who say, *"Fuck off, this is what I think"* are the only interesting people.'

There's a quote from Francis Bacon about being in the National Gallery looking at Velázquez and Titian: 'It's not so much the painting that excites me as that the painting unlocks all kinds of valves of sensation within me which return me to life more violently.' It seems to me that you want to be in touch with life violently all the time, without interruption, and that maybe it isn't possible.

Well, 'violently'. Maybe that's what an artist is.

You can replace 'more violently' with 'more colourfully beautifully' and it's exactly the same thing. And that's the dilemma between Matisse or Bacon and Picasso. The word 'violently' is negative, all right, and you get 'violently' with Bacon. What floats Bacon's boat is violence. And what floats Matisse's boat is colour. And there's no fucking difference is what I'm saying. In art it's the same fucking thing. Bacon can't argue with fucking Matisse, if you look at the *Snail*. That colour, in itself, if you live in a darkened fucking room, is violent. But it's not called violence; it's colour.

I have a built-in thing in me. I don't just solve formal problems with colour. I solve physical problems with colour. I solve all problems with colour. That's why I'm more like Matisse.

I can show you. I can show you now. Get two bits of coloured card and move them apart against white and you don't have to do anything except watch. And there's a point where you just go, 'Abso – *fucking* – lutely*.' And they just go there. And no one can argue with it. I win hands down. I just feel it. It's in my bones.

You've got colour, pure colour on its own. And then you've got the meaning of objects. And with the spot paintings, that's when you take the colour out, and you deal with it separately. You take all the colour out of a situation, 'cause it's getting in your way, and you bang it into the spot paintings. And then you deal with the objects and everything else separately. And that's who I am. Totally. That's what I do. The colour gets in my way. So I take it out and just put it in the spots.

Do you think you've got too much innate good taste? It's seems to me that you're frightened of that, frightened of being too tasteful.

I tell you what: I'm frightened of being a fucking curtain designer.

That's what I'm trying to say.

Well, you're saying it in a very nice way.

[*For the past twenty minutes DH has been mooching around, improvising bits and pieces into a large collage on his office floor – a piece of blue card with 'Polaroid' written on it, an orange vinyl seat-back, a white tray, a pink plastic lighter, a box of matches, a yellow and green painting done by Connor, a pale blue cassette tape, a scrap of yellow paper...*]

Wrong yellow... We can have a bit of it... OK. Hang on...

Very Patrick Heron.

It *is* Patrick Heron... I'm going to put this in. It says, 'Whatever you're into, get into it.' Look at that, just lying there, against the wood. Brilliant... I bet that blue is *really* close to that blue. Fucking unbelievable. It's identical... So what we need... We got to make this sing, OK?... No, c'mon. Trust me. This thing's going to go off... I could go for a cheap shot... The thing is, it all infuses *meaning*... I know what it is. D'you know what we need? Deep red. This red. We need a nice big piece of it... But then we need yellow... It is Patrick Heron. But we do need yellow... This won't work. We need lemon... This is just what I used to do when I was at college... I tell you what, if you can give me that... See, now it's getting too complicated... We need something. Actually, no. Let's turn the lights up... I'll put that in there, just to make it buzz a bit more... Fuck, that does buzz a bit more... Oooh, I think we might be there... Now we're talking... The matches and the lighter are happy accidents...

[*Stands back.*] Home and dry... That's my boy... That's a fucking sculpture by me. It's, like, I'm a master at it. A step on from Kurt Schwitters. How much is that worth? What's it saying about the world? Not much. I'm not looking at the world. I'm looking at the office.

I did that for years. That's what I did for years. And you just don't get anywhere with it. I'm brilliant at that. That's a Damien Hirst, and it's not like things that anybody else has done before. It's a mixture of colour and meaning. But it doesn't really say enough about colour, and it doesn't really say enough about meaning. And it's not really relevant to today. I'm not looking for what's fucking going on. I'm looking for blue, or red, or yellow, or purple. And hey, by the by, these are matches and a lighter and relate to smoking.

So what are we going to call it? Are we going to call it *Sing a Song of Sixpence*, or *Polaroid*? Or maybe we should call it *With Orange Seat*, d'you know what I mean? And that's what it is, and that's where I got to. And that's why you have to move on. I was brilliant at it but I had no fucking future. It was going nowhere. There *was* nowhere to go with it. I had a tutorial [at Goldsmiths'] with Basil Beattie, who said, 'Well, you need an exhibition. And that's it, mate. There you are. You've arrived.' Kind of thing. And I was thinking, Well, that's not it. The fly piece is what came out of that.

The spot paintings are a billion times better than [the collages], in terms of getting colour to sing. It's just, like, a very exciting discovery, where you get this scientific formula that you add to this sort of mess. And also you wanted to create a logo for yourself as well. I was totally aware of what everybody else was doing.

You could also see it as separating the feminine side of yourself from the masculine side of yourself. The spot paintings and the butterfly paintings are conventionally aesthetic objects, while the formaldehyde and vitrine sculptures aren't and can probably be regarded as more 'masculine' in their heaviness and even, sometimes, gruesomeness.

I went from Kurt Schwitters to Cornell and the boxes. In the boxes you work out... I think it's primarily about the meaning of the objects. I really pinpoint what the things in there mean.

So the spots totally deal with the colour. I've put that to bed. This buzz of colour can never get in my way any more, although it's totally ongoing, all the time. There it goes: *Bzzzzzzzzzzzz.* The background to everything is put to bed over there. It's separated out.

And then you can start thinking about what a lighter means. Instead of going, 'What's your favourite coloured lighter?' I can go, 'Which is the lighter that says *lighter* the most?' Or: 'What does a white lighter mean?'

When I saw *Still* for the first time [in 1994], I remember that what hit me most wasn't the scale of the stainless-steel cabinet or the lethalness of the surgical instruments set out along the shelves, but the two splashes of blue that were some kind of kidney-shaped plastic-bowl objects.

That couldn't happen without me doing the spot paintings at the same time. Without the spot paintings, that sculpture you're talking about would have been a godawful mess. But once you do the spot paintings, and take that [colour considerations] away, it just spews out somehow.

It was successful in the spot paintings for me to take colour and treat it with geometry. And the main thing I did after that was to put a box around everything I made.

You mentioned earlier about the move from the spots to the fly piece being a huge leap. You're not wrong. It looks now like an impossible jump.

I remember being in a real dilemma with this Kurt Schwitters stuff. I also remember the dilemma over whether I was a curator or an artist. And also at the same time having the feeling of somehow selling out by making the spot paintings. That I'd somehow been won over by this *New Art* Tate show idea. And not being sure about it. Still having this big belief in this big fucking swept-up pile, and this Kurt Schwitters– Mr Barnes idea of, you know, living this fucking horror–dirt thing of life. And thinking that this is easy, just popping some colours on the wall, and that I'd failed.

I just felt I couldn't… I had a massive fear. All I had for a few months was… In the middle of all this, I just knew that all I had to do was make an artwork that was *about* something. That was all. I was just thinking, I have to make something that is *about* something. And something fucking important.

I'd done the spots and I'd done the medicine cabinets. So I'd sort of got objects and paintings. I'd taken the medicine cabinet straight from the chemist's and put it on the wall. I made the first one myself, by hand in my kitchen. I bought a cabinet from someone's house, like a kind of bureau, and I measured it and made my own. I went to Texas Homebase and bought the wood and the stoppers and the screws and did it all in my kitchen.

Mat [Collishaw] used it, actually. It was after *Freeze*, and we were using the building as a studio. Me, Mat, Sarah [Lucas], Angus [Fairhurst] and Angela [Bulloch]; Simon Patterson as well, I think. We were getting in a situation where I was bringing that in, and then Mat was fucking sawing it up. Mat was a cunt. That's why I love him. I'd come in and it would be all covered in paint. 'Oh, I used the glass doors for my lightbox.' It was really like that. So in the end I just measured it and made my own out of wood at home in Greenwich.

Anyway, I'd come round to this idea of 'new art'. I'd put down the colour in the spot paintings, and I'd done the medicine cabinets. But I'd *lost* something. Something was lost, in terms of these Kurt Schwitters things, in terms of Rothko's paintings, in terms of the belief I had in whether it was real or not, in 'paint how you feel', in this kind of great art that was just *awesome*, that was like someone putting their fucking

life and soul into something they make. And it was just… Something was wrong. I was just wandering around going, 'I have to make something that's *about* something… I have to make something that's *about* something…' Because otherwise I'm going to end up dippy-dappying around in the art world before I start. And I just kept fucking chewing it over and kept chewing it over and thinking it has to be about something important. It's about sweeping it all up into a pile. It's about that. And that was it. It just came out of that.

I don't know where it came from. But I just said, 'What if I had a life cycle in a box? And what if it was a rotting fucking head, and it was real, and it had flies on it…' I swear, I don't know where it came from. Which is why I think it's the best piece I ever made. The best piece I've made to date.

I somehow started at the end. It's weird. When I met Lucian Freud, he came up to me and said, 'Damien, I've seen the fly piece. And I think you started with the final act.' From the vision of a second-year art student, it's quite a fucking heady piece, that. I mean, it's hard to follow. What do you follow it with?

What was it in your background that led you to know about butterfly farms and maggot breeding?
I'd been told you can do whatever you want. And I just took it totally, totally literally. Because I had *nothing*. You only have to ask 'what if?' three or four times about stupid things to realize you can get everything. It becomes your given. You realize you can get whatever the fuck you want. Cows' heads, chopped-up cows, butterflies…

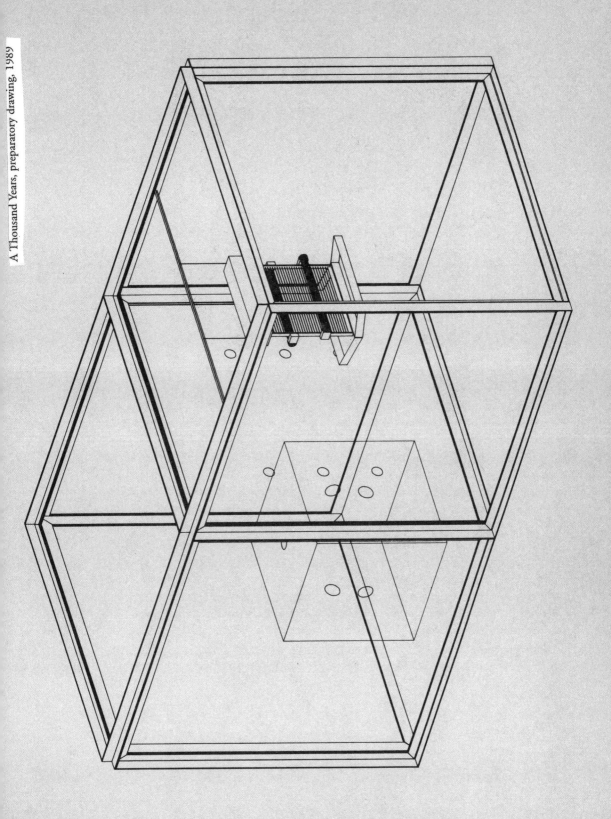

A Thousand Years, preparatory drawing, 1989

Bradley Hirst with friends, Leeds, 1982

I did flies. You only do one sculpture, and it completely breaks you free from anything. This was before formaldehyde, the fly piece. Way before the formaldehyde pieces or anything like that. I wanted it to be *about* something. It just kept getting to me. I don't know what 'about something' means now. I didn't know what it meant then. But it was heavy, and it was big, and it was important, and it had to be *about* something. And it had to fit into these kind of Minimal criteria. And there was the dirt – it was the dirt of Kurt Schwitters, as opposed to the colour of… I don't know.

And I remember I thoroughly fucking enjoyed it when I worked it out. Because I worked out the cheapest way to make it, using two halves, and it was like: You're born; you look around; you die.

People used to come up to me and say, 'What you working on at the moment?' And I'd say, 'I'm doing this sculpture and it's got two compartments made out of glass and steel, and it's got flies in a box and they get born and they fly around and they fly into the other half with the fly-killer and they die and there's a cow's head they can feed on…' And they just used to all laugh at me like fuck. They were all laughing at me. They just thought I'd totally lost my mind.

And I was thinking about it, and I was totally minimalizing it and making it into this visually really pleasing fucking structure. I was working it all out. It'll have holes; it's like dice…

I could describe it *perfectly*, holding nothing back. I could describe it absolutely perfectly, what it was, before I made it. And they just went, 'You've lost your fucking mind. It's shit.' I remember I had a conversation with Gary Hume where I said, 'What d'you think about this for a title: *A Thousand Years*?' And he went, 'Ha!! You can't call it *A Thousand Years*. It's fucking stupid.'

How had you arrived at the title?
I was just thinking about what it was. Because I was doing two of them. I was going to make two, to solidify it or something. I'd always thought with the collages that they were these one-off objects. And I always loved bits of carpet and I was always ripping them. So I just thought, Well, if I ripped a carpet in

half, I could make two. I could rip a bit of carpet up and put it on both. And if I got a bit of wood I could split it down the middle. So they look like these unique things but they're actually pairs, though they're slightly different, like Ming vases. The two always, like, *really* excited me.

I know you'll say it's because you're a Gemini, but that's one thing I've never really understood, your fascination with doubles and twinning. The film script you once worked on was about parallel selves and being cloned. You've said you would like to be a twin.
On the one hand you've got the *Mona Lisa*, and on the other hand you've got mass production – Coca-Cola cans. If you had the *Mona Lisa*s, and there were only two, it just seems infinitely more powerful than the single painting. It's not the second 'discovered' *Mona Lisa*. It's the *Mona Lisa*s: one facing one way and one facing the other way. One's better painted, but it's the *Mona Lisa*s. And if you had the pair it just seems to *imply* mass production. It undermines this idea of you as yourself being unique. There's a comfort from it that I fucking love. Absolutely love. You know: They're not the same; they're similar.

I could have read it wrong, but the script seemed to imply that you were also terrified of the idea of a parallel self; of the existence of this you—but—not—you.
But that's why it's great. Because it implies that there's more. It implies that you're not unique. I had that dream which was terrifying, of meeting myself. I *know* I'm unique. But I think of it as book-ends. I think everybody's two. You're cut in half. You cut yourself down the fucking middle. You are two.

You have science and you have art. You have logic and you have chaos. You have landscape and you have a grid.

You have clones: bang-bang. That's mathematical. And you get individuals, and they've got botulisms, spots, and they don't wash. That's the real-world bit. And in the middle of it, you sort of botch a bit of both. There's something there. It is where everything is.

Like Ming vases. Like book-ends. Like bedside cabinets. Like any great, odd pairs of things. Like any two things which are double but individually unique. *Duelling pistols*. They're both made at exactly the same time, by the same person, they're put together in the box, they go through a massive period of time, and they're like that. They exist. They have their own life independently of each other, but they live together, and for all intents and purposes they're the same, but they're not. And if you haven't got the pair, it's worth less. Like twins. It's just fantastic. It just seems different to everything else.

It's like, you can have a girlfriend, one of twins. And you still want to fuck her sister, 'cause it's *different*. It's different, but it's not.

In life, everything's based on the one-off. You get one hit; you get one chance. So this seems perfect. It's like *déjà vu*. Bang-bang. If you say it and it doesn't work, you can say it again, and it does work. If you do two things twice, in a collage, say – in your *life* – you get these fabulous differences that you'd never get anywhere else.

People find it difficult to understand why, for the last two or three years, there hasn't been any new work. You hear rumbles about 'a block'.
I cane myself hard. I think there are two different kinds of artists and I think they're exactly the same. There are artists who are recognized in their lifetime, and there are artists who aren't. I find half of it really sad – I find half of *life* really sad – and half of it really fucking optimistic. But you're sat there and you just suddenly go, 'Something's wrong.' And you notice it.

I think I've bitten off more than I can chew. It's maybe a last-ditch attempt to be an *enfant terrible* or something, I don't know. It's a way of avoiding the point where you have to lay something on the line.

As you go along you pick up this stuff and you put it in a bag on your back. This is an analogy. And with time, the bag gets heavier and heavier, and you try to discard the bag, but you can't. But eventually there's a point where you're going to have to take the bag off your back, and there's a really tempting fucking feeling to get the bag and throw it in the river. But once you take the bag off your back, you've got to tip it out on the floor so everybody walking behind you can take a look at it.

I'm not under any illusions. I don't think I'm the best artist that's ever lived. But I've discovered a hell of a lot along the way that I have to hand on to artists behind me who are on the same sort of journey. I mean, in a way, I thought that it might be good if this book was a kind of how-to-do-it book for young artists. And I hope it's got an element of that in it. All this information that I've got, it's really important to give back to people who are as hungry as I was when I started.

But it's getting the bag off your fucking back. 'Just get a couple more things stuffed in it.' I'd love to carry everyone on my back till I die. I'd really love that. But it's wrong. That's a lie. It doesn't work.

You were saying a couple of days ago that this time, with this show, the work's more personal.

I've changed as a person. I mean, I used to love exhibitions; I used to love private views; I used to love parties. I used to love all that. But I'm at the point in my life where you get to a certain age and you kind of get calmer on some levels. You think differently.

You start off questioning things around you, like your parents, like previous artists. You kick against what exists. And then you get to a point when you suddenly start to *become* the thing that exists. And I think that's when it gets personal. Instead of talking about 'the world', you start talking about individuals. And that individual is yourself.

It's like: I did all the first spot paintings, and as soon as I worked out how to do it, I employed other people. It was all hands off. And it was spot paintings, spin paintings and sculptures. And it was all very easy.

And now I've got this idea of something I want to do which came out of the menus at Pharmacy and from I.F.P. – 'Information, Fiction, Publicité', this group of artists in Paris who use lightboxes with sky on them that they put on the ceiling. You go into a show in a basement and you look at the ceiling and it's bright with light and it's the sky. And they're great.

So I've been doing these butterfly paintings and I've been looking at the sky a fuck of a lot. And the thing that's totally struck me is that the sky looks like paint, and it looks like gloss paint. It really does. You know Richter does these realistic paintings of skies? Well, the way clouds form in the skies is a little bit like the way you get a brush and go like that with a bit of paint. There's a real similarity there.

So I said to Hugh [Allan] that I wanted to try and do sky backgrounds with butterflies stuck on them, but I still want this solid fucking gloss-paint horror. I don't want it to look like a kind of oil-painted beautiful sky that's been created. If you use it thick gloss paint really does, in a very sculptural way, start to form fucking clouds. I want it to look like an accident of gloss paint with butterflies stuck in it.

So I remember a situation where I was doing these sky paintings with Hugh. He'd got me all these brushes and the paint, and I got down there and Rupert [a studio assistant] was there, and I couldn't do it. I couldn't follow it through. And Hugh's going, 'I don't think it's going to work, Damien.' And I know he thinks it isn't going work. Everybody thinks it isn't going to work. No one thinks it's going to work, ever.

And I have a really incredibly fucking messy technique, which is, like, fucked up. So it's like I'm fannying around with it. And I get one I quite like, and as soon as it's looking like it might work, I want to stick butterflies on it just in case it does work, so I've got a painting that's finished.

So I'm down there in that situation, where I've got the butterflies, I've got the paint, I don't know what the fuck I'm doing, but I know I'm after something which is good. And it's kind of a lone thing, where I can handle Hugh being there but I can't handle Rupert being there. So I'm messing about with it, and Rupert's cleaning my brushes and going, 'What if you try this…' And Hugh's going, 'It's not going to work. I don't like it.' But Rupert's there, so I kind of half finish it and I stick the butterflies in it and I leave. And I said to Hugh, 'God, I wish Rupert hadn't been there.' And I employ this guy. But I don't know this guy.

I have a very personal thing I do as an artist, which is making art. But then the people who work for me don't really operate on a personal level. It's, like, more of a machine-made level. I mean, the spot paintings, once you get it right, they have to be repeated endlessly. It's not a great fucking job. It's, like, I create the things. And it's an ugly fucking worm when you begin, and it might fail. Now I try not to have relationships with people, 'cause it gets really complicated. It's like: I make it, and they do it.

How fragile is your identity? Do you have any sense of being drawn into a world where, bit by bit, you will stop being the person you were?

It's impossible. It's absolutely totally impossible. Because I can see it coming a fucking mile away. It's just, like: *Fuck off*. I understand the history of art. And I know Picasso's a bit of an egomaniac, and I know de Kooning was, and I know Matisse was, and I know Jackson Pollock was. The fucking great ones. They never failed artistically. And, basically, that's what it takes. It's like: Fuck everything you hear. Carry on with what you believe. It's fantastic, and it works.

My Dad left when I was twelve years old. We had no money and the electric was cut off. So selling out was just totally out of the question. The only thing I had was what I believed, and I've built everything on that.

'We sat talking of how happy we felt and of how it couldn't surely last. We'd have to pay for it. We'd be struck down from afar by disaster because we were, perhaps, too happy. To be young, good-looking, healthy, famous, comparatively rich *and* happy was surely going against nature.' That's Joe Orton in the *Orton Diaries*. Have you ever felt that in the last five years?

Never. OK, I've felt it, but I'm on a totally different track. I came in as a dirty fucking ninety-year-old, d'you know what I mean? Rotting as a corpse. I didn't come in from that viewpoint. I never thought 'beautiful'. I came in as Mr Barnes. I came in as a bag man. I came in at the opposite end. I came in with the fly piece.

Spiritually, you mean?

Just on every level. Art's a lifetime objective. I didn't come in childishly. I came in as Mr Barnes. Probably the most major piece I'm ever going to make in my lifetime I made right at the beginning. And it's almost like I went backwards. I came in trying to find a way to get through the whole of life with art.

I've got two buttons: 'on' and 'off'. Black or white. That's it. It's, like, it either works or it doesn't work. The moment it stops working, it's off.

People suspect that you've got some... That in some way you're pushing the boundaries of what it is to be alive now.

I think you're being kind. I think people suspect a hell of a lot fucking worse. I think people suspect that the objective is fame, success, power, money...

But the bottom line is that there's a magic to it which exists. I really believe that. I mean, I pretend all the time that I know what I'm doing and some of the time I don't know up from fucking down. But you've got to be convincing. And the only reason I'd waste the fucking time to *be* convincing is if I know the magic's there. There's a magic to things which is fantastic that exists. It really fucking exists. It's a real, absolute, total, solid fucking magic. There's no illusion about that. There just isn't. And if you lose that magic... People lose it.

The only thing I worry about, especially drinking and caning it a lot, is I hope I'm not lying. To myself. I hope I'm not believing the wrong things. I constantly have to hunt the fucking thing down. And you run out of hunting. I mean, I skirt dangerously close to the edge of something ugly, and I believe in something incredibly pure. And when that fucks up – if that fucks up – then I don't have a role.

Art's an incredibly fucking complicated lie that I'm building up myself. And it'll either last until I die, or it's dead in the water from the outset. And that's it. Hard luck.

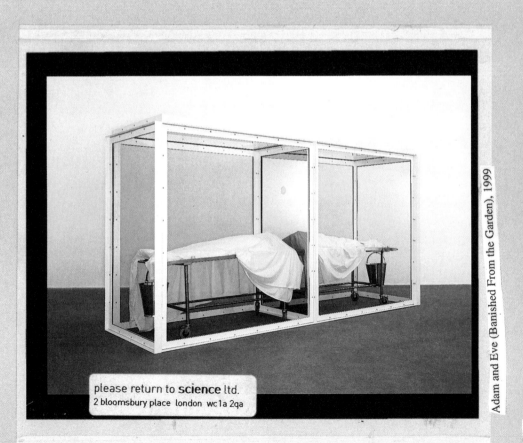

please return to **science** ltd.
2 bloomsbury place london wc1a 2qa

Adam and Eve (Banished From the Garden), 1999

DH had acquired 20,000 square feet of new studio space in a Cotswold village near Stroud. He had bought himself a museum-scale space, and time. The works for Theories, Models, Methods, Approaches, Assumptions, Results and Findings, the autumn show at the Gagosian Gallery, were up and ready to be viewed. Charles Saatchi and Larry Gagosian had been down to see them a few days earlier.

CORE MP 0523
B+1½

FUJIFILM RVP 56853 AE ACCF

final

An Unreasonable Fear of Death and Dying (detail), 2000

Blood seemed to be the symbol linking most of the new work DH had been making. Blood and smoking. Blood and smoking and violent death. Sometimes, such as in a piece called An Unreasonable Fear of Death and Dying, the blood was graphic, splattered all over the rugs and furniture and glass of the vitrines. In An Unreasonable Fear.... a chainsaw sawed an armchair in half and sharks played on a tape loop on the television; a can of Charm air-freshener ('Nature's Way') stood on the blood-spattered cistern, behind the door with the word 'Die' finger-painted in blood.

In other instances, the blood was merely implied. Adam and Eve (Banished from the Garden) featured two corpses on mortuary trolleys, buckets, bones; an unfinished cheese sandwich rested on one of the corpses. Figures in a Landscape was a vitrine divided into nine cells. Each cell contained bulging black binbags deodorized with sachets of Haze concentrated fragrance gel and 'Superfresh Neutradol'. 'Stop me B4 I kill again' read the message written in lipstick on an old wardrobe mirror.
The immediate impression was of menace. It felt a dangerous place. In addition to dozens of Sabatier knives jutting skywards, the whole studio had been turned into a labyrinth of steely, reflecting surfaces and lacerating industrially cut edges. There were skeletons and blood; human body parts arranged on shelves and bagged in bin-liners; surgical instruments and corpses. And, towering above it all, the sculpture that Damien referred to as 'the big guy' – a twenty-foot six-ton bronze cast of an anatomical children's toy that Charles Saatchi was four days away from buying for a million pounds. The whole of it the fruits of two years' labour and a million-plus dollars.

The interview was recorded on the train going back to London.

INTERVIEW 6

STROUD – PADDINGTON TRAIN WEDNESDAY. 22.03.00

<Gordon Burn>You're not drinking at the minute. Why is that?

<Damien Hirst>It's started to affect me in a really weird way. I don't have to drink a lot. It's, like, I went out with Maia a while ago and I drunk water in between drinks, took it easy and just drank beer. But I just got smashed. Like, really rampaging. *Blackouts*. I used to never get blackouts. I get blackouts now. I don't know if it's something mental. But I just think it's safer to lay off it for a bit, and calm down. I think I need a holiday. Maia was saying something about your liver can change; the way that your body converts alcohol… But I don't know.

You admitted to me the other day that making this show turned you into a mean alcoholic. Was it that stressful?

'Mean' did I say? I think I've spread myself so thin. I was just drinking too much to be concentrating so hard. So something's got to give.

It's always seemed to me that you use drugs and drink as a way of being in the moment that you're sharing with everybody else, but seeing something in the moment that nobody else can see, because they're not at the same mental place you are. I found a quote from Schopenhauer that seems to cover it: 'To have original, extraordinary, and perhaps even immortal ideas, one has but to isolate oneself from the world for a few moments so completely that the most commonplace happenings appear to be new and unfamiliar, and in this way reveal their true essence.'

Hic! Hic! [*Laughter.*]

I suppose in a way I do have a funny relationship with it. But it just seems to change all the time, though. I mean, you can use it to isolate yourself, and that can focus you. Definitely… I got involved in drink *and* drugs, didn't I? Mixed. So it's a kind of different thing. I mean, I always mix my drinks. I don't stick to one drink. And then I started taking cocaine and drink. And I think there's some point when you do that where it becomes a different drug in its own right. There's a balance I was after between a certain amount of this and a certain amount of that. Like a fucking alchemist.

You do do that. 'I need a tequila now because I need the lift.' You dose yourself, like a pharmacist.

I think you start creating a new drug with that, when you add it with cocaine. When you add two chemicals together, you get a different chemical. So I think I did that. But then overnight I turned into a babbling fucking wreck. It was completely overnight. I've spoken to Maia about it. It happened like *that*. I just couldn't control it any more. It wasn't like I did anything extreme or anything. It just went to pot. I was becoming violent, but I wasn't in control, that's why. I was walking round in the morning and they'd be going, 'You did this.' '*Did* I?' So I couldn't even remember the violence. I don't even think it was the violence. It was just everything.

In the eight or nine years that I've known you, you've never shown signs of aggression.

I think that lies in everybody, when you get to a certain point with alcohol. I just hope I'll be able to drink again, 'cause I love it. It's my drug of choice. I think I've just got to get it all out of my system, and then start again. [*Laughs.*] 'Cause I hate the idea of giving up. Anything.

This is the first time your friends have been phoning up Maia saying, 'We're worried about him.'

Oh, they've always done that. Everyone's always fucking done that. But I've never cared. But this time I've woken up in the morning going, 'God, did I do *that*? Did I do this? What *did* I do?' Blackouts, and sort of feeling like somebody else. It's like Dr Jekyll and Mr Hyde have broken in half, and Dr Jekyll's not in control.

Was the work for the show done when this started to happen?

It was getting done, yeh. But the madness of it… It was a build-up. It was definitely building up, and it

was all involved in that. Because I wasn't just doing a show, I was doing a gallery, having a studio, and everything was channelling into this bottleneck of when it was all going to be ready.

Normally I've used my energy to charge towards something, and this was energy used to hold everything back. And I'm fucking no good at that. Like the date. Everyone was rushing to May, and I was trying to hold everyone back, saying, 'Fuck it, we can do it whenever we want.' I'm trying to get the pieces made in a human, slow way, but against a constant barrage of demands and deadlines and questions. 'Can we do it in May? Can we do it in May?' So the pressure was like negative, inverted pressure. I still haven't worked it out.

So I was holding it all back. I felt because I've got a new studio, the pace at which I arrive at this new studio is the pace I'm going to have to carry on for ever. So I just knew I wanted to slow it all down. Just to have hold of the work long enough to get it right. 'Cause I was using galleries like studios before that. I've been using the week before a show was installed in a gallery like a studio before that, and things were going wrong.

That was the Bischofsberger show.
Yeh. The work became more personal after that, I think. My need to be involved in it became more personal. It was less showing off and more personal. Maybe it's to do with growing up, I don't know.

Some of the new pieces are like capsules of your life. It's like lowering a vitrine over a part of your life.
They're the first things that have got age in them, really. Old age. Without it just being savage horror like in the fly piece. Human old age. The frailty of old age. I don't think I've hit that before, except in the collages.

DH, Japan, 2001

It's also the first time you've used an actual human figure instead of animal carcases representing the human figure.

Or the lack of a human. Human absence from a man-made environment. Only objects are left.

There's more narrative to the pieces, which makes them reminiscent of the show you had very early on at Jay Chiat in New York.

That piece with the blood [*An Unreasonable Fear of Death and Dying*] does go back to that. But I was thinking this is much more... gritty. I was thinking that the blood is the thing that brings everything all together somehow. Because you've got the ping-pong balls [in *Theories, Models, Methods, Approaches, Assumptions, Results and Findings*] and they're almost like white blood cells as well. I mean, there's a lot throughout. Like, smoking goes throughout...

You know in *Adam and Eve (Banished from the Garden)*, I was thinking I was going to put a sandwich on that, on one of the corpses. On Adam. A cheese sandwich with a bite out of it. I think that's really horrific, a sandwich in the mortuary, d'you know what I mean? It's like a real common occurrence in a mortuary, and that relates back to the sandwich in the other piece [*From the Cradle to the Grave*]. I didn't do it and it's been photographed, but I think for the show when I do it, I'll put it on there. Because, y'know, you're horrified by all that death, and then when you see a sandwich on there...

There are lots of links. The Jay Chiat piece with the blood and the white rubber coat, it's got the live fish in it, the goldfish in the bowl. [*She Wanted to Find the Most Perfect*

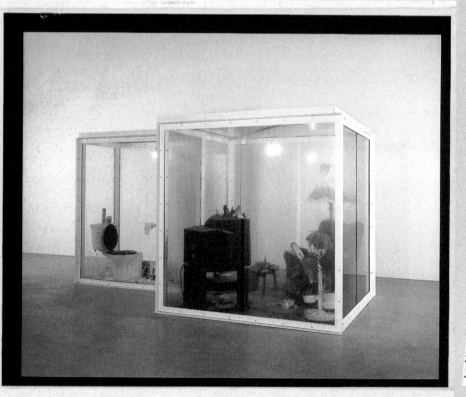

An Unreasonable rear of Death and Dying, 2000

142

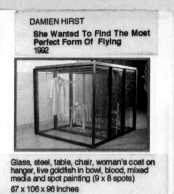

Form of Flying (1992) depicts the suicide of a young woman. The glass walls of the vitrine are semi-obscured with blood, and blood stains a chair, a table and various scattered items of clothing. Only a white coat on a hanger, reminiscent of the white lab coat in *Lost Love*, has escaped the carnage.] The goldfish and the personal belongings of a woman are other links between the blood bath of *The Most Perfect Form of Flying* and the site of conception that is apparently the subject of *Lost Love* and *Love Lost*.

Yeh, they are. I never thought of it.

But I can't wait to get 'em out of there really, because I think I can go deeper with the new works. I mean, the pieces I've done, like that old guy's house [*From the Cradle to the Grave*]... I would like to explore that build-up of the existence of a man a bit deeper. Like just having an armchair around and sitting on it over and over again. I could leave it in there for six months and start to build up this layered existence inside the sculptures somehow.

Mr Barnes and Chris's Crackers have obviously had an input. Hugh [Allan] was saying the blood piece is Devonshire Avenue [the house where DH grew up in Leeds], basically.

I think it's more universal. It's like anywhere. It's anywhere where you stand still long enough to see what being there causes. It's anywhere where you don't have much money. Things get worn and you can't afford to replace them. In the North of England, pretty much everywhere's like that. Or was. Oh shit! [*He spills coffee for the second time over his white T-shirt and the jacket of his white suit. He has also knocked over a can of Coke.*] What the fucking hell's going on? You know what this is all about, don't you? It's about my white suit. It's my own battle with my own white suit. It's definitely the white suit. If I was drunk, it would already be covered in red wine.

Were they consciously autobiographical, these new pieces? Or did they just turn out like that?

It's very, very instinctive, the whole thing. I attempted everything simplistically in the beginning, with a very simple idea. And then anything that worked out I left alone; anything that didn't I kept leaving and then trying again from a different angle. So the ones that are more complicated are kind of layered with meaning, but they work. In a situation where there's no pressure, you can resolve each piece. Like the one with the little girl [*The Way We Were*] is probably the most difficult one to work out, and the one that was most likely to fail. But by just allowing it to fail, and trying to rebuild it, trying to look at it again, and being prepared to throw it away if it doesn't work out, then I think it becomes the most successful in a way.

Was the starting point for that the old laboratory equipment?

I built the box, and then I said I wanted a piece which looked like the mad... I saw the Hammer House of Horror film where there was something bubbling in the background with Peter Cushing in front of it. And I suddenly thought, 'Jesus Christ, science used to be like that not that long ago.' And it's just changed so much, I just thought it looked fucking ridiculous. So I started thinking of things that were like that. So I went out to look for that, and Hugh got it from a... I was trying to make it look new. I was going

The Way We Were (detail), 2000

to buy a book with old experiments in. Because schools aren't like that any more. So I got some stuff from an old hospital and set it up and liked it. And then when I saw that little girl [a disabled-child collecting box of the kind that used to stand outside post offices and chemists' shops]… There's a guy as well. I'd like to try and track the guy down. You know, you just feel sorry for her. It's kind of gone.

Why stick the 'please give generously' sticker back on?
So it looked like it could still function as what it was, rather than be a relic.

It's the working bars on the electric fire that make that piece. The hot red of them.
They're from the same time, them kind of fires. Put your hand inside, it's warm. It's really hot in there.

They're incredibly poignant for some reason. You always associate them with bedsits and isolation and poor people.
In a way it's like the blue in the fly-killer. You really feel like grabbing it… But [camp voice:] fire has been a hugely important thing in the whole of our existences. Mankind. Heat. So it does have a real…

It takes you away from misery pretty directly. It's a fundamental need, isn't it? Heat. Along with food…
I could murder a cuppa tea.

It seems to me the two other twin things the work addresses are the rigour of science
and the irrationality of art.
I think the science and the art are both lacking in some sort of spirituality. And I think that they're sort of
headbutting each other trying to get something like that back. I don't know. I can't quite work it out, but
it's something like that. Because there's all these religious references as well. I'm instinctively drawn to
these things. If you think art plus the rigour of science equals something spiritual, well, I think it's the
other way round… It's an art–science–religion thing that's going on.

The two fish–tank pieces [Lost Love and Love Lost] seem like internal landscapes, where
the concreteness and rigour of the rational world are under constant threat of being
undermined by the subconscious and superstition, dread and dreams.
I see science as being like parenthood; an adult idea or approach.
 But those sculptures are pretty direct. There's something really simple. If you've got a gynaecologist's
office under water with fish swimming about, then there's something fishy going on. And fishy fannies
come straight after that. I think. In the logic of it. I quite like the idea that the doctor's had to take his
watch and his rings [part of the furniture of Love Lost] off, so that you get the doctor's personality into
the hand that's going to finger about with you down there. The woman's got her shoes on the floor,
and there's the coat and the handbag. So there's a hugely sexual element to it. And women smell of
fucking kippers.

The gross–out, provocative part of your personality is the other thing that is given
free rein in a lot of the new work.
Yeh. But once you get serious… I mean, how you got somewhere and where you're going are completely
different things. They're ideas that have been floating round for three or four years or something, or even
before, for all those pieces.

A couple of Sundays ago was the first time you saw the tanks with fish in them. It must
have been strange to have had the idea for so many years, and then not to have been
the first, or even the tenth, person to see it realized.
Well, it just looks like a fish tank. Have you seen my fish tank in my house? I've got my shark – a model
of a shark – I've got that in the bottom of the fish tank. I've got some false teeth in it, and some fish in it.
It's just there. I said to Maia, 'Look, let's not put normal things in it.' I've got an old beer bottle. It's like
the bottom of a beck. All trash in it. And I love it. Because the fish just swim about in all this shit… I like it
because I like a toilet on the wall. I fed them this morning before I came up. There's one won from the fair.
I've had him over a year now. And then we've got another one from the pet shop. I couldn't work it out.
I think It must be our water. 'Cause when I grew up in Leeds, they just died in a week, every time
we got them from the fairground. It must be the tap water or summat.

Where has art been for you in the last few years? Has it been away? Somebody said to
me recently, 'He puts all the risk into his life now instead of into his art.'

It's not true. I'm just an artist. I work better when I'm an artist. But the art world lets you down. That's it. The art world's very shallow, and very small, and it's very easy to get to the top of it. It's great to help you get direction. But then you burst through the top of it and you've got no idea where the fuck to go. And you're surrounded by people who are encouraging you in what to do and you know it's wrong. You've got to go against the grain. If you go with the grain, you get used to it, you relax, you take it easy and then suddenly you've got to go against the grain again, and it's really hard work. Of course, it's really tempting…

I know that you've been aware of the talk going round since last summer: 'Oh, he's all burned out.'
Oh, but I love all that. It's only in my own head where I've been worried. That's the only thing I worry about. I don't really worry about what people say… Sometimes I have glimpes… When I've got this big new studio and a lot of money outgoing and not knowing what you're fucking doing, that's all I worry about. Or just thinking that maybe you *have* run out of ideas.

If Charles Saatchi and Larry Gagosian had come down last week and taken a look and gone: 'Hmm, not bad…'
I wouldn't have given a fuck, because I was satisfied with it. I was happy. Basically, I put them off coming down till I was satisfied. And if I'm satisfied, then I really don't give a fuck. There's no way you can. You don't make a piece for that. I mean, it's been incredibly hard work *not* doing anything for four fucking years, in terms of the art world. And I haven't done anything for four years because I've not felt it was

'Jay', Children's entertainer. DH. Connor's 4th birthday party, Combe Martin, 1989

any good. Or not resolved enough. You know, not happy with it. And I look at Oasis bringing out this new album now, and I just think, 'If you're not happy with it, why bring it out?' 'Cause that's what fucks everything up… I've done it in a different way. I've got the money off them first. I suppose that's what's caused me a lot of pressure as well is that I've had money off *them*. They've given me money. And I don't like taking money off people, and I don't like feeling I'm in debt to people. I'll never get in a situation like that again. I've used it to…

Like the big guy [*Hymn*]. I financed that myself. But all the money I had off them was used to set myself up so that I never get under pressure again. So that I've not got someone knocking on the door when I'm experimenting on something that's cost a lot of money, d'you know what I mean? To take a little toy like that of Connor's and enlarge it to that sort of size, there's a big possibility that it's going to look shit.

Is it a toy? I assumed it was from a teaching-hospital.
I wouldn't have done it with a teaching-hospital one. I did it with a toy. It's called 'The Child Scientist'. I might even get sued for it. I expect it. Because I copied it so directly. It's fantastic. I just thought it was so brilliant, and it was so accurate, it was like a chemistry set, and I loved it that it was a toy. It was really similar to a medical thing, but much happier, friendlier, and more colourful and bright. And I just thought, 'Wow! I wanna do that.' I suppose it came from that idea of Koons doing those things [the witches hat etc]. I just thought, 'Twenty feet tall. Fantastic.' But there's no way you can get an idea of whether that's going to work or not. So to go to Saatchi and say, 'give us some money,' and it turns out it's shit and then he has to have it… So I managed to make that, blow it up, have it in my studio and sit with it until I was convinced it was good, and then decide whether I want to sell it or not. And Jay [Jopling] freaked out over it. He was: 'Let's get someone else to pay for it. Get someone else to pay for it!' And it's just shite doing that. It just doesn't work out. You don't get anyone else to pay for it. You pay for it yourself.

Why did you do it in bronze?
I just wanted it to be grand. It can go outside. It's vandal-proof. Underneath it is this big fucking grand iconic fucking artwork. I mean, I love painted bronze. The paint on it's like skin… It's an outdoor sculpture. It's like a car. It'll decay. So eventually what you'll be left with is this solid bronze man with bits of paint hanging off it. So in a way it's like what happens to your body. I liked it for that reason. That's why I went in for bronze.

It reminds me of something you said when you did the *Building Sites* film on the Worsley Building in Leeds for the BBC: 'It's almost as if the outside of the building, the exterior, is denying that it's a part of the same processes of decay and destruction and corruption as the human bodies inside the building. The dead bodies come and go and the living bodies come and go, and the building stays the same. I get the feeling from the building that it's more alive than me, which is terrifying.'
The guy at the foundry [where *Hymn* was cast], when I went in there, he says, 'What d'you want?' So I gave him the toy and said, 'I want it made this big, twenty feet, with a base this height.' And he said, 'What do you want it to look like at the end?' And I said, 'Plastic!' He nearly had a heart attack. He said, 'But it's a bronze.' I said, 'I want it to look like plastic.' 'Well, why do you want it to be bronze?' 'Because I want it to be grand, and I want it to be bronze.' And just when he finished making it, he phoned me up

and he's like, 'C'mon, we can do some great patinas… We can do a really great red patina.' I said, 'What, bright red? Like plastic?' He said, 'Well, no. Not like plastic.' 'Well, can you make it took like plastic?' And in the end, he thought it was great and he really liked it.

Most people will come away from it thinking it is plastic.

They will when it's new. But they won't in ten years' time. It's like a car. It can be fixed up like a car or it can't be. It's tough. It's car paint. But in twenty years' time it's going to look like a twenty-year-old car… I felt very sad when it wasn't there today when I went down. I missed it… When money comes in I do things like that on the side. I'm beginning to more and more.

Gagosian gave me a million dollars towards the show, which is due back on sales, or half on sales and half somewhere else.

How does that work with Charles [Saatchi], because he and Gagosian are business partners?

I don't know if they are. I mean, I'm not supposed to know that they are. I don't give a fuck. I've got one relationship with a gallery. I get a million dollars towards fabrication costs on a show, which is recuperable by the gallery. So it's not a great deal. It just brings you up into a position where you've got cash to experiment.

I mean, I was starting to panic, because the show was getting delayed. And especially with my reputation, you're getting all these rumours around, and there's no work seen. And the way I work is you don't see anything till the very end anyway. And even if you do, it doesn't look like there's anything there. I was like a year and a half late.

Somebody said to me, 'Do you like all the work that goes into making your art?' And I said, 'No, I fucking hate it.' I really like it when they come in at the end and it looks like it just appeared and you've done fuck-all work. But lots of people, I suppose, do like all that work. But I don't like it, really. I don't enjoy that bit.

It seems to me that what you've been doing in the last four years – certainly in the past eighteen months – is lowering expectations. Encouraging people to believe that you've blown it, burned out, become a full-time hooligan and piss-head. Is it a kind of deliberate strategy?

Oh, I've always done that. Regularly when I used to go to openings, when *Freeze* was going off, I used to go in looking like a tramp. Then I'd go in in a suit, then I'd go in like a tramp… So people would just be going, 'Fucking Damien's losing it.' 'Oh wow, he's really on top of it.' 'Oh my God he's losing it.' 'No, he's on top of it.' And they never know where the fuck they are. It's about expectation. It's theatre. It's about raising expectations and lowering expectations. Theatre. It's more like a joke with a punchline. You can say it's manipulating. But you can say a joke's manipulative.

But it's very theatrical. The way I got involved with the art world… You get people to think one thing, and then you come round from another direction. I mean, you do it in an artwork. I think that's what all artists do. They draw you into some sort of belief system and then – bang! – they hit you with something else. The one–two. Bacon does it. With a kind of bareness of paint, or a sensuality… Michelangelo does it. Everybody does it.

In the art world it's all so short-lived. You don't show up tomorrow and… I'm the only fucker living in Devon. People see me once every six months pissed out me head in the Groucho Club and go, 'He's losing it.' Where the fuck do they think I am all the rest of the time? The truth is it's the opposite way round. I'm lying on me arse for two months in the country, and then coming up to London for a bender. 'Where's *your* house in the country?' In lots of ways you're saner than you were before.

That's the art world thing, and you've got to break that. You've got to constantly make new things. You've got to constantly reinvent yourself. There's a kind of hunger. Well, you just have to starve people. You have to forget about it. You have to convince yourself that it's not going to go away if you go away… There are hundreds of art worlds.

Hymn, 2000

Damien Hirst
Rehab is for quitters
1998-99

Full plastic skeleton, glass, ping pong balls
and compressor
36 x 108 x 84 in. (91.4 x 274.4 x 213.4 cm)
Photo Credit: Stephen White

You become a kind of public figure. I had Norman Rosenthal [exhibitions secretary at the Royal Academy] phoning Maia up, saying, 'I'm really worried about Damien.' You get things like that.

You did meet him naked at four o'clock in the afternoon sitting at the piano in the Colony Room.
So what's fucking new! Will you tell me when I haven't done that?... I try consciously not to do it. I do try consciously. I just fucking enjoy it. That's the bottom line. I became conscious of it suddenly, that one minute everybody's laughing like mad when you're taking your clothes off in the Colony Room, and then suddenly everyone's saying you're losing it. I don't know what the fuck happened or why people do that. Maybe they've just grown up, or maybe it's me, or maybe it's something in your gait or your manner or your personality, that suddenly you exude this unsureity about yourself that you never exuded before... I don't know what the fuck it is. But something changed that meant my behaviour wasn't getting the reaction I was used to. Because *I* didn't change. I didn't suddenly start behaving in a more over-the-top way, except maybe, like you said, more aggressive.

Plus, as well, I was very rusty with art. I hadn't done it for ages. So it's like suddenly I've got to pick up... Having the studio as well, and I think I underestimated how much I had to do... I don't know. Did you read that thing about Maradona at the weekend? Fucking good. It just said that he could never ever conquer addiction because it requires effort. And everything he's ever succeeded at in his life required no effort. He said, 'My heart's not very well, but whenever I see a ball I just want to kick it.' He said, 'What can you do when you can no longer give goals to your children?' He meant the people of Argentina as his children... Weird.

I've definitely felt that I've been involved in a difficulty with art – with the combination of art and social life and things like that – that there's been a difficulty that I've never had to deal with before. It's always been easy. With all the art and everything else, I've just gone in and gone, 'Hey!' And it's like a party and, wow, you've pulled it off. Have an idea and grab it...

You made making Pharmacy, the restaurant, feel like that. All through 1997 you worked away quietly at it, and then suddenly it was there.
I think maybe it started to go down a bit from that. Maybe that was more effort than I admitted. That really took it out of me. And then I think after Pharmacy and my book I really felt I was in the position where I had to catch up all the ground I'd lost. So I put in even more effort than I needed to. And then also being a party animal and duh-duh-duh, and the house in Devon, I just had too much on. I started to blow gaskets and pop rivets and...

I saw it quite the other way. I thought you thought Pharmacy was so much the perfect idea of a postmodern piece of work – the total sculpture, combining life and art – that it was hard to move on from there.
The restaurant, it just wasn't art at the end of the day. You end up getting involved in fucking aprons, knives and forks, pots and pans, all the shit of life that you don't really want to get involved in. Stocks and shares, ties, boots, windows, glass, Blutak, glue, string, wood...

I thought you had a postmodern take on that – you saw that as much as art as anything in a gallery.

Doing Pharmacy made me realize why you're not allowed to touch art – why it says 'do not touch' in art galleries. [*Laughs.*] You go in after a week and it's fucked, d'you know what I mean? It's like all the things that can go wrong in your house if you get shit builders in, combined with letting a herd of elephants into the art gallery.

It definitely helped me to not feel trapped in the art world, and to not feel I had to make art. And I really wanted to get to that point. It starts to encroach on your artistic ideas. If you feel you've got to make money, then you can't be as brave in what you want to explore. You can't go out there on a limb and experiment with something that might be totally unsaleable. I mean, there's an element of what I do in art which is very much to do with something to go over the fucking sofa: it brightens the room up, it goes on the wall.

Art's not about money. Selling the big guy [*Hymn*] for a million pounds. I mean Jay [Jopling] said to me the other day, 'Aren't you worried about Charles putting it in the Saatchi Gallery before it goes to New York?' I said, 'A million pounds, Jay. A million pounds.' I'd sell my fucking granny for a million pounds… A lot of what I say is hypocritical, but I think with a benchmark of a million pounds you owe it to everyone around you and behind you to take the money.

Why was that figure important? Why wouldn't you let him get away with £950,000, which he tried to do?

Because I'm thirty-four and it's a million pounds. It's a hell of a lot of money. It's almost an insult to go fifty thousand short on it. I mean Frank, my accountant, said to me on the phone, he said, 'Jeez, Damien, he's fuckin' come back and offered us nine fifty. For the sake of fuckin' fifty…' He says, 'How cheap can you get?' I said, 'Well, I agree with you, Frank, but don't forget you can buy a fucking three-bedroomed house where I grew up in Leeds for fifty thousand pounds.' I like saying when somebody says, 'How much did you sell it for?' 'One. A long one.'

At one point Saatchi wanted to buy the big man sight unseen. It turned out that in fact he had been slipped a Polaroid of it by one of the installers from Momart. Why did it upset you so much when you thought he was laying down money for something he had yet to clap eyes on?

I hated it. I couldn't believe he would do that. Because you make visual art. And for him to do that would mean that it was nothing to do with what it looked like. It was all to do with gambling. I started thinking that maybe Saatchi has some other agenda where he just thought, 'Well, if I pay a million for Damien's work, whatever it is, then that means I can sell his other work for more than that, I can flood the market…' I thought it was all market concerns. I'd always credited him with a lot more than that, up to that point. I was quite relieved to find out that he'd seen a Polaroid of it from Momart. Basically, he was behaving like a man who'd seen it, and in the end he had seen it.

There was a magazine piece recently which suggested Saatchi had started the whole Britart thing by commissioning the shark.

It's just full of shit, isn't it? They make it up as they go along, don't they? He bought Gary Hume; he bought Michael Landy. He bought my medicine cabinets from the *New Contemporaries* at the ICA,

then he bought the fly piece from *Gambler*, and then after that he got the shark. He got some spot paintings before that as well. He got a load of stuff.

Were you instrumental in him selling off the American work in his collection?
Nah, it was wedge. Money. He couldn't afford it. And the market was going to go down. He buys cheap and he sells expensive. So that was what he did. He sold expensive, then bought cheap. He bought cheap the Americans, then he sold it expensive. Then he bought cheap the English and he's going to sell it expensive. That's what he does.

And you're quite happy about that?
I don't give a *shit*. He's got a fabulous space. He buys a lot, and he gets a lot of people to see it.

How competitive are you with him? 'You've got a big one; now come and see my big one.' Twenty thousand square feet plays thirty thousand square feet.
It's a completely different thing. But when he was looking at my studio I did say to him, 'I blame you.' And he laughed. 'Cause when I was an art student I went down to look at his space and I just fucking wanted one. Immediately. I mean, art looks great in there. Art looks great in here. So you make art for it.

Did you always know you'd get one?
I didn't get one till I needed one. I want a lot of things. But I don't actually want to possess them. [Stroud] is a lucky one. It's out of London. It's not the same thing really. It's a personal space. I love the fact that there's no windows. I love it. It's completely separated and isolated from anywhere else.

Money's the thing you can't get your mind round. That's why I put the credit card on the edge like that, in that piece [*From the Cradle to the Grave*]. Can't take it with you! Whereas art and science and religion you can just about get your mind round, money seems to skitter through everything and be ungraspable.

I just don't understand it. People tell you what things are worth, but it's not what they're worth. I mean, you've got someone here who makes a product and then you've got a consumer. And they're the only people who are in invincible positions. The person who wants it and the person who makes it. And then there's a whole fucking chain of cunts and bitches who get in the middle, and that keeps changing backwards and forwards. I just keep focused on that: you've got someone there and someone there. And so long as you're in one of those positions, you're going to be all right.

In the four years since the last show, were you always rehearsing art in your mind? That's how you always strike me, even when you're apparently at your most out if it.
I'm always working on sculptures. I'm on the lookout constantly for something that could be used. Things just come from ages ago. They just get etched in your brain. Like I've always had the idea for a magic box with knives. You know, where the woman goes in the box and you stick the knives in and pull them out again. I've always felt it could make a sculpture, and then to suddenly add it to this one [*The Way We Were*]... 'Why don't I put knives in those holes?' I made that shape without anything in it originally. Most of those I made the cases first. I didn't have any ideas, so I just did drawings of a load of shapes of boxes that I liked. I've got another seven or eight in my studio in Gloucestershire that I haven't even unpacked.

The studio's like a big box over all the other boxes.
Well, everything's a box, isn't it? Everything's a box.

Richard Wentworth thinks the vitrines are an easy option. It's like the proscenium arch
in the theatre. Anything you put up there is, by definition, going to look dramatic.
I can't walk away without the idea that people are just going to start fingering things and messing
about with them.

They were originally made to keep the flies in, keep the formaldehyde in....
And keep people out as well. You can keep them out that way, or you can keep them away with it being
dangerous, like the glass pieces. I don't have any problem when it's big sheer bits of glass [the skeletons].
I think they can defend themselves. But when you start getting little bits of cigarette ash and fag butts...
When you're putting things so carefully together like that, every five minutes you're guaranteed

From the Cradle to the Grave (detail), 2000

somebody's going to be sticking a Coke can on the table. And it has a completely different meaning. Anything personal on there's going to fuck it up.

I'm sure a lot of people would say the skeleton piece is a corruption of the original pure idea [I want to spend the rest of my life...]

I've always wanted to use a skeleton. But they're too heavy-handed, really. It's too loaded as iconography. Doom; death. Whooo! Like the vanitas and everything. So to give it those cartoon eyes... It's got that dumb slapstick in there. I couldn't resist it. It's called *Death is Irrelevant*. It's almost a child's way of looking at death, in a very cynical way... Remember in the Blur video ['Country House'] there's a skeleton that comes out of the ground which has got those glasses on with the eyes on springs that fall out, just for a second. I thought that was funny. A great idea of how death was going to creep up behind you. Boo!

So what do you feel now? Relief or excitement, or...

I still feel there's quite a lot to do. I mean, I feel I've got a great... toy. I think I'll be working on loads of other things. I want to do some big formaldehyde things again. I want to do a cow hacked open like that with its arms open. I'm going to do three, sixteen foot. A whole crucifixion. Can't resist it. Sixteen-foot tanks. Massive. With all cows skinned and peeled apart, tied to RSJs with barbed wire. Fantastic. I'm going to do the crucifixion; I'm going to do St Sebastian with Sabatier knives, and the flayed guy on a big wheel; Rembrandt's ox.

I'm not working for an exhibition, I'm working for myself. I can afford to quietly work on *Couple Fucking Dead (Twice)* for a few years until I get it right. That's what it needed. I was spending other people's money. You've got to spend your own money to work out things as complicated as that. Which is exactly what I'm going to do. And the rainbow in the gallery. I just want to start working on a load of things like that at the same time. Casually. Know what I mean? And then, when they're good, start looking for somewhere to exhibit them. And then you die.

I was talking to Hugh the other day about how he thought he'd die, and he said, 'Heart disease. How about you?' 'Hit by a bus on the way to chemo.' 'Chemo! Wow! What a drug!' 'Chemo. Not as good as smack. Over and out.'

Why do you like jokes so much?

Hunchback has a shit. Dog fucks it. Mum wanks.

Why did you not like me comparing you to Les Dawson [in an article in the *Observer* magazine]?

Because I'm an artist, not a fucking comedian. I flirt around with jokes and I find humour quite exciting. But really I much prefer William Blake as a mentor than Les Dawson. Because Les Dawson is a fat, bigoted, sad old fucked-up dead comic. And Blake is a fucking genius. So if I had a choice...

There's a pronounced serial-killer element in the new work.

I like that idea of figures in a landscape. You know: a dead body in a binbag is a figure in a landscape.

There are slogans written in lipstick and blood. 'Stop me B4 I kill again' on the wardrobe mirror in *Figures in a Landscape*.

That was a reference to my career. It was like that joke with Joe [Strummer]. I asked him, 'What's the biggest thing you've ever killed?' And he replied, 'My career.'

So I thought it was quite funny to have that, as a kind of cry to the public. It comes from *The Shining*, where he writes 'redrum' on the mirror. And in *The Exorcist* when she's possessed and it's inside her, she writes on her chest, 'Help me', from the inside. Like trying to get out of your predicament.

I said the other day to Maia that I feel a bit like I don't want to be Damien Hirst, and it's too late to do anything about it. I don't like being Damien Hirst, I've decided. But you can't avoid it. So I think on the next mirror I'll write, 'Help me…' [*Camp voice:*] I'm just trying to make the best of a bad job, really. [*Laughter.*]

Sorry I got a bit giddy at the end.

DH, Joe Strummer, Combe Martin, 1999

Lundy is an island off the coast of North Devon with twenty full-time residents. It has one shop, one pub, no cars, a lot of sheep and a shifting population of birdwatchers and walkers. We went there for a few days to escape the telephone and the television and the eerie carnival that Damien's life sometimes seems to have become.

He has developed a performance persona that is intended both to shore up and to disconcert the art yobbo reputation he has been cultivating now for the best part of a decade. And the role he has been touring for the last few years – the period of the gestation and completion of the work in *Theories, Models, Methods, Approaches...* at Gagosian – is that of the famous fuck-up, chaotic and wilful, and permanently, maddeningly, out of his tree. To the point where it is often impossible to know (perhaps even for Damien himself) where 'theatre' ends and reality begins.

DH, Japan, 2001

He has come to be seen as the natural inheritor of Francis Bacon, and it can be no accident that the most legendary of his actings-out have happened at the Colony Room. a place indelibly associated with Bacon and the mythology of *haut*-bohemian London. (When she opened the club in 1949 – it's really only a narrow. single upstairs room – the owner. Muriel Belcher. had paid Bacon £10 a week for a while to bring in his rich friends and generally tout for her.)

The performative, gross-out, slyly provocative part of Hirst's personality is a side of him that is given rein across much of the new work. It accounted for the sense of a layered existence inside the most complicated and debris-littered (and probably autobiographical) of the sculptures. *Rehab is for Quitters* is one example of how the strategy he has applied in life has carried over to the art. As the bumper-sticker jokiness of the title suggests, it is what many people would see as a deliberate desecration of the wistfulness and quiet elegance of its precursor, *I want to spend the rest of my life everywhere, with everyone, one to one, always, forever, now* (1991). It is up to others to make links between *Rehab is for Quitters* and Grünewald's or Bacon's crucifixions, or the bone-figure style of Picasso if they want. Hirst's task – apparently the latest stage in a developing aesthetic – is (he appears to be saying) to disappoint expectations of what his art should be by floating a turd in the proverbial punchbowl and subverting the pleasant appearance of things.

INTERVIEW 7

LUNDY
TUESDAY.
18.04.00

<Gordon Burn>Hugh [Allan] believes that working on the market stall in Leeds with your mother when you were young taught you a lot about entrepreneurship.
<Damien Hirst> Well, 'entrepreneurship'... I suppose it was sort of pre-empting Mr Barnes. It was the Leeds Thursday market, which is a kind of step up from car-boot sales. And Castleford. But I had to do it just because I was there...

I started buying jewellery. I bought jewellery. And I found things. It's about looking. I met a guy who had a stall and he taught me what silver looks like. And gold. Forget about hallmarks and all that bollocks. He just said, 'Look at it.' And I looked at it, and I thought about it, and I saw it.

A diamond is a *ferociously* beautiful thing. And silver shines in a way that is really fucking gorgeous. And gold is the goldest kind of thing. I took it on board seriously. And I *looked* very hard. And I started to recognize what was gold and what wasn't gold, by the look of it. There's white gold, there's yellow gold, and there's red gold. There's platinum, there's silver, there's diamonds. There's all these things, and they look a particular way. They're like the difference between canvas and denim.

Spoons. Massive suitcases full of spoons, and knives and forks. All you got to do is buy one teaspoon. I ended up hanging around, and I paid 40p for big gold St Christophers, and silver spoons. I was there at six o'clock in the morning with my mum, looking round all the stalls, looking in all the boxes, getting all the gear. I was basically buying it from all the people who didn't know jackshit and selling it to all the jewellers.

Who sells the best burger? McDonald's, the Ivy, or Burger King? Fucking McDonald's.

The way that light bangs through a diamond just makes you gasp and stand still. A zirconian [cultivated diamond] is so clinical. Like, diamonds have flaws – imperceptible fucking flaws. Zirconians don't. The fucked-up-ness of things is beautiful.

Diamonds are beautiful. It's not about the money. That's the thing. We've got these things. We inherit these things. They're very, very beautiful. Maybe art's one of them. And they got kicked in the head by money men. I mean, diamonds are worthless. They're just carbon. But they dance, man. They just sparkle. They're just, like, mesmerizing. Get one in your hands. I'm telling you. You're mesmerized beyond belief. A diamond in sunlight, you could be with it for hours.

Are diamonds good or not? Are they just a bit of glass, with accumulated metaphorical significance? Are they inherited beauty? Or are they actually genuine objects of supreme beauty connected with life? What is it? Across the board, what is it? Where do we live? Stained-glass windows. Phwoar!

Ask anyone everywhere. Everyone loves diamonds. When was the last time any fucker looked at diamonds in sunlight? Get out there! It's like I said about Saatchi: how could you put value on something you've never seen? Diamonds have got this massive value because they're *ace*. And zirconians aren't as ace. They sparkle differently.

You know rainbows are great, don't you? You can't buy them or sell them. And diamonds actually do physically generate this mesmerizing, fabulous fucking quality. I'm not lying. It shatters and spangles. It pulls itself to pieces and everything else. And gold does as well. Look at Rembrandt's painting of gold. It's almost see-through. I swear to you. And it's a thing that kills me.

What's the importance of one-off?

Connor said to me the other night, 'What's a soul, Daddy?' I said it's the part of you that makes you different from everybody else. Otherwise we'd all be the same. Your soul is part of the thing that lives after you die. Which is more you than everybody else is themselves.

Why is it so thrilling when a Jeff Koons or an Andy Warhol takes a vacuum cleaner or a can of soup...

... and turns it into a diamond? Because they turn it into a diamond. You just see it for the first time, and it's gorgeous and it's amazing. But it's more than that. It's genuinely tapping the public consciousness,

because of what a Koons represents. It's the lobster on the telephone. When you get it right, once you put it there, it can never go back. It's the Picasso bike seat with the handlebars. You might never realize it, but you can't get on a bike without thinking of a bull. If you know anything about art, you just can't.

You fiddle about with things. Things just fucking *connect*.

Why did you start collecting those bits of glass from the beach in Devon? Is there any connection with diamonds?
You know what they call those bits of glass from the beach? 'Mermaids' tears'. They're from Victorian bottle dumps.

The action of the world on things again.
Exactly. Absolutely. Just out to sea. The Victorians went out and dumped them. 'Mermaids' tears'. Sharks' eggs are called 'mermaids' purses'.

I can't resist anything that's... Maia's been buying these big soup tureens. She's going to buy one

Work in progress, Goldsmiths' College, 1986

Death is Irrelevant (detail), 2000

of those big metal cages and drop it with the soup tureens into the sea and let barnacles grow on them.

We saw them in Harrods once: 'These are the fucking plates from the HMS *Gibraltar*'s cock.' You buy them for loads of money, and they're covered in barnacles.

It's like the gynae couch and the computer equipment in *Lost Love* and *Love Lost* – the green algae coating it all over time.
I wish I could be the age I am now and just walk out in the middle of it all and just stand there and let barnacles grow on me. And eventually collapse.

Diamonds have been around for billions of years. *Billions* of years. And you haven't. It's carbon with the shit taken out of it. And things become clear after billions of years, on some level. They don't become clear. They become *sparkingly* fucking clear. They become transparently dancingly rainbow-like.

But that much beauty can be a burden to the person you're giving it to: I don't deserve it. I can't look after it. I'm going to lose it.'
Flog it. *Flog it.* 'Useless beauty.' I'm not into useless beauty.

You believe in *useful* beauty then?

Yes, but I believe in useless objects. I've got the skeleton of a real human in one of my artworks [*Death is Irrelevant*]. D'you think the soul of the person is in that sculpture? I've got another one inside my body.

'You killed a goldfish to make an artwork...' 'You got a shark for an artwork...' I've got a real fucking skeleton of a dead fucking human being in a sculpture with his fucking eyeballs boogling about like googly cunts. And no one bats an eyelid. It's been somebody's mother, somebody's son, somebody's someone. Something really important is banged in there, and it's like: 'Hey. Cartoon man.' *Jeezuschrist.* Isn't it weird?

You could argue that, by doing what you've done with it, you're retrieving its soul.

Rehab is for Quitters is the fake skeleton. *Death is Irrelevant* is the real one. The real one is a really serious piece of sculpture, I think. I had to make a joke title for the other one, because it's a fake skeleton.

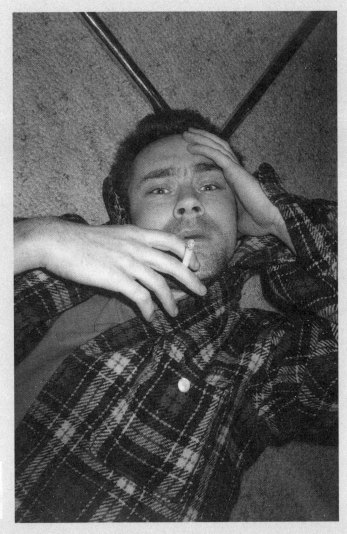

We're kind of back to the real cow's head and the fake cow's head, in that case.

No, we're not. We're back to art and life. You sign your mother. You're Gilbert and George and you sign your mother. It's still fucking art.

The thing is, as an artist, you die on the shitter. You're near mid-shit; you die. It's great. Hopefully our generation will think so out loud, and be so lost and so fucking confused, that we'll die on the shitter. 'Cause that's the only way to do it. And all these other fuckers should have got off the shitter long ago and let us get on.

'Shit or get off the pot.'

Exactly. I'll get off. Or die on it shitting.

It's *such* an exciting time to be alive. And art's such an exciting way of going about things. The centre of the fucking art world's in England. You know that, don't you?

a bicycle
made for 2.

roadkill

feathers

Battered ← feathers ←

Beauty

↓
Nature

↓
The CYCLE

↓
Love

↓
of
people

↓
Destruction

moustache →

worm

Her

curls → sad → offer

B

A

There's been an obvious tendency in the last ten years for artists to take the most debased, overlooked, marginalized, pissed–upon objects and materials, and turn them into the most valued objects and materials.

As an artist, there's nothing useless. There's no useless materials. There's nothing base in materials. Artists have done it for thousands of years. You take the shit from the bottom and put it up the top, and you get beautiful things.

Art's got the aura because people are prepared to hold it close to them for thousands of years. Longer than people. Whereas you chuck videos in the bin, you smoke fags, and you throw your clothes away, and you buy charlie, and your food rots in your fridge, and you redesign your house... But art, they spend ages repairing it. 'Listen, get in the binbag now and find them tights.' ''Cause that's not tights. It's a Sarah Lucas.'

I think I've asked you this before. Is it possible to be a horrible specimen of a human being and still make great art?

I had an argument with Maia the other day, and she said, 'I freak out when you lose your temper – when you get mad and you get violent and you go crazy. My dad was violent, and it scares me when you get like that.' I said, 'Look, I make *violent* artworks. I think violently. I communicate violently. I'm *not* violent. I'm an artist. I really use violence as a way to communicate.' I mean, I use violent images. I fuck about with violent images in a big way. I violently communicate how I feel as an artist.

I don't think of your images as being particularly violent.

What? Hacking things in half, sticking knives through things, kicking blood all over things, blowing things up, ripping things apart, just ramming it in your face, sticking it up your arse, scaring the shit out of you... I communicate violently. I'm not a violent person. But I definitely wrestle with violent images, in a huge way. I get *excited* by violent imagery.

But then it becomes weirdly tranquil – becalmed – once it's made. Once the image is fixed.

That's what I said to Maia. I skirt round the danger zone with it. But I don't *really*. I'm not into danger and I'm not into being scared. I'm on the lookout. But I'm not a violent artist, and I'm not a violent person.

I'm not even sure that you communicate violently. What do you mean by that?

Right. COME ON! *COME ON!*

But your work doesn't yell. It doesn't harangue. It has a still, focused quality. Even that piece with the blood splattered around inside it. At the centre of that is a goldfish swimming quietly round in a bowl. The violence *has* happened. This is the aftermath. It's not happening now.

[*DH doesn't reply. He goes on scribbling something on a piece of paper.*]

[*Finally:*] OK. That's the cycle of all things. I've worked it out.

[*He has written, in a circle, the following:* beauty. nature. love. people. destruction. cunts. sad. otter. worm. moustache. teachers. French teachers. beauty.]

The cycle of creation. I like the squareness of the circle. I'm so proud of that.

I got the sense in the last couple of years that you wanted other people to catch up.
They can't. I'm the best man… Yeh, I did. I got moody for a couple of years. I moodied it out. But I'm kicking off now. I've got a lot of power and a lot of energy. And I'm really looking forward to the work I'm making at the moment, because it's, like, I feel like a fucking… poet. Something really weird. The subtlety of time, of being able to rearrange things until they're *right*. I love that.

What would have happened with the work if you hadn't gone into the restaurants and all the extraneous activities?
I would've kept the media image alive, and mulled it over until ready. Just when I thought I was dying, I would've wiped my arse every now and then and flogged it.

You could have been selling a lot more art in the last five years than you were.
Shit art, yes. You can't sell more art than you can make.

As an artist, there's no point sticking with a good idea. Most people are *encouraged* to only have one good idea, or two good ideas, in their lives.

I mean, Nick Serota's telling me I'm a genius; I've got Charles Saatchi kissing me on the lips… What the fuck d'you do? They start kissing you when you encroach on their world. The only thing you can't fucking argue with is – *morning, darling!* – if an artist has an idea. You never know where it's going to come from.

I'm not Charles Saatchi's barrel-organ monkey, and I'm not Nick Serota's barrel-organ monkey. But when they see you, after you've been in the bowels of hell, when they see you surviving, they start touchy-feeling you, going, 'Gosh, you made it. Against all odds.' You just want them to fucking rot in hell and die. *Morning, darling!* Fucking true, though.

Why did you not do Venice? [DH had turned down the invitation of the British Council to be Britain's official representative at the 1999 Venice Biennale.]
It didn't feel right. Honestly and simply, it didn't feel right. I didn't have it.

I got kicked in the head after Bischofsberger. I did something wrong, and I've only just recovered from it.

Did they [the British Council] understand that?
I don't give a shit. They thought it was arrogant, but it wasn't. Maybe it was, in fact. I don't know. But it didn't feel right. If in doubt, sling it out.

Bischofsberger was the beginning of the end. And I saw it. So I stopped. It was shit. And I'm not having it.

Is there any evidence that turning down Venice has fucked up your relationship with the British art establishment?
I invented the fucking thing. They're all failed artists. They want you to *die*. They've been wanting me to die for ages. I absolutely don't give a shit. If I've got good art, they'll do what I fucking tell 'em. If I haven't, they'll kick me in the head.

I'm dangerous to them. I mess up their parade. It's a dangerous game you play with Nick Serota. It feels like Nick Serota's not buying one to teach me a lesson. And *I'm* going to embarrass *him* for not

having one. It's that fucked up. 'Why have the Tate not got a Damien Hirst?' 'Damien Hirst turned out to be shit.' That's his game.

But the thing is museums are for dead artists. What the hell are me and Nick Serota sniffing around each other for? It's ridiculous. Thirty years on, Nick Serota can have the pick of the bunch, tried and tested, guaranteed. What are people like me doing in the fucking Tate? What's the Tate doing speculating? *Why?* I just don't get it.

It's box office. They've seen the numbers for the Turner Prize exhibitions. They know what pulls them in.

Ah, box office! Dead right. Fantastic. Art's popular. That's my generation. It wasn't before. And that's what they don't know how to deal with. Museums are boring. The worst places to look at art. Enter the next generation. Art's popular. Isn't that an awesome thing?

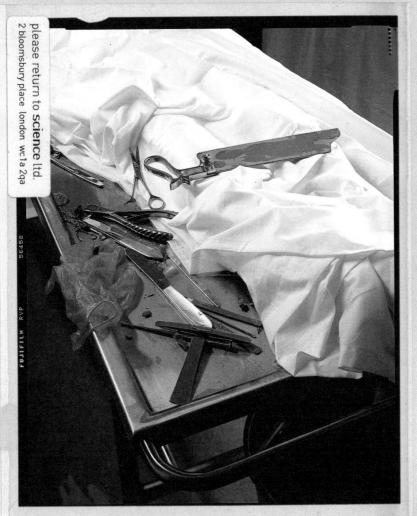

please return to **science ltd.**
2 bloomsbury place london wc1a 2qa

Adam and Eve (Banished From
the Garden) (detail), 1999

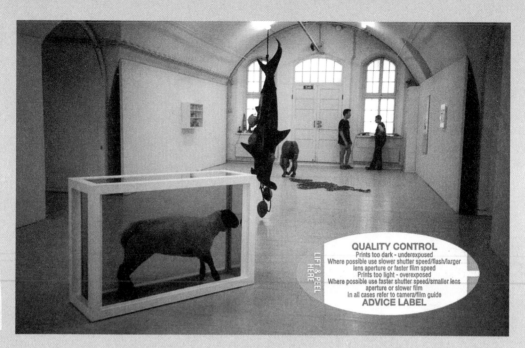

QUALITY CONTROL
Prints too dark - underexposed
Where possible use slower shutter speed/flash/larger
lens aperture or faster film speed
Prints too light - overexposed
Where possible use faster shutter speed/smaller lens
aperture or slower film
in all cases refer to camera/film guide
ADVICE LABEL

LIFT & PEEL HERE

It's an amazing thing.

An *amazing* thing. In my lifetime. It was stuffy when I got into it. Fucking 'A'. I blame [Carl] Andre.

For a long time the critics and curators were lagging far behind the public taste.

I think how it went was: David Mach's sculpture killing that guy [a man was burned to death after he set fire to *Polaris*, Mach's public sculpture of a submarine made from six thousand car tyres, on a walkway behind the Hayward Gallery, London, in 1983]; Andre's bricks in the Tate… I think it was Cambridge and Oxford graduates getting jobs on the *Mirror* and the *Sun*, and the *Express* and the *Mail*. All these educated people – *failed* educated people – believing that they were speaking to these dumb, ignorant masses, like arse-crack builders. Because they were 'chaps' they tried to take the piss out of the art, which brought it into everyone's consciousness. That's definitely what happened. And after Andre, when I came along, it was already there.

You were box office while the art professionals were still snooty and sniffy and trying to avert their noses from the stink.

That's what I'm saying. I grew up in box office. It was box office before I came into it. When I decided I wanted to be an artist, art became box office. I went in there and thought, 'I want to entertain, with art.' Not: 'I want to rot in a garret and chop my ear off.'

Was *New York Art Now* at Saatchi [in 1987] with Koons, Gober, Bickerton, Steinbach an important show to you?

Massive for me. It was the first point where we disagreed with our tutors [at Goldsmiths']. They said it was shit. They said, 'It won't last.' While we were just blown away. It was the first time when we turned around and went, 'It's ace!' And Jon Thompson went, 'It's not, Damien.'

Its easiness. The way it gave the finger to the history of art. The way it was out of time.

I remember Michael Craig-Martin going, 'It's not that good. Be careful.' Worse. But it was the best thing ever. 'Goodbye, Old School. Good morning, New School... Sorry, guys, you got it wrong. Kiss my arse. Over and out.'

It was the hole in them [the tutors] that I saw: 'You can do what you want. You can do what you want... But you can't do that.' *Aah!* Bollocks! Bullshit! You can still do what you want!

It was the end of the 1980s. It was unsustainable. I mean, the 1980s, it was *ridiculous*. Just totally ridiculous. The art was ace. But once you falter, once you get on the wrong foot, then you fuck it up. So Ashley's work started fucking up. He's stuck with [Ileana] Sonnabend when he should have told her to fuck off. Haim Steinbach and Jeff Koons told her to fuck off. They left her. They managed to get outside of it all. But Ashley was trapped in the ivory tower by Sonnabend. And that's where he is. And he's cynical now. Which has ruined it all.

Yeh, but he hated the fact that I'm the curator. *He wants to be the best drawer in the fucking class.* He had his exhibition in New York open the same day as me [in 1996]. Ridiculous. On purpose. To kick me in the head. I went, 'Ashley, it's a relay race, and you've handed it on to me.' I went, 'Ashley, you've lost your mind. Don't do this.' And he goes, 'Let's see what happens then.' So nobody goes to Ashley's opening. Why didn't he do it the day before, and we could have had this big, fuck-off Hirst–Bickerton weekend?

He's my hero. I love him. Or I wouldn't get mad.

No, no, no. What did Matthew Freud see in me that he wanted to destroy? Freedom. Choice. Understanding. Art. A reason to live. A belief in something above and beyond cash.

The cunts rule the world. If you want to say that art is a pile of shit, like a lot of people in the world do today, what you do is, you publicly get hold of Damien Hirst, you ram him on the ground, you stand on top of him with a fucking Union Jack in your hand, you ram it in his head, and you have a photograph taken. You've conquered Everest. [*Laughter.*]

No, but really. Really, really, really. People are afraid of art. Everybody's afraid of art. Everybody's always been afraid of art. And I'm one of the artists who physically represent that fear.

It's, like, you really hate art, but you invite Richard Wentworth to your dinner, and he'll sit down next to you, and you're not afraid of it any more, because art falls down to the same rules as everything else. But I don't. I absolutely fucking don't. Because I don't give a shit.

I'm not saying I'm any good. But I'm prepared to die. In a deal across a board table, I go, 'Look, you either do what I tell you or you suck my cock.' It's close to kamikaze. I don't give a shit. But I do give a shit. Artists give a shit about different things to these money-grabbing cunts.

It's something to hide from. You hide as an artist. But if you take that thing that you're hiding from

and you place it right bang on the table at a business meeting, then it's not something to hide from; it's something to celebrate. And I'm doing neither.

Yeh, but what he's basically always doing is: 'Enough's enough. How about I give you a bit of this and you give me a bit of that, and we'll cut the slack…' And I'm going: *'Kiss my arse!'* Which is what I do. *'I don't give a shit! Let's go in the ground together!'* And you wish he'd go away.

But the thing is he's a PR guru. And so am I. So what d'you do? He's looking at me like: 'We're going to find this fucker's Achilles heel eventually.' But they don't. If you're a good artist, you don't have an Achilles heel. Because you're just a piece of shit in the middle of the road that eventually's going to get hit by a truck. And if the truck's going to be Matthew Freud, then you're going to derail the truck as well.

He believes I do give a shit. It's, like, you can *buy* anything. Everything's got a price. And I'm on Matthew's agenda. So he's going to be working extra hard to take all my power away. To somehow do some kind of business deal which leaves me with nothing. And then he's going to go *phtttttttth!* like in the school playground.

In my generation – in my lifetime – art meets business. Artists become businessmen. Nothing you can do about it. I keep rattling him. I'm having a laugh.

I really rate Sigmund, and I really rate Lucian. Lucian's brilliant. He's such a great guy. He's a great artist – a great painter. If you look at them close up, they look like abstract paintings, and from far away they look like flesh. Everyone else has got rubbings out. You've got nibbles; you've got fear. Lucian, when you get up close, it turns into a de Kooning.

At the end of the day, every article you read about Pharmacy is about me. And I'm the one who gets the shit for it; no one else does. At dinner parties, Matthew goes up to people and goes, 'Yes, I did Pharmacy. I'm the man behind Damien Hirst.' Which is fair enough. But you can't go round saying, 'I'm the man behind Damien Hirst', without having Damien Hirst behind you.

This is all stuff when I didn't know what to do, art-wise. I had a lot of time on my hands. I was thinking about things.

I'm a romantic artist. I'm a lyrical artist. I'm interested in beauty. Now I'm inventing the world in the way that I always knew it.

I'm on the lookout all the time. I love the smell of it; I love the colour of it; I love the beauty of it, and I

don't care. It's like water. It's just there. It's there for the taking. And the things I want to say are much bigger than anything I've ever wanted to say ever before.

Do you have a sense of liberation since you stopped having to take business meetings to discuss staffing problems and budgets and pots and pans?
I feel invigorated that I've rediscovered that there's a difference between art and *everything* else. I feel totally invigorated by that. When I stopped doing art, art was becoming a bit of a bind.

Artists are irresponsible. But to be able to take four years off is a massive responsibility. You don't have to fuck it up. You just stop doing it. I love that.

Hockney's handled that quite well, hasn't he? And Peter Blake.
Yeh, very well. Peter Blake's a hero. He's one of my heroes from when I was a kid. Before Gilbert and George and all that. Before even Bacon.

And I told you I bumped into Hockney in Hamley's the other day. Both of us on our own. And we were kind of embarrassed. Hirst and Hockney at Hamley's. It was good. It was normal. Normal unease with a person you hardly know.

Hockney isn't lying. Hockney's got a twinkle in his eye. Jasper Johns has got no twinkle in his eye whatsoever.

Where do you stand on other British artists of Hockney's generation?
I don't trust any artist who's a 'Sir'. 'I've made my bed. What are you doing in it?' Know what I mean? I'm a fucking rat flea.

Richard Hamilton's not on the map. But he will be, twenty years from now. Hamilton's really massive. He'll just go ballistic. Because he locked so many things together.

Pop art is Warhol. But if British art continues to seem as important as it seems today – if it *is* as important as it possibly could be – Hamilton becomes the conduit for that. And pop art gets taken through Warhol over to Hamilton, in the scheme of things.

A good case can always be made that pop art didn't start in New York in 1960, but in London at the ICA in 1955 or 1956.
And that's going to ring true. And Hamilton's going to be the ringleader of it all.

DH, Leeds, 1967

If you're following something, you're not inventing it. It either exists or it doesn't. A lot of people look at me and they *think* I'm actually creating it. The lot. Everything. They think that I am actually at the helm of something. They think that whatever I do is followed. What they don't realize is that I'm following something, to work out how to do it. I'm finding things; I'm not creating anything. I'm digging around in bins. I'm digging around in dead artists' bins trying to find things. I'm looking for the world.

INTERVIEW 8

LUNDY WEDNESDAY. 19.04.00. EVENIN

<Damien Hirst>[*Camp voice:*] So, go on then, what is the *je ne sais quoi* of this? Of me? What is it? What's the interest? What d'you think the interest is? What d'you think the difference is between me and Tracey Emin, for instance? I've been having funny dreams recently.

<Gordon Burn> Since you got the [Gagosian] show done?
I've been having nightmares.

I always imagined you having nightmares – being a nightmare sort of person.

I had a dream that I was trapped in space and it was inescapable, in some dimension. Like in a hot tent, but not a hot tent. A place where I knew I had to be for ever but where I was going to lose it completely and couldn't be there for ever… I woke up sweating and had to have a shit.

I liked what you said when we were on the cliffs earlier today about buying Tracey's blanket. [Tracey Emin was currently showing a blanket on to which she had urinated at the inaugural show of Jay Jopling's new Hoxton space, White Cube 2.] Buy the blanket; clean the blanket; give it to an Oxfam shop. Then you get dealers from across the globe trying to track it down, because now it's worth fifty times more than when it started, like Rauschenberg erasing the de Kooning drawing.

The other way I could do it is: Buy the blanket, wash it and put it on the guest bed. Then sell it to a museum when I'm sixty. [*Laughter*.]

 It's funny, because once you rub something out, it's still there really, isn't it? I mean it actually physically is there. It's not like a blank piece of paper. That's why Bacon's fantastic, because he doesn't rub out. He just accepts his lot. It's like correcting. Correcting things. You're on a public fucking stage. You've got to be yourself. It's not like acting, being an artist. So to be able to erase it, you're making the same gestures as… It's like: 'Live with it, you cunt.' If it's weak, that's you. To be weak publicly is a great way to make art. [*Camp voice:*] Because we all feel a little bit like weeping babies underneath and died-out cigarettes now and again, don't we? [*Laughter.*]

Pollock's greatness is supposed to lie in his naked display of angst and emotion.

Yeh, but he covered it up with that whole fucking charade as well. The Americans, they always do that, don't they? It was guaranteed it was going to look pretty, d'you know what I mean? Whatever he did. He didn't fucking go up there and wriggle. He wasn't a worm on a hook. He admitted he hid behind his work. And he was the best of the gestural Americans. The great big Americans. But Bacon does it better, because he smashes right through. When you compare Bacon to Pollock, Pollock starts to look like he's producing logos. When what's really happening is he's scrabbling about in this void which has been created by photography, between abstraction and figuration. That's the truth of it. But the moment he gets there, it starts to look like logos.

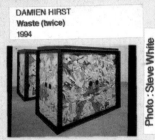

DAMIEN HIRST
Waste (twice)
1994

Photo : Steve White

Glass, steel, wood and medical waste
Each vitrine : 5 x 7 x 3.5 feet

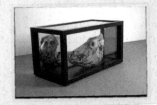

DAMIEN HIRST
Judas Escariot (The Twelve Disciples)
1994

Steel, glass, formaldehyde solution
and bull's head
46 x 91.5 x 46 cm
Photo : Stephen White

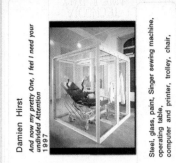

Damien Hirst
And now my pretty One, I feel I need your undivided Attention
1997
Steel, glass, paint, Singer sewing machine, operating table, computer and printer, trolley, chair,

The importance of Pollock was that he was the first person to make a distance between the brush and the canvas.
It had to be done. But once it had been done, you might as well die, I suppose. That's his contribution to the chunky knackerbag of life. [*Laughter.*]

The only thing to hide behind is glass. Which is fantastic to hide behind. What a substance. You know: nowhere to hide.

It's an alienating device. Why was Bacon so insistent on the glass?
It's the most transparent thing to ever hide behind. It's the most solid and transparent thing you could ever fucking hide behind. Just, you know, *massive* amounts of fear. It can kill you.

The thing I can't work out with Bacon is his homosexuality. I suppose as a gay guy you've got no sort of attachment. That's the thing that maybe helped him out. You've got no family…

You've got driven into your head this meet-a-girl, fall-in-love, live-happily-ever-after kind of fucking thing. But all that's gone, and dead in the water [if you're gay]. So you become an individual. And as a homosexual you're a unique individual. And if you become an artist, then you're totally hacked off from everything that exists. You're isolated and floating around like a fucking satellite.

So then once you accept that any relationship you're going to have is with a man, you have to design it. And it's like: 'Fuck that. I'm designing my own work. I'm not designing relationships.' [*Les Dawson voice:*] I'll wait for all the homos to catch me up. In heaven. [*Laughter.*]

Did I tell you about my interview the other day when I did that [TV] thing about Bacon? The guy read me a letter out, which was the last letter written by Bacon before he died, which talks about me. On camera. Fucking freaked me out. It was kind of funny. It was to an artist in Ireland. It wasn't a great letter or anything. But it was a dead guy's letter.

Is it just a story that he went to see the fly piece at the Saatchi Gallery before he died?
No, I know he went. He mentions it in the letter. It just goes, 'Hi, blah blah I'm not feeling well blah blah it was great to see you the other day. Just went to the Saatchi Gallery and saw this show of new British artists. Bit creepy blah blah. There's a piece by this new artist' – I don't think he mentions my name – 'and it's got a cow's head in it and a fly-killer and loads of flies and they fly around. It kind of works.' *It kind of works!* Like: 'Nice toilet upstairs. It kind of works.' Fantastic.

When he was there I got a call from Jenny [Blyth] at the gallery. And she said, 'I don't know if this is interesting to you, but Francis Bacon's here, and he's been in front of your piece for an hour.' Honestly, I got a phone call that said that. It was a bit embarrassing. I didn't know what the fuck to say. I dismissed it, but I understand why he could have liked it – dead fucking flies.

So I dissociated myself from it as an artist and just thought of it as a spectacle, and quite liked it.

In the interviews with [David] Sylvester, he talks about killing cattle in a slaughterhouse being like crucifixions – the closest you could get to a crucifixion. It would be possible

- I've been having funny dreams recently

Q: Since you got the [Gagosian] show done?

- I've been having nightmares.

Q: I always imagined you having nightmares — being a nightmare kind of person

- I tell you what, if you take 4 years out/ here and don't do anything so shocked to see that you're actually doing something that they don't know what way to take it. [Gks piece has appeared in the show. The opening WC2 show has been reviewed. Been all the hypes surrounding 'Heaven'] you know so if you've shown look like somebody who looks to shown anything for quite a while. I've never stopped in that town years. But to suddenly come basically say something something... I mean, everybody looks at it & they're expecting to hate/but they say to. Because you look at it and first if all you think it's a pile of shit. But then you have to take it — you have to take it — in terms of all the rest of my work and look at it.
But in reality it probably is a pile of shit. Because I haven't taken it in terms of the rest of my work at all. I've just gone for it like to attacking child. I haven't done anything for it not a fucking 'Damien Hirst'.

Q: is it main't a strategy to leave a gap, and have people speculating about what you were doing?
- I don't have strategies. you can have strategies as long as you're facting good. As long a you're able to deliver results, you can have strategies. But strategies don't work on their own. They only work if you're in the vein and you've got the vision. I might strategies if you can get away with it.

Q: Are you surprised by the Richard Cork thing today, calling 'Heaven' the best sculpture in the 21st C?
- I'm not sure what I think it is yet. But I kind of thought it. I noticed it would come out of. But I don't quite know how ok. I mean, it's like, you've got the ball... I always say I don't complete unless I know I can win. Which in a really weird thing when you're dealing with life & death, 'cause you can't.

[* To]

Q: I've never heard you say ...
– Well you've got like ... death on the one hand,
and then you've got being a more successful
artist in the world on the other. They're conflicting
desires, aren't they?

[Camps] So you can see, that is the je ne sais quois of ...
it, no? What is 'it'? that's the interest? What do you
think the interest is? What do you think the
billions is between ... Tracey Emin, for instance
per se?

S. the dream ... I had a dream / that I was trapped in
space. I was trapped in space and it was
inescapable, in some direction. Like in a hot tent,
but not a hot tent. A place where I knew I would
be forever but when I was going to be it eventually.
+ couldn't be there forever ... I woke up sweating and I
had to have a shit.
It seemed like a combination of a bit of dream. I don't
think last night's got anything to do with coming here with
you. ~~...~~
~~...~~ [laughter] Ah, it's
weirder than that. I don't know what it is.

Q: What was it [er said about buying her blanket?
[TE was currently showing a blanket, taking indeep
disorientation.] Buying the blanket, to an Oxfam shop.
~~this is a good idea~~ jives it to it. It's a good idea.

Q: Ren will get collectors ... trying to track it down, because now it's worth ...
so there was there when it started, like
Rauschenberg ... it be ... drawing.
– Re ... way I could do it it's ... the blanket,
work it and put it on the guest bed. Ren sell it to
a museum when I'm 60. [Laughter]

(~~...~~) It's funny, because once you
Webster, VHS something out, it's still there really, isn't it?
I mean it actually physically is there. It's not like
a blank piece of paper. Rauschenberg
could have done it if he got a de Kooning, Ren
give a totally blank piece if you + say I've
rubbed it out. And secretly you've got it in a
vault in Switzerland for your own family after
you're dead.
But rubbing out is a kind of drawing... That's
why Bacon's fantastic, because he doesn't ...
out. He just accepts his lot. It's like correcting.
Correcting things you're on a public (acting) stage.
You've got to be yourself. It's not like acting,
being an artist. So to be able to erase it, you're
making the same gestures, ... It's like: Like
with in the cunt. If it's weak, that's you.
To be weak publicly is a great way to make art.
[Camps] Because we all feel a little bit like
weeping babies underneath and ... out cigarettes
now and again, don't we? [laughter]

to put forward the view that you are systematically going through Bacon's images and obsessions and giving them a concrete existence.
I am definitely. I am definitely systematically going through it. Definitely.

Are you being ironic?
No, not ironically. It just works.

I mean, in saying that, are you being ironic?
No. I am definitely systematically going through Bacon's work like that. I'm aware of it. But that's the difference between… I mean, there's a massive difference between sculpture and painting. Massive difference. It's not like… I'm not copying Bacon's paintings. But it's like… I mean, I'm aware that there's a big connection between… If I run out of ideas it's very easy to look at a Bacon book and go, 'Fucking hell.' And when it becomes three-dimensional it turns into something else. And they work incredibly well, three-dimensionally.

I dug it out the other day, the Sylvester book. And it's weird, when I looked at it, I'd gone through it six or seven years ago writing 'DH' in the margins.
I haven't read it for years… D'you mean what I *say* is like Bacon?

No, the work. But then also what he says about cows in the slaughterhouse smelling the nearness of their own death — the smell of fear that comes off them; shitting themselves with fear. And he said that, as an atheist, that was the closest he could come to a crucifixion.
I think as a child I got a fuck of a lot from Bacon. If you speak to Marcus [Harvey] and Hugh [Allan], I think we all got a fuck of a lot from Bacon. We looked at the whole history of art, and there sticking out like a fucking ugly sore fucked-up thumb was Bacon. We just, y'know, got on our fucking knees in front of it and went, *'Jeezuschrist.'*
 Marcus always said to me there's three great English things you can't break, and they're Bacon, Shakespeare and cricket. [laughs]

By the time the fly piece reached the Saatchi Gallery you were having to use a prosthetic cow's head because of the health regulations. I remember the whisper going around at the time: 'It's not a real head, you know. It's from the special-effects department.'
This is the difference between sculpture and painting. They're going, 'It's not *really* a fucking boat. It's paint on canvas.' This is the dilemma I have. There's this great thing which fucking Anthony Caro is the bastion of: 'truth to materials' in sculpture. You don't see it in painting, because painting's illusion from the start.
 I mean, ideally, as an idealist, I would really love everything to be as real as possible. But *life*'s real and art's not real. It's just fundamentally not fucking real.
 And there's a huge thing about you've got to take the smell away in order to make people *look* at a fucking horrible thing. So if you want to see your dead dad…
 I did it with a real cow's head [at *Gambler*]. And it stunk the fucking place out. People wouldn't go in the room. They wouldn't go in the room. I took the cow's head and burned it and it had maggots under

180

the skin. It was rotting like a cunt. I said, 'Leave it, leave it, leave it.' They freaked out. People would not go in the room at *Gambler*. And in the end I had to compromise. I took it out, and I fucking nearly retched taking it out. And I put it in a dustbin and I lit a massive fire in the dustbin. The skin's flapping, and when I dropped it in, the skin all peeled off, it was covered in maggots, and I burned the fucking thing. It was black and burned. I put it back [in the vitrine] burned. I put a burned head in it because I still wanted it to be real. And the room stank for weeks. It just stank.

And I toyed around with the idea of doing a certificate for Charles [Saatchi], stipulating that he had to have a real head in there. I wanted a real cow's head in there. But if you have a real cow's head, no one goes and looks at it. I'm aware of that. So it wasn't a compromise. It's not a compromise. I'm not into stinking everyone out of the gallery. I'm into drawing them into the gallery. So they go, 'Fake head!' And I don't give a shit. So long as they *think* it's real. As long as you don't know, I don't fucking care. It only fails when I get a cow's head made that looks shite. And I fooled Bacon.

I was in there for hours, with dog food and ketchup and blood and mayonnaise and lard. I had this thing made that was shit, and I was in there and I made it look real. Covered it in stuff that flies would eat. Until you just went, 'What the fuck is that?' Everyone went, 'Is it real or isn't it real?' No one knew it wasn't real.

I've said it before: I'm into theatre. I'm a theatrical artist. If someone says to me, 'You can make that out of polystyrene and it'll look like steel', I'll do it. I will just definitely do it.

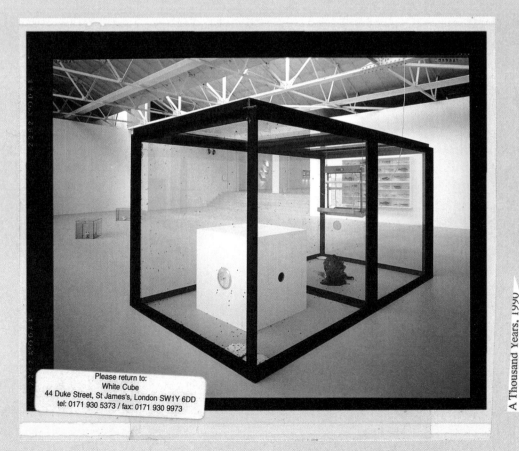

A Thousand Years, 1990

181

But the bronze [*Hymn*] is the reverse of that, isn't it? Something that weighs six tons made to look like plastic.

Yeh, it's definitely the reverse of it. Or is it?

The thing is, everybody wants to be made of bronze themselves. They want their relationships to be made of bronze; they want their houses to be made of bronze… Bronze implies a lack of entropy. But it's fucked. It doesn't exist.

I love the meaning of bronze in art history. I made it look like plastic.

What do you understand by 'entropy'?

It's why houses fall down. It's the force in the universe that makes houses fall down. It's why a fucking star dies. It's why a planet is born. It's a massive energetic power in the universe. It's the simplest route from A to B, without going back again. It's why water always finds its own level.

Eventually this whole world will wear out to nothing. And that is caused by entropy. It's a force. It's not stood still. Everybody thinks, 'Here we are. Nothing's going to change.' Everything changes. And the reason it changes is because of entropy. It's the action of the world on itself. Put it up, it's going to eventually come down. You can't leave it there and assume it's going to be there for ever.

You're obviously aware of the link between Soutine *and* Francis Bacon *and what you're doing. Soutine painting from a real beast until the place stank and he had the neighbours down on him.*

I *love* Soutine and Francis Bacon. Completely. But what I was doing is not painting. It's completely different. This wasn't in my studio. It was in an exhibition. Soutine would never have exhibited the dead animals. I wanted reality. And it's something I'm still chewing over, and can't get my mind around.

How do you rate Freud against Bacon?

You look at Lucian Freud, and Lucian Freud's an infinitely better painter. But you can just see why he shits himself while Bacon's alive. Because he represents something just so fucking enormous that Lucian's incapable of.

You mean that Freud's technically the better painter?

I'm not saying that. But I am in a way. But it's a sigh of relief from Freud when the *cunt* dies.

I mean, Lucian Freud, without Bacon, would be the best painter we've got. But he's not. He's shit next to Bacon. And Bacon can't paint, and Freud can. What's going on?

So what makes Bacon the better artist?

Because he'll go right out there on the edge of the cliff and he'll stand there and he'll put his arms in the air with his shirt off in India without his passport and go, *'Come and get me, you cunts!'* D'you know what I mean? And no one can get him because of it. He doesn't falter. He doesn't fail. And it doesn't matter he's a homosexual. Everybody wants to do that, and can't. All everybody ever wants is somebody to represent that, that 'come-and-kill-me'.

Are you surprised by the Richard Cork thing [in *The Times*] today, calling *Hymn* the best sculpture of the twenty-first century?

Damien Hirst
Installation
FREEZE
1988

Canary Wharf, London
Derelict building photographed in 1996

Photo Credit: Courtesy Jay Jopling, London

Damien Hirst
Installation
FREEZE
1988

Canary Wharf, London
Derelict building photographed in 1996

Photo Credit: Courtesy Jay Jopling, London

I'm not sure what I think of it yet. But I kind of thought if I waited it would come out OK. But I don't quite know how OK. I mean, it's like, you've got the ball… I always say I don't compete unless I know I can win. Which is a really weird thing when you're dealing with life and death, 'cause you can't.

'Always say'? I've never heard you say that before.
Well, you've got life and death on the one hand, and then you've got being the most successful artist in the world on the other. They're conflicting desires, aren't they?

These new pieces I've done look like somebody who hasn't done anything for quite a while. I've never stopped in that four years. But to suddenly come out with something… I mean, everybody basically says they look at it and they're expecting to hate it, but they don't. Because you look at it and first of all you think it's a pile of shit. But then you have to take it – you *have* to take it – in terms of all the rest of my work and look at it.

But in reality it probably is a pile of shit. Because I *haven't* taken it in terms of the rest of my work at all. I've just gone for it like a fucking child. I haven't done anything in order to make it not a fucking 'Damien Hirst'.

It wasn't a strategy to leave a gap, and have people speculating about what you were doing? To get the rumour mill buzzing?
I don't have strategies. Strategies don't work on their own. They only work if you're in the vein and you've got the vision. I enjoy strategies if you can get away with it.

You did *Freeze* in only your second year at Goldsmiths'. It must have been strange going back to college after the ripples caused by that. Did the accusations of being a 'careerist' start as far back as then?
It was a nightmare, our third year. We were, like, in the *Guardian* every fucking week. I didn't go in. I did one piece the whole year. People were doing *Anti-Freeze* and all sorts. The tutors were jealous. Fucking chaos. I did one lecture about *Freeze* and all these people came in wearing big thick fur coats. I was really nervous about doing it, and this guy stood up and said, 'I just want to say that we're wearing these thick overcoats because we think all the work here's very cold.' Hostile. *Anti*-Freeze.

I mean, everybody wants to be fucking successful. And when you're in an art-school situation and you do *Freeze* with seventeen people, you automatically exclude everybody else in the college, whatever you

do. And if it's shit, you get loads of support. And if it's brilliant, you get kicked in the head. Nothing you can do about it. People kick each other in the head in a way you wouldn't believe.

I remember I spent ages listening, trying to work it out, listening to what people said. About selling out. Right at the beginning, I got all this about selling out. 'You're a cunt, you're just selling out.' I remember there was this one guy, and there's one thing he kept coming up with all the time: 'You're selling to the fucking Saatchis. How can you do that? Morally?' It was always 'the Saatchis'. Doris [Charles's wife] had already fucked off. It was only Charles. And I was thinking, 'God, I've fucked up. I've fucked up.' I was going through it in my head, thinking about it. I was caught in the whole world of it. I was going that route. And I was aware of it.

And I remember this guy in his degree show; Saatchi wanted to buy something, and he bought it. And I just went, 'You cunt.' And I realized, the whole fucking thing, I was the only one losing sleep over it. He just didn't give a fuck. He just sold it straight to Charles like that, and then died without trace. Spends a fucking year bending my ear about this shite, and then – Bang! – sold immediately. Like that. No discussion, nothing. So you go, 'Oh, I see. I see the fucking thing. That's it.'

Did you get a hard-on doing the spots, knowing that you were finally doing something that was good?

No, I didn't know they were good. Michael Craig-Martin came in and said they were brilliant. That was the first time I noticed they were good. I didn't think about it. I had too much on.

But they did look ace. That was the thing. When they were made, they looked great. Everything looked great. It was phase three of *Freeze*. It was still alive. I think it was Sarah [Lucas]'s idea to go, 'C'mon, we've got the building, why don't we fucking do another one?' And everyone else was kind of going, 'Oh no, they're not *still* here.' I think the fact that somebody came and bought stuff, that renewed it.

The painters – Ian Davenport, Gary Hume, Fiona Rae – had sold to Saatchi and/or been taken up by Bond Street galleries.

Everybody had been down, and people had got successful. Everybody else had been successful, and we were sort of pottering around doing the last part on our own. And Maureen O. Paley came down and she brought these two collectors. They were from Los Angeles and New York. She called up out of the blue, she never spoke to me about anything, and she came down. And while I was showing them round, one of them turned to Maureen and said, 'How much is that? I want to buy it. How much is it?' And I didn't say anything, because she's supposed to be a dealer, and I'm a second-year art student. And she comes out with a price. She says, 'Oh, it's £350.' Which was far too cheap. So I didn't say anything.

So he had it, and they went round and bought a load more. She was making it up off the top of her head. She'd never even discussed anything with me. I think she was as gobsmacked as I was. And it was my first introduction to how fucking shit these cunts were. From my point of view, I thought they knew what they were doing. And there was a point where it was my absolute introduction to the fact that they don't know what the fuck they're doing.

So she basically sold them one of my boxes for 500 quid; she sold Angela Bulloch for 350 quid; a spot painting by me for, like, 300 quid… Totally made up. So I waited. Then the two collectors left. And when they left, I went, 'What're you doing?' And she said, 'What do you mean, what am I doing?' She'd sold Mat Collishaw's bullet-hole piece for 500 quid. He'd spent, like, 800 quid on it. The lightbox with the bullet hole.

And I was like: 'Look, you can't fucking do that. You got all the prices wrong. You owe us money.' And she said, 'Well, I have to take 50 per cent.' And I said, 'You're taking fuck-all. You're taking absolutely fuck-all.' I was into damage limitation – embarrassment limitation – about what she'd done.

But you must understand: I was a second-year art student, so I was a *really fucking awkward cunt*. Can you imagine what it must be like if you're in that situation?

But in the end she came back and said they'd bought my box piece, but it *had* to be in one piece. Joined together. I'd just got Blutak and tacked it on to the wall. But they wanted to buy it and ship it as one piece. So I had to fasten it together as one big piece.

Basically, we all worked our nuts off to try and give them these things. And she said she wanted to work with all five of us; she wanted to represent us all and give us a group show. And then she turned around at the end of it all, came back to me and said, 'Except Sarah.' And that was another lesson to me. Angela [Bulloch] was the only one who ended up working with her after that. I just went, 'Bollocks.' I just couldn't do it. Couldn't deal with it.

I remember I had all my boxes on the floor, and I was using those push pins that you bend over, those gold pins. I was having to cut holes through boxes, and it was massive, and I was having to get my arm right in, just to fasten another box. I'm doing it with Mat [Collishaw] in there. I got a lot of money for mine 'cause it had cost nothing to make. Mat lost money. I was making money. And I just remember one day, I just jumped on the fucking lot and smashed it to bits. Like: *'Fuck off!'* It was fantastic. It was in the middle of doing it. I just went, 'I don't give a fuck! I can't fucking do it!' He wanted it in one piece, and it was just impossible. Smashed it to fuck, laughing. I still get calls about it now.

Tell you another thing I did. I wrote a certificate for one of the spot [wall] paintings this guy bought. And Maureen ripped it up, and fucking wrote her own. It says on it, 'This certificate certifies ownership.' And so I've got this thing sent back by Sotheby's. He's trying to sell it. Will I authorize this? And I said, 'That's not the thing I did.' I did it on the back of the *Freeze* catalogue. I ripped the *Freeze* catalogue in half and

wrote it out by hand. So then she thought it was shit, and redid it herself. So he's got a photocopied signature on it, and she's probably thrown the other thing out. So he's coming at me, and I'm going at him, and I've put them all back in touch with Maureen. And she's phoning me going, 'Please, Damien, I never saw it…'

There was two of them. Painted straight on to the wall. Directly on the wall. So the certificate certifies ownership: the spots must be this big, the distance between them this big… It's called *Edge* and *Row*, with half-spots down one edge and half-spots down the other. So I cut the catalogue in half and made two certificates. Now they're trying to sell the certificate that Maureen made which has got a photocopy of my signature on it. 'This is what Damien gave me.' But it's not. I wrote them both out in pencil, in very neat capital letters, then went over them in black felt-tip, and gave one to Maureen. I was sat in the building with no one coming in and I had to do a certificate, so I took the back of the catalogue and just cut it in half. It's copper on the back.

Was that an accident that it was cut in half? Because that would be the first thing you had ever cut in half.
No, I'd cut a peach in half for me and Bradley, way before that.

I know what you're driving at. But it's not true. This is where cutting in half came from. It came from taking two the same, like Ming vases, and doing something different to each of them. *Edge* and *Row*. Identical paintings. One was cut down the edge; one was cut along a row. And cutting things in half came out of that.

Ending with the half-spots makes them look like rows in a neverending series that can go on for ever. Like something being scrolled up on a screen.
I definitely imagined that. Like a machine. Like: 'Buy your own art.' A big machine: you come in; you load it up with paint; a couple of seconds, and it's done. A painting machine.

There's some sort of fear. I just thought, 'There's two things: treat 'em differently to make them unique.' I didn't want them mass-produced, and I didn't want unique. I wanted something in the middle. Always. [*As he is talking, DH is urinating into a plastic beaker.*]

There's a toilet upstairs.
Topologically, a toilet and a sink are the same things, and I keep having to prove it.

But hygienically they're different.
Hygienically they're the same thing. They've only got water flowing through. That's why I love it. 'Ugh, don't pee in the sink.' I mean, you've got a sink and you've got a fucking shitter in your house, and I would definitely wash myself in the shitter. Flush it first, and wash your arse. [*Laughter.*] D'you not do that? Then next to it you've got a bidet, and then you've got a sink. They're all these big white ceramic things with a hole in and water flowing through. Ridiculous. The cleaner comes in. She puts the gloves on, and she cleans the toilet, she cleans the sink, she cleans the bidet. Same gloves. Same cleanliness.

'Oh God, I used the loo brush to clean my teeth!' Have you ever blown your nose on arse-wipe? That's for your *arse*! You can't blow your nose on arse-wipe! Whatever next! Both ends. It's the same fucking thing.

Hey. Both ends. Same deal. Respect. Top night. Over and out. Pub.

December 9.

THE GROUCHO CLUB

Dear Damien,

How would you like it if one of us came round to your house + pissed in the sink! For the most part I feel everyone at the club treats you with respect do you not feel that we deserve the same respect in return.

Mary-Lou.

45 DEAN STREET LONDON W1V 5AP
TELEPHONE 0171 439 4685 FACSIMILE 0171 437 0373
THE GROUCHO CLUB LONDON PLC REG NO 1802099 REG OFFICE AS ABOVE VAT NO 386 3287 17

INTERVIEW 9

LUNDY
WEDNESDAY –
THURSDAY.
19 – 20.04.00.
LATE EVENING

<Gordon Burn> Let's talk a bit more about what you called 'art meets business' — artists becoming businessmen.

DH, Frank Dunphy, hotel lobby, Japan, 2001

<Damien Hirst>When I first went to Frank [Dunphy; DH's accountant and business manager], one of the first things he pointed out to me was, because of who I am, I can't lie. It's, like, other people might do these underhand dirty deals, round the back. But Frank was pointing out they're going to put me in jail for a grand; they're not going to mess about. They're going to make an example of me for all art students. Frank just completely pointed that out to me, to do everything by the book.

I used to think people with money were cunts, and then there were the people without, who were alright. And then I met Frank, who taught me about it, and it's been great.

It's so tempting to say, 'I believe in art. I don't believe in money.' It's why I always shout at Sarah [Lucas] when I'm pissed. 'Put your goddamn prices up! You're driving me fucking nuts!' I think she's got a responsibility to do it. But she's scared if she puts them up, she gives a shit about money. She's trying to say she doesn't give a shit. She's got every gallery in the world who wants to show her, and it's disgusting that she's behaving like that. Because for any artist looking at her and admiring her, they'd love to be in her position. It's one thing to be cool and not give a shit. But to have every gallery in the world courting you and do fuck-all about it is appalling. These are the glory years. The best years of her life. I absolutely know what Sarah's worth, because I'm right there at the fucking middle of it all. All you've got to do is know she's better than Rachel Whiteread, and look at the price difference, d'you know what I mean? Rachel Whiteread has played a very safe game. Sarah's out there strapped to the mast like Turner in the storm, making excellent pieces over and over again.

Where should the artist fit in to the money equation?
Don't get scared. Just don't get scared, no matter how big the figures get. That's the thing: hanging on to the fact that, no matter how big it gets, it's not scary.

I've shit myself. I'm shitting myself at the moment. Honestly, you do. But you can't.

When Marcus [Harvey] said you were the most guilt-free person he'd ever met, what do you think he meant by that?

I don't know. I was a bit surprised by that. I'd say that my work's very Catholic. It reeks of it, if you look between the lines. The biggest thing Catholicism has got to offer is guilt. So when he says I'm without guilt, I don't know what he means.

Perhaps he's got the word wrong. Perhaps he means 'unafraid to fail'. I mean, guilt's obviously something that holds Marcus back. What Marcus said to me, and he said it quite recently, which has always disturbed me, is he came up to me and said that I was put on the planet for him, to know how to go about things. That's always disturbed me.

I mean, I'm not tearing up the inside lane in order for him to come past me. I'm hurtling up the inside lane at such a ferocious rate that I'll never stop.

Is art competitive?

Is the art world?

Lost Love (detail), 2000

Is art?

They both are. But the great thing about art, I think, is all you've got is yourself, and you've got to give it your all. If you don't, you're out of the running. It's out of your hands.

Was part of your success 'sucking the wind out of everyone else's lungs', as Marcus put it? In other words, it isn't enough just for you to succeed; everybody else has to fail.
No. It's a lot easier to get noticed in a group. But the thing is I want to be excellent on my terms, not on anybody else's.

It's all about bullshitting. Are you bullshitting your way to the top, or are you going for it? And it's very easy to bullshit people who are alive now, but you can't bullshit people who haven't been born.

If you're seriously interested in art, then you're seriously interested in art. It's a completely different game. And all that other stuff, it might be enjoyable in the short term, but at the end of the day you're going nowhere and you'll end up nowhere and you'll be a blip on the landscape, and that's it. Gone.

I suppose that a lot of the confusion arises because you've been so actively involved in the process of conducting your career, in terms of promotion, publicity, presentation, press. You got involved in every area.
I'm involved with *now*, like every other fucking artist. This is it. And right now the world is different to every other time there's ever been. And just what if, just maybe, this is the first time money's ever become important for artists? And maybe for ever after this it will be. Maybe we're just at that point. Where money's an element in the composition.

You're not inventing anything; you're just discovering. You're looking at what is already there. And maybe that's what is there. Maybe it's just hard luck; I was born at the wrong time. This is what I do. You're a conduit from art to money. It's getting closer and closer and closer. And if money becomes king, then it just does. But there's a point where you've got to take it on. I'm not afraid of that.

There was a point in the 1980s when you had Jeffrey Deitch and Jeff Koons coming out of Wall Street, and art was being traded openly on the market like any commodity. Art and money seemed to come pretty close then.
People want to expose art for what they consider it to be, which is a sham – on all levels. You constantly have cab drivers going, 'You're having a larf, aren't you, mate?' You get that all the time. And anybody with money has always wanted to get power over art. Like Margaret Thatcher changing the eye on the Rodrigo Moynihan portrait of her.

Churchill's wife destroying the Graham Sutherland portrait.
Exactly. It's politically a great thing to do. But, at the end of the day, where does the power lie? I mean, I grew up in a world where Charles Saatchi believed he could affect art values with buying power. And he still believes he can do it. That's what he tries to do. And you just think, You can't, mate.

The only thing you can never bargain for is brand-new art by brand-new artists that really knocks your fucking socks off. Art that's right in the centre of the world the way it is and says everything. And when that happens you're going to want to possess it.

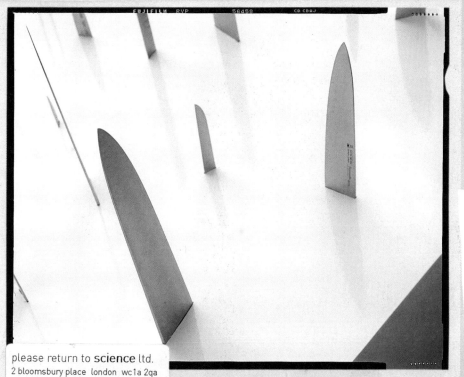

please return to **science** ltd.
2 bloomsbury place london wc1a 2qa

The History of Pain (detail), 1999

Do you think Charles recognizes it with his eyes, or does he hear about it with his ears?
I think he recognizes it with his wallet. He's addicted to shopping, d'you know what I mean? He cannot get his mind round it. He doesn't understand his love for it. I think he got addicted to *things*. And the most dangerous thing if you're a man like Charles is art, because you're just totally out of control. It's like: 'Hard luck, mate, you picked the wrong guy. Art was the wrong guy for you to pick to get addicted to.' 'Cause he likes control. And he's being dragged around on a leash. Art's dragging him round on a leash, and he doesn't know it. Or maybe he does know it. But there's no way he'll stop. He loves it, so he wants to possess it.

He got so arrogant. He tried to buy Midland Bank. And then he suddenly tried to control art. And once you do, art puts a fucking leash around your neck and drags you round by the heels. You're fucked. You can't do it. Especially today.

D'you think he gets turned on by the work, or does he get turned on by owning the work?
I think he gets turned on by the work. I wouldn't play with him if he didn't.

After Pharmacy, it's been reported that he was about to open a restaurant called Sensation, with pieces from the collection in it. Is the relationship between you competitive?
No. I think he knows he's not an artist.

I think he's a generous guy. He's generous to artists. He's a cut-throat businessman. He's childish. I love him. Child*like*. I bet as a businessman he's childish. But as an art collector, he's childlike. So that's the side I see of him.

With Whites (detail), 1983–85

Work in progress. Goldsmiths' College. 1986

Is your relationship with each other symbiotic – you change him, and he changes you?

I don't know… I met Charles through Kay [Saatchi's second wife]. I like Kay. She introduced me to Charles. She was working at Waddington's with Ian Davenport. She had a career in art. She was working in the gallery and she was a hot fucking thing. And then she married Charles, and she's out of the scene. She brought him to see *Freeze* when they were going out together. She was, like, a route to Charles as a normal human being: 'Don't be scared of him, he's all right really.'

He never collected Ian Davenport, did he?

No. But I think he has to buy. I think Charles wakes up in the morning and goes, 'I've *got* to buy art today.' Even if there isn't any around. He *has* to buy art more than he wants to buy art. That's what I mean by liking shopping. And, in barren times, he'll end up with a load of shit. And in heady times he'll get a load of fucking great stuff. You know, buy whole shows. But he's not going to stop buying it just because there isn't any there.

Addictions. I used to think that smoking was the most complicated. More complicated than money. But money is more complicated.

The cigarette you had last night was your first for six months – you claim.

My whole relationship with smoking has changed. I managed to convince myself – which is the hardest thing in the world – that I really, genuinely, didn't like it. That's the hardest thing. I mean, Hockney can't convince himself; David Bowie can't manage it. It's a very insidious addiction. It comes from right behind you. It steps back away from you the moment you try and grab it. It's at least trying to have a relationship with you until you die. It's like a lover. And the more you try and explain and understand it, it just steps back a little bit further, and a little bit further… It doesn't mind sleeping in the back yard while you go out and have fun. It'll be with you for ever. So it's a very insidious fucking freaky little relationship. It's got no morals. It'll put up with shit just to be with you.

I have one every six months now. I'll be back smoking in ten minutes. It's just even further away, and more insidious. It's always there. But in a way I *like* the fact that it kills you. That's the thing I like about it.

It's like embracing… It's like a very diluted way of facing death, constantly. It's not like the big bang. It's like the little nibble. That's why I like it.

But most people smoke, in an indirect way, to relieve them of the anxiety of thinking about death.
They *think* they do.

You kill yourself to live. It's sexy that it kills you. It's not like growing a tobacco plant in your garden, chopping it up, rolling it in a piece of paper and smoking it, which is normal, like everything else in life. It has, somehow, financially been removed from the rest of the world and represented in a way that it just, like, fucks up, and is sexy and weird, and not, and kind of says it all. They've done it with pills. They do it with everything.

It's like, in terms of clothes, there's hardly any clothes you imbue with personality. There's leather jackets and jeans. They're like skin, of another animal.

But we're sold things that, the moment we come in contact with them, we start to screw them up. We believe it. That's worse than Catholic guilt. I mean, everything you get a hold of, you ruin. That's from beginning to end.

It's like your joke about labelling the teapots: 'Bought, Barnstaple Market, 15 August, 1995.' It's like that idea for the soup tureens.
That's what Mr Barnes did, though. Everything's got a place. I mean, a kettle: somebody's spent hours designing it, so why can't you spend hours looking at it? You can if you stick it on the wall. That's what artists do. What's wrong with that? Just because it's broken and doesn't work any more as a teapot, it's still a great object. All you got to do is glue it to the table. That's all artists do. And then you're the mad fuck with the teapot glued to the table.

What do you think when you see the 'snout workers' – people standing outside the place where they work, smoking?
I like it. I think it's great. It's flushed the fuckers out. It's like the maggots have come out through the surface of the skin of the building. You see the straining muscles and you go, 'That'll be the smokers, then.' And you think where are they going to go next.

You can't make a profit out of death, unfortunately. Although everybody does.

You would obviously feel closer to the snout workers than to the in–workers?
Oh yeh. I don't trust people who don't smoke.

The way we smoke is a massive twentieth-century thing. I asked David Bowie, 'Why d'you smoke Marlboro Lights?' And he said, 'I used to smoke Silk Cut, and I used to smoke the posh ones. But Marlboro Lights you can get anywhere in the world. Africa. Anywhere. It's the only global brand of cigarette.' I went, 'Ooh, yeh!' Changed immediately.

I noticed in the new work it's Marlboro Lights. You always used to use Silk Cut.
Because it's global. It's a universal trigger.

In *The Way We Were*, I've got the first unopened packet, wrapped in plastic. It's the first time I've ever used that. *The Way We Were.* Maybe it's because I wasn't born with a fag in my mouth.

But I think if I'd never smoked I'd still have made those pieces. Hopefully. One of the best things that ever happened to me was being able to afford to smoke. Fantastic. I loved it. Lovely situation, that. I got addicted to smoking when I couldn't afford it. That was horrible. On the lookout constantly for when you can ask someone for a fag, 'cause you've already asked them three times in a row. Really listening to what they say, when all you want is their fags.

[*Pause.*]

Whose going to wash your blow-up doll when you're too old? 'Hey, Maia, you couldn't wash me blow-up doll, could you, love? I'll be home in a bit.' That happens. Guaranteed that happens. 'Terry, you never wash your blow-up doll, it's disgusting.' 'Oh sorry, love.' [*Laughter.*] It's funny. But it's guaranteed that's a normal occurrence, somewhere. There's some bloke with a puncture kit repairing his blow-up doll as we speak. Can't afford to buy another one. Once you mend a puncture on a blow-up doll you're having a serious relationship with it.

Work in progress, Goldsmiths' College, 1986

INTERVIEW 10

LUNDY
THURSDAY.
20.04.00.
EVENING

<Gordon Burn>*I'm Afraid of Nothing. It's a good title. But the idea of Nothing does scare you, the way it scares everybody. You are terrified of it, aren't you?*
<Damien Hirst>Death? Actually it is beginning to scare me a bit for some reason, but it shouldn't. I can't work it out. Maybe it's just the charlie, and the booze.

Theories, Models, Methods, Approaches, Assumptions, Results and Findings (detail), 2000

I reckon you can tell by your state of mind when you're going to die. I think you know. I think everyone knows.

There's a point when you're biologically and psychologically up for it, and a point when you're not. There's a point when you just know how long you're going to live, and you know when you're going to die. That's it. If you go beyond that you're a fool. I mean, you've got technology to keep you alive as long as you like. But how alive do you want to be for how long? If you don't want to be there, what's the point? As a human being, you peak, don't you? It's not like a battery – you don't start on full cylinders. You grow, you become strong, and then you weaken. So I think that gets a bit scary. Everybody dies of cancer.

You see a career as a sort of condensed life. But it's much shorter than a life.
It's not a 'career'. You're holding a flag for something that's important. The deeper you go, the more exciting it gets. It's just relentless. The more energy you put in, the more rewarding it is. Because you're running out of energy, and it's not going to relent.

I tell you what: I was actually probably looking forward to a really ugly, messy, public death. And I'm not going to get it. 'How can the light that shone so brightly suddenly shine so pale…?' It's fucking mad out there. You can do what you like. There are no limits.

When I read this quote from Tom Waits I thought of you: 'Most of us expect artists to do irresponsible things, to be out of control. Somehow we believe that if you're way down there, you're going to bring something back up for us, and we won't have to make the trip. This is part of the tradition with artists; the problem with that is that you will have people who will write you a ticket to go to hell. Go to hell with gasoline drawers on and bring me back some chicken chow mein while you're at it.'
Love it.

Then he says this: 'The fact is that everybody who starts doing this to a certain extent develops some kind of a persona or image in order to survive. Otherwise it's very dangerous to go out there. It's much safer to approach this with some kind of persona or image in order to survive. Because if it's not a ventriloquist act, if it's just you, then it's really scary.'
I was born with a persona. Tom Waits can say that because he's older. I'm of a generation where a persona goes without saying. It's just in your toolbag when you're born. It's just part of my make-up. I've never questioned it. It's like everybody I know. You get it in your kitbag.

I'm a chameleon. That's my joy. I lie and change my mind and make things up. I'm a snake; I'm an eel; I'm a chameleon. And that's not slippery. It's truthful, to change like that.

In that area, the best thing that's ever come out of Britain, or anywhere, is the Beatles. It's a massive lesson for everyone. It's the most inspiring thing. To watch them publicly grow up in a very real arena of publicity and fame and success and everything… To see them publicly, before everybody, go through that… I was born in those years. That's what I do.

You were too young to witness it in real time. You were only born in 1965.
Fuck real time. This is even better. It's not like being there, 'cause you can't see it when you're there. I was right at the perfect point, in between that and punk, to be able to look at it from the distance you need.

If you say to me, 'What kind of music do you like?', I go, 'The Beatles.' Full stop. But if you ask the people who were there, they go, 'Well, the Beatles just did ballads, and they did country 'n' western, and they took rock 'n' roll and they took black music and r&b...'

They took every fucking kind of music. They took everything they wanted. They took the *lot*. They just took the lot. To me, that's the Beatles. They're not country 'n' western. They're not r&b. They're *the Beatles*. They just went and got everything they wanted and they're pure to themselves and they did it.

While you were there, you were going, 'Do I like the Stones? Do I like the Beatles?' There's no contest for me. The Stones are just nowhere. They're absolutely fucking nowhere. [*Crosses to the window.*] Oh, look at that little black bunny. Little cute black fucking bunny. Can you see it? There's a baby one an' all...

You set out fairly cold-bloodedly to make people love you – even fall in love with you. D'you mean as a human being or as an artist?

Both. But mainly as a person.

Yeh. But what's one man's weakness is another man's strength. I can look at myself and go, 'Oh God, I'm really fucked up 'cause I don't like being alone.' Or I can go, 'I really love being with people.' Fuck being alone. I don't want to be alone. I love being with other people. And then you can say, 'Well, that's cold-blooded.' When perhaps it's optimistic and energetic.

You can't run towards people without examining what it's like to be on your own. And I've done that. Whenever I am on my own, I just go, 'Oooh. Here we are.' But I'll do anything, hungrily, to avoid it. And when I get there, I'm like: 'Ooh. This is different.' I'm not afraid of being alone. But I work out who I am by being with other people.

Carol Gorner, DH, Frank Dunphy, 2001

When I am on my own I just totally slow down. I start idling. First of all I get the itches, and I want to pick up the phone and I want to talk to people. And then all that calms down, and then I watch a bit of telly and I start to feel as if I'm in the world…

Anyway, what d'you mean, 'get people to love me'? I'm fucking ace. It's not about turning into the Pied Piper and taking people off the cliffs. I've never done that. I don't do that. I just go, 'My way works. Hard luck. If you want a good time, come with me.'

I remember when I was a kid, my dad had a car, because he was a car salesman, and we all used to go to Addle Cragg in Leeds. And I remember going to Addle Cragg with a load of my mates and we had a great time. And the next week all these older kids came up to me and gave me these, like, toys and said, 'Next time you go to Addle Cragg, can we come?' 'Cause we'd had such a good laugh. I remember them sort of buying me off. I didn't like it. But I remember being aware that somehow us lot had gone off and we'd had a great time in the woods and it had filtered back and everyone had gone, 'Fucking hell, we had a great time with Damien.' So maybe it's to do with that.

But I also remember Sandy the dog shagging me, and my dad knocking on the window. I was looking through my legs seeing this big pink fucking carrot and showing all me mates. 'Fucking look at that! Isn't that mental!' And my dad's going, 'Get off your knees, Damien. Sandy the dog's shagging you.'

Does that answer the question? [*Laughter.*] 'I worked out I was fun when I first got into bestiality.'

Has it ever been a burden, being so gregarious?
No, not the gregariousness. It's the famous shit. That's been a burden for *ages*. It knackers me out.

Is that why you're such a fugitive person in London?
I don't live in London.

But you've given up going to almost all social events – openings, dinners, parties.
Because I represent something that doesn't exist. People talk to me as 'Damien Hirst', but I'm not. I'm Damien Hirst. 'How the hell have *you* been! So glad you could come!' It's a pile of bollocks. What's the word? 'Insincerity.' It's a massive soup of stinking insincerity. A load of lightweight alcoholics. Heavy alcoholics can't even get in.

But you keep hitting me with this thing about personality. About this infectious personality, and getting people on board. It's a nice thing to say. But if you're not careful, it can also be nasty.

If you are who you are, and you've got this power and you abuse it, then you're shite. But if you use it to your advantage and it makes everybody happy, then that's not such a bad thing.

I mean, when I did *Freeze*, I ended up on my own, mate. 'Cause I went, 'C'mon, we can kick the walls down! We can do it…' And then they all go, 'Will you shut the fuck up. We're not *like* you.' That's what happens. So having that sort of personality is not really a benefit.

But I believed it, that's the thing. And if you believe it, it's infectious. But you *have* to believe it. I've never abused my personality in order to get where I want to be. I've *used* it, but I've never abused it. It's just part of my nature.

I tell you what, it's such a let-down when you meet some of these cunts that you love to read about in books when you're a student. They seem so exciting. But you meet them in real life and they're just personality-less fucking dorks. It's so sad.

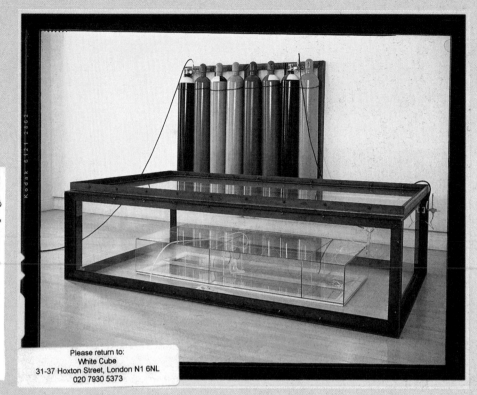

Please return to:
White Cube
31-37 Hoxton Street, London N1 6NL
020 7930 5373

In New York, one of the first things you do when you get there every trip is go to the top of the Empire State Building to look around and locate yourself.

That's the best thing to do, get to the highest point. When I used to take magic mushrooms in Leeds, I used to go up to the highest point. We used to get up and have a look down. I mean, it's the natural thing to do, isn't it? Every time I come to Lundy I want to go up the lighthouse. In Devon, I go to the top of the hill and look back at the house. You see where you are. It's a perspective, isn't it? You need that perspective. I feed the ponies. That's why I put the ponies up there. If you've got to feed them every day, then you're going to get this view every day.

It always struck me as extraordinary that you said no to Larry Gagosian at a point in your career when you felt you weren't ready. It's the sort of offer most young artists would kill for.

It's on-the-ground, goddamn stinking logic. It's absolutely right. You see your own demise there staring you in the face. I said to him, 'If you're as interested in showing me as you say you are, then you still will be in three years' time. If you're not, then I shouldn't be doing it now.' If you follow the logic, rather than follow the buzz, then that's where you end up. And the thing is it works.

Don't forget: I was an arrogant son-of-a-bitch who'd done his own shows. I didn't think I needed anybody. So there's that as well. 'You should see me in the East End you West End cunts.' I was in a dream world.

I don't think it's normal for a thirty-year-old to start coming out with great twentieth-century sculptures.

204

I don't believe in genius. I believe in freedom. I can't think that I was *that* good. I just can't believe it.

I don't think genius exists. Not where I'm coming from – not from council estates and allotments and Leeds United. I mean, Michelangelo, sure. He's a genius. But he was a genius from day one. I don't think I've got that kind of *gift* or anything. So it can only be freedom. It just means that we've not been free.

Genius is easy. Genius means that everybody isn't an artist. Freedom means that everybody is an artist. I believe in freedom. I don't believe in genius. I don't think that artists are special people. I think they're normal people who have managed to harness somehow what is important for everybody. I don't think they're *born* special. I think it's a language thing. It just suits some people. They can say more that way.

OK. I was looking for this earlier. Max Beerbohm on Dr Johnson: 'Johnson's endless sociability came of his inherent melancholy: he could not bear to be alone; and his very mirth was but a mode of escape from the dark thoughts within him. Of those the thought of death was the most dreadful to him, and the most insistent. He was forever wondering how death would come to him, and how he would acquit himself in the extreme moment.'
Signed, Dracula.

We can all always be killed at any point in the most gruesome way known to man. Always. It just doesn't make fucking sense. 'Have you washed behind your ears, love?' Slash! It's like: 'Have you flossed?' And then the beasts walk in. They fuck you up the arse and they cut your fucking head off. Or they keep you in a pit and fuck you senseless for ten days, just when you're in the middle of flossing. [*Laughter.*]

You have to laugh at everything. You *have* to.

Why?
Because if you don't... Because it's so goddam serious.

If you draw a line between what you laugh at and what you don't laugh at, then there's no point in laughing at anything. It's not on the cards. It's dumb. You've got to laugh at the lot. There's got to be a way to laugh at it all. I think a joke's like art; it's like water. It's got to be able to go everywhere. You can use humour and art as a model of the world, to see what would happen 'if'.

When does a piece of art become art?
Every artist's studio is littered with failed art. If you go through an artist's dustbin, you become an artist yourself, just by picking bits out that you like. An artist's dustbin's quite a frightening thing. You know: '*Don't* throw that away... No, that's *great*.'

I once shared a studio with Angus [Fairhurst], and I was doing a painting in the corner one morning and he suddenly goes, '*Don't!*' That's why you don't share studios with people. '*Don't! You'll ruin it!*' And then going, 'Nothing', afterwards. 'Sorry, it was nothing.' Trying to give you your space back.

And did you stop?
Of course I did. Got my own studio. We both did.

There are some driven, personal things that are very hard to make into art. And then there are other things that you discover, that just work like *that*. But they don't go out the studio if they're not art.

The hardest one I'm working on at the moment is *The Way We Were*. I've put swords in it now. It's really good. It's just so multi-layered and raises such fucking complicated questions. I've got Bradley

[DH's brother] now, trying to make the swords look old, distressing the swords. I'm wrestling with it, and I'm enjoying wrestling with it. I know what I'm up to, but it's not about words. It's a visual thing. I know about the sword of Damocles, and I know about magic acts, and I know about 'The Way We Were', and I know the way that they connect. I know about what an artist is, and what an artist was.

I haven't spent this much time on a piece for a long time. Usually I do all the work in my head, then execute it with a couple of adjustments. Whereas this one's like… It's basically failed. It started failed. It should have been discarded. But I haven't done it that way. I'm really working hard. It's much more like a collage. It's surviving in a way that has given me a new lease of life in some direction.

How does Hugh [Allan] function in that situation? Would he ever intervene to talk you away from what he thought was a bad idea, or a piece that was failing?

I work very hand in hand with Hugh, but he'll keep his mouth shut until he sees me scrabbling about in the dark. And then he'll tell me what he thinks. Because he's watched me so many times do something wrong and get it right. I'm completely comfortable with Hugh. We remember what we were both like when we grew up, so I can use him as an anchor.

Hugh's always going, 'If you turn out to be a flake, I'm not fucking working with you.' I always get that from Hugh. He's the first one. If I go, 'I'm working on this piece, and it's really important to me,' Hugh knows if it's not important. Hugh knows it in my eyes. If I tell him I believe in something when I don't, we both know.

Do you think in the early days the consumption of e helped to temper your anger?

I didn't like e. I didn't take that much of it. I only did e a few times.

I took a lot of it in one moment. Like ten e's in twelve hours. And I felt I lost a part of myself. It's a very dangerous drug.

Is that when you spent three weeks in your room, grinding down your teeth?

Yeh. It was one moment. My drug of choice is booze. I complicate that. I can't be bothered with e at the end of the day. I like it when it gets gushy. But I'm not an e person. I did it five times. But I overdid it five times. I understand about talking shite on charlie. But I've never ever had any great understanding of e.

Your drug of choice has landed you in some scrapes recently. There was the incident in Dublin last month when you dropped your trousers in the hotel bar and inserted a chicken bone in your foreskin.

I'm in the firing line. I'm being sued by this woman for getting my cock out, for $50,000. And I'm never going to get out of the firing line. I never am. And if you're in the firing line, people are going to take shots at you. There's nothing you can do about it. That's where I live now.

<Gordon Burn> What was that all about with the guy in the pub last night?

<Damien Hirst> I want a scene. I've *always* wanted a scene. I want a scene. I want a scenario. I want a situation.

DH, up chimney, Combe Martin, 2000

Damien Hirst
The Last Supper
1999
Thirteen screen prints
Each print: 60 x 40 in. (152.5 x 101.5 cm)
Photo Credit: Courtesy Jay Jopling, London

Why?

Why? Because it makes me feel alive. Even in terms of colour. I want violent colour. I want a situation. I can't help it. I don't want an *easy* life.

I seek and destroy. I'm not saying I'm hard. At school it was about being hard – the cock of the school. I'm not that. But the thing is I was very comfortable with his hatred. I like fighting. And I'm itching to go back there. And I'm itching to smash him in the face when every option's removed on Lundy.

I come here for four days, and I want to behave like I've been here for ever. *That's* my goddamn problem, d'you understand that? In *any* situation. I have to behave like I've been there for ever. I can't be a tourist. Anywhere. I come here for four days, and I've got to get my shirt off, and stand on top of the thing and go, 'You're all mine. I own the gaff.' I *have* to do it. And I don't just have to do it, I have to win.

So if you think, like that guy last night thought, that you can whisper to your girlfriend that I'm a twat, then you're going to get me coming down on you like a ton of bricks, you maggot. 'Cause I'm the king maggot. I know what a maggot is, d'you know what I mean? I am one. I live it. Arrive on the island. Disturb the island. Leave the island.

C'mon. Let's do a four-hour marathon fucking session, you cunts. *We're doing this for the good of mankind!* [*Laughter.*]

Why are you an artist and not a scientist?

Because I'm theatrical. I'm into beauty for the sake of beauty. I love the way that art doesn't really affect the world. Science affects the world much more directly. I don't want to affect the world that directly. I want to affect the world obliquely. I want to be on the wall for two hundred years rather than in your face for five minutes.

Current ageing theory has it that our bodies are designed to live long enough to reproduce and ensure the survival of offspring; after that we gradually fall apart. I've seen the elderly body compared to an automobile repair shop run by ageing mechanics. And yet the modernist fantasy persists that everyone and everything can be cured. It's definitely a fantasy.

Art's trying to find a role for itself, d'you know what I mean? It is worth doing, it does exist, and it is necessary. But it's such an awkward area. It's, like, decorative shit in need of a function; looking for a higher meaning for itself.

It seems to be partly the aesthetics of medicine and science that you like. It's a way of reining in the art, or giving it a framework to build on.

I like the idea of an artist as a scientist. A painter as a machine. The packages in *The Last Supper* and in the medicine cabinets are very, very minimal. They look like Sol LeWitts and Donald Judds. They're trying to sell the product, and they're like minimalism.

They're trying to generate confidence by looking non-consumerist?

They're not flamboyant, are they? They're not allowed to sell themselves, except in a very clinical way. Which starts to become very funny.

But I don't go that deeply into the comparison between science and art. I skim the top off it. I don't want to cure cancer. I want to exploit it; I want to expose it. I mean, I think everybody dies of cancer. I do think that. It's just another word for old age.

Where's God now? God's fucked off. So all these big issues, like art and science and cancer, are all clambering about on this barren landscape where God used to exist.

You say that there's a lot of biblical references in this new lot of work.

They're very strong stories. I've just read a book called *God: The Biography*.

It's seems to me that the emphasis now in the work is more on the humorous element, sometimes at the expense of the poetic side of the work.

I'm totally aware that if you get too romantic, you're not going to be taken seriously. Basically, people are very, very powerfully visually educated. So they know all the tricks. If you start getting maudlin, it's not going to work. They're going to sniff you out. So you've got to be ahead of that visual game.

The Last Supper, 2000

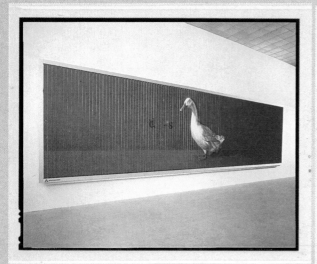
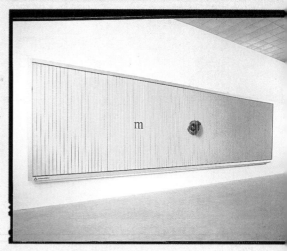

But it's not like a fear. It's constant hard work. You can't start getting nostalgic with yourself and with your artworks. You can't have that. It's got to be right there – right in the forefront. Dynamic. Bang! Never seen it before. Never knew it would come from this angle. That's what you're after.

You were saying about the Bacon interviews that they're quite heavy and serious and that there are not many 'laffs' in them because, given the climate of when they were made, that's how artists and art were seen. Art was a solemn thing.

In a way, the humour is a by-product of thinking about creating meaning through the relationships of objects. So if you're moving things round in your mind a lot, then you're looking for this fundamental, poignant relationship of two things or three things or more that says something that you're after. I mean, things in the wrong places are incredibly exciting. A full ashtray in the fridge. It's fucking out of order. But it's not that difficult to move it into the fridge. And once you move it into the fridge, people start to see it again. Or maybe it's too shocking to have it in the fridge; maybe you just put it in the sink. But along the way you get an incredible amount of hilarious things that *don't* say what you want. So the humour's almost like a spin-off of it. You know: the cucumber and the jar of Vaseline. You can guarantee that hundreds and thousands of people will look at it and think the same thing. If you go through that logic, you can't help thinking about going in the ten-items-or-less checkout at the supermarket with just the jar of Vaseline and the cucumber. 'Early night? Having an early night are you?'

Just by thinking about how a visual language works, you gets thousands of really hilarious combinations.

But by doing something like that with the cucumber and the Vaseline, you're playing with this oikish, Jack–the–lad, oy–oy image, which risks alienating perhaps your traditional culture audience.

There's a really fine line, and I'm very aware of it. I don't slip over the edge. I mean, I throw a hell of a lot of ideas away. It never goes over the top, on that level.

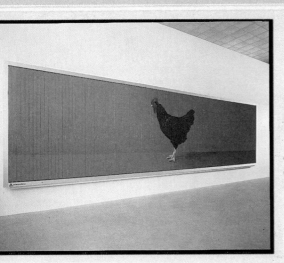

Who's Afraid of Red Yellow and Blue, 2000

This is something Christopher Gibbs once said about Robert Fraser: 'I think Robert was far too enthralled with his lower nature. I really do think he was seriously indulgent to his appetites. I mean, to a loony degree he let them rule his head and dull his heart. I don't know what he thought he was getting out of it all – after all, he was very intelligent.' That's the classic view of somebody who lived the way Fraser lived, and who presented the kind of persona to the world that you present.

I think I would disagree with that statement. I think that Robert Fraser probably had a great time. To hell with the rest of the world. If that guy who's saying that can't see what he got out of it, he's out of his fucking mind. It's like: 'Fuck off. I like chocolate; I'm guzzling it and I'm happy as a pig in shit. What d'you mean, "What do I get out of it?" I'm munching me way through Maltesers till I die. What the fucking hell else do you want me to do? You can't see what I'm getting out of it, when I could be wearing a pinstripe suit and apologizing to the dustbin men?'

What d'you mean?

It just goes back to that quote of yours: 'I find myself becoming more and more yobbish when I expected to become more intellectual.'

You can have a shit in a gallery if you want. But the moment I start thinking about having a shit in a gallery it starts to become a complicated issue, and it's got to be done right. It eventually becomes not worth doing.

As an individual, you're shattered into bits, and that's not a bad thing. But you just go, 'Look, which bit do you want? Do you want the chameleon; do you want the artist; do you want the voyeur; do you want the fucking… cupid?' Who you talking to? I genuinely believe that. There's a lot of people in your head. So there's a time and a place for everything. I think like that *all* the time, rather than going from a raucous period into a quiet period into whatever. I just think that everybody's there, and they're all different aspects of it.

With the new pale spot paintings, you looked at them and went, 'Hmmm, they're a bit sad.'
The implication was that you disapproved of that.

Now I like them.

I think they look sad, but I think they look sad in relation to the other spot paintings. After I just made them, they looked like something had gone wrong. It looked like I had tried to do those, and they had turned out like these. They looked sad in those terms. Like if you're developing photographs, they look like the ones you chuck out that didn't work. They look pale and insipid, and a bit sad and tragic. I don't know what I was after, but they've kind of changed from being insipid to being very subtle.

There's an urge in you to go for the upbeat all the time and not allow in the pale and tragic.

I don't think there is. You can say that, but if you look closely, it's not really there. But I think there's an urge in all of us to go for the upbeat. People don't tolerate other people being in a bad mood. 'Cheer up, you miserable bugger, come on…' 'Shut up wittering, it may never happen…' 'Plenty more fish in the

Naja Naja Oxiana, 2000

214

sea...' That's the way we live. So it's obviously enlarged in my work. It's exaggerated in the work, but I think it's the same thing in your life. That's what it's supposed to be about: being here now.

There's a myth about artists. They think that if you're a great artist, people will tolerate anything. But, I mean, everyone hates a fucking moaner. Leave the moaner at home. You've got nothing to say, if you're in a miserable fucking twisted mood. But you can say it massive. You can say, 'Sometimes we all get in miserable twisted moods, and it's OK.'

You said when Pharmacy was being done that you saw it like the fly piece – the people in the restaurant were like the flies, moving around.
Yeh, but in a good way. I didn't mean it in a bad way. It brought it to life. It was alive. Which was really strange. Like a baby. Like Connor's alive. Like artworks aren't normally alive. There's no 'do not touch' signs. It's not a museum. It's full on. Pumping. It's got a heart and it lives and it breathes and money goes through it.

But then there's the bind of it.

You used to think that Pharmacy the restaurant worked better than Pharmacy the installation. Have you changed your mind?
Art's special, and restaurants are boring. It dilutes it. Initially, as an artwork, it's great. But, at the end of the day, it's not an artwork, it's a restaurant. That's the whole cycle of it.

You're dealing with it as an artist. And it's a *surprise* as an artist to see people sitting around in it in a completely different way to anything you've ever seen. It's exciting and you enjoy it. And then eventually you notice that it's just another restaurant, and the real art's in the Tate. Unfortunately.

They're two different things. I mean, people go, 'A medicine cabinet's worth £200,000; what's Pharmacy worth?' But you can't double it up like that. I have very serious contracts where, if anything goes wrong, then these things aren't art. Say if Pharmacy went bankrupt, and the receivers moved in and they took all the things off the walls and they divided them up and they put them into art auctions as [individual] Damien Hirst sculptures and they all start going for £200,000, I'd be fucked. It would start to affect me quite badly. Even though they are the actual same things, they're not.

They're not art. I own them. But in my mind I don't own them as artworks. It's a restaurant, d'you know what I mean? Like the butterfly paintings upstairs. Jay's always trying to get hold of them. But, in terms of art, I would never have made those paintings.

It's an interesting reversal of the Duchampian idea of the found object. With Pharmacy, you took found objects and made them art objects by placing them in a gallery. And then you displaced them again into a life situation. It's a kind of triple-take on the idea of the readymade.

The way that I combined it all for myself in my mind was to say I want to make a great place for people to be. Which was a sort of compromise between that art-and-life thing.

Museums are for dead artists, and they're encroaching on live artists and young artists. Which is quite frightening. It's constricting. They'll be exhibiting Connor's work next, if they get the chance.

Almost a century later, people still get very agitated when they're confronted by something in a gallery that has apparently just been transferred there from its place in the world. Tracey [Emin]'s Bed is a good example. Even what you were saying about your own reaction to Sarah [Lucas]'s manky mattress in Sensation.

I think people want to be elevated. To ram back in their own faces what they've got at home is a bit of an insult. But it's not. But they think it is.

The story is everyone's trying to tell everyone else that what they've got at home is what they're looking for, you thick cunts. And because it affronts you, that means that they're dead right.

At the same time, as it happens, you were making pieces using the detritus of your life – taking Connor's toys and bits and pieces from around the house and putting them in vitrines.

Yeh, but I've always made art from what's around me. I did a bed piece in Zurich. It was called *Last night I dreamed that I didn't have a head*. It was a bed with sandwiches, condoms, magazines, all shit lying everywhere, lamps, books… It's got a hole in the bed and all the duvet's pulled into it like somebody's been sucked through the bed. And behind it in another section is a huge stuffed bear.

I mean, Tracey and Sarah did the *Shop*, which I think was one of the phenomenal things of our generation. It's a bit like *Freeze*, it's a bit like *Pharmacy*. We're constantly punctuated with these things. It's happened quite a lot. You're trying to fit into an art world that won't fit you. It's, like, if you want to sit down, you've got to build yourself a chair. It's ridiculous.

Some people have seen your work as juvenile – the equivalent of saying 'fuck' in front of your granny.

I do do that, but I don't think I do it very often. There's a hell of a lot underlying it, but I am a bit of a slut for that kind of thing. I used to do drawings of severed limbs when I was at school. Borrowing the teacher's red pen for blood, and drawing it obsessively, over and over again. Also knives, stabbings, guns… I'm definitely aware of it, but it's not that morbid. I'm definitely aware of the differences between images and reality. I think the image is something very exciting. It's in every film, every TV programme, blood everywhere and people getting killed. And it's not real. So I think we're all aware of that. I like drama. It's high drama, isn't it?

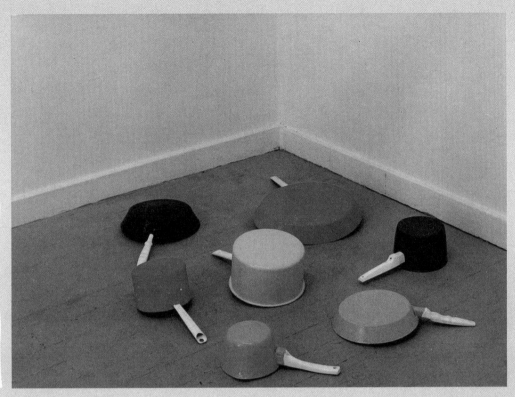

Work in progress, Goldsmiths' College, 1986

But with those things, it's a cheap shot. It's the cheap end of my shot. But I can still find a place for a punch in the face, and a slap, and a bang. I still like the idea that it says 'do not touch', you push the button and the boxing glove smashes you in the face. I'll never go off that. I'm aware that it's very limited. But sometimes you just have an image, and that's all you want to do with it. Slap somebody round the face with it.

I don't think I'll ever stop being childish like that, if that's what you want to call it. But I'm aware if you do that over and over again, that what everybody says is true.

Something like the lamb in *Some Went Mad...* was resolutely unsensational.
The 'sensational' thing that people talk about is less than 5 per cent of what I do. It's probably less than 1 per cent of what I do.

Your shorthand when you meet people is: 'I'm the bloke who saws cows in half.'
I like the failure of that, though. It's like a cartoon. Maybe I don't like that.

It's strange; we're here, having these conversations surrounded by lambs, and I've made no connection until now between what's in the fields and the lamb in the tank [*Away from the Flock*], which is one of your best-known pieces.
Maybe there isn't any connection. [*Sings:*] 'Spring is in the air...' The lamb is another religious connection. It's Jesus, isn't it? Baby Jesus.

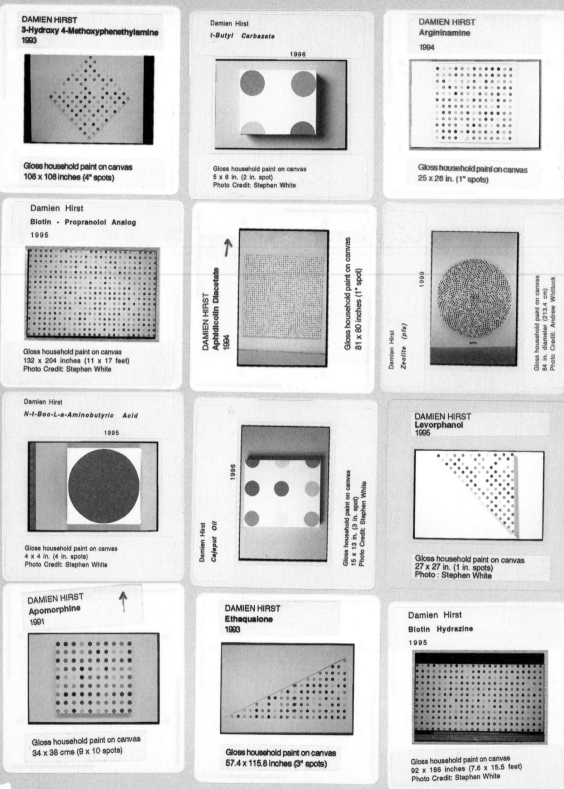

DAMIEN HIRST
3-Hydroxy 4-Methoxyphenethylamine
1993

Gloss household paint on canvas
108 x 108 inches (4" spots)

Damien Hirst
t-Butyl Carbazate
1996

Gloss household paint on canvas
5 x 6 in. (2 in. spot)
Photo Credit: Stephen White

DAMIEN HIRST
Argininamine
1994

Gloss household paint on canvas
25 x 26 in. (1" spots)

Damien Hirst
Biotin - Propranolol Analog
1995

Gloss household paint on canvas
132 x 204 inches (11 x 17 feet)
Photo Credit: Stephen White

DAMIEN HIRST
Aphidicolin Diacetate
1994

Gloss household paint on canvas
81 x 80 inches (1" spot)

Damien Hirst
Zeolite (pfs)
1999

Gloss household paint on canvas
84 in. diameter (213.4 cm)
Photo Credit: Andrew Whittuck

Damien Hirst
N-t-Boc-L-a-Aminobutyric Acid
1995

Gloss household paint on canvas
4 x 4 in. (4 in. spots)
Photo Credit: Stephen White

Damien Hirst
Cajeput Oil
1996

Gloss household paint on canvas
15 x 13 in. (3 in. spot)
Photo Credit: Stephen White

DAMIEN HIRST
Levorphanol
1995

Gloss household paint on canvas
27 x 27 in. (1 in. spots)
Photo : Stephen White

DAMIEN HIRST
Apomorphine
1991

Gloss household paint on canvas
34 x 38 cms (9 x 10 spots)

DAMIEN HIRST
Ethaqualone
1993

Gloss household paint on canvas
57.4 x 115.8 inches (3" spots)

Damien Hirst
Biotin Hydrazine
1995

Gloss household paint on canvas
92 x 186 inches (7.6 x 15.5 feet)
Photo Credit: Stephen White

When the lambs were trying to get into the church last night, I became aware of it. The lambs all up the old church steps. 'Tell Him I sent you. I know Him.' I became aware of my own lamb in formaldehyde, all tragic with its fleece needing washing.

You're just looking out for something that says what you're trying to say.

I think that most people would have missed the biblical reference of *Away from the Flock* and seen it as nakedly autobiographical, depicting yourself.

I don't think so, but I'm not sure. For me it was about taking something out of the world and killing it to look at it. It's away from the flock in the same way that the scientist in *A Way of Seeing* is away from the flock. It's just that fucking failure of trying so hard to do something that you destroy the thing that you're trying to preserve. I mean, it's not a 'preserved' lamb. It's a fucking dead lamb. But then it has a kind of new life. It looks kind of sprightly and gambolling. Gamboller. There's a tragedy to it. I went, 'Ooh, yeh.'

A lot of the good things about the things you make happen after the fact, or are happy accidents. Like when I did the cow and calf [*Mother and Child Divided*], the feet didn't touch the floor, and I liked that. It was an accident. I measured it wrong. But because it didn't touch the floor, it just elevated it into this really floating thing, which looked great. Transcendental.

That statement of yours which I think we've touched on before, about people thinking you were using formaldehyde to preserve an artwork for posterity, when in reality you were using it to communicate an idea – that's a difficult concept to get your mind around, in a way.

You've got it in art all the time. What are you trying to keep alive: the original object, or the idea? I mean, have you seen the Manzoni balloon, *Artist's Breath*? It's become a bit of snot on a bit of wood. And it's changing hands for... It's a really tricky one. Manzoni could have sold with it a couple of bottles of his own breath.

It's conceptual art. If the shark gets fucked up, buy another shark. I don't mind. If the water leaks, put some more water in it. If the glass breaks, get another bit of glass. The whole thing's totally replaceable, if you want to replace it. People decide in the future.

I mean, if you get Ellsworth Kellys and they've been repainted, they're not worth as much as the ones that have got the original colour. Whereas Ellsworth Kelly said he didn't mind them being repainted. He said he wanted them to look glossy and slick. But the whole art world goes, 'Nononononono...' 'Don't touch that. It's a Hirst.' I had some bloke shouting that at me when I was having a wank the other day. [*Laughter.*]

So what is authenticity?

I absolutely don't give a shit. It's not my problem.

I want my art to have an existence similar to my own. My art is intangible; it's intransigent; and it's fucking sublime. I can't be fucked with dealing with the decay of my own art. I'm dealing with the decaying of myself. Get down the shop and get another mackerel.

You've always seen the spot paintings as a single piece: one thing. You've stopped making them and so the piece is finished and now you're planning to bring all 300-plus spot paintings together for the first time.

Twelve rooms. It's going to kill people dead. I think kids will run round screaming, loving it, and I think other people will get lost, like in a maze. You won't know up from down. It'll be like being in a ship and just cutting the fucking ropes in the middle of a storm. You'll just be lost. Once you've got more than four, you've got nothing to compare them to. You're in completely white rooms. I think you'll get panicked. I think it'll cause a... I think you'll get scared. They'll scare you. Unless you're a child. Children will love the joy of it. Whereas it's very difficult for adults to enjoy that kind of thing.

Like Groundhog Day.
Worse. You lose your security. *And* they're very fucking seductive. So you get seduced into something you don't want. It's a place you don't want to go.

It's something I've been excited about for years. Ever since I first started making them. Just making an installation of all those spots. It's an assault on your senses. They grab hold of you and give you a good shaking. As adults, we're not used to that kind of shit. It's more shocking and more cheap than any kind of gory image.

Seeing them all together would tell you a lot about, say, crowds. 'Lonely in a crowd.'
They're a fantastic symbol of the idea that you don't have to touch me to affect me. In a really fierce way. It's an amazing fact that all objects leap beyond their own dimension. Nothing will stay still and stay in its place. Everything just jumps out and grabs you. That's how advertising works.

They've become Damien Hirst, haven't they? They're a logo?
I think that's to belittle them. I think they're more than that. They really are powerful.

I had a meeting with Nick Serota and he doesn't believe it's a great show. I mean, no one can see it but me. They can't see what I'm talking about.

It's just like pulling faces at someone, over and over again, repeatedly. It's just a shock. They're all different versions of the same thing. You won't be able to get it out of your head.

It was supposed to be an endless series. But I'm not On Kawara. I'm Damien Hirst.

We've touched in the past on that Lisson generation of artists and how for a while they produced some good work. What happened there?
I think they just relaxed. I don't think you can relax as an artist. Ever. There's no easy lives. You're going for it. It's constant. Twenty-four hours a day.

They relaxed. They were explorers. And they sat the fuck down. If you're an explorer, you've got to explore. They got out of the driving seat and let Nicholas [Logsdail] get in the driving seat. And he drove them off the fucking cliff. There's no one to blame after that.

Earlier today you said, 'I love art. It's great hanging something on your walls that you can have a relationship with, day by day.' But you haven't got a lot of art on your own walls at home.
Because I've only just got used to my fucking walls. It's creeping in there now. I've only got used to the fact that the house isn't going away. I've only just got to the point where I trust it enough not to go away.

It's going to look like a curiosity museum by the time I've fucking finished. It is.

I walk in there and want it to look like I've been there for sixty years, from day one. And it's ridiculous.

Because you spend sixty years in there, and it does. I want it now. And by the time you get it you're dead. So don't go rushing towards that black shadow, young sir! [*Laughter*.] It's creeping towards you, cheeky-pants.

It's going to be a great book of interviews, this. [*Laughter*.]

It does take it out of you, doesn't it, talking?

Enough about me. Anyway, what do you think about me? What do you think of the spin paintings?

Not much.

I don't like them much. No, I think the spin paintings are good. But they're fucking overpriced. That's all it is. They cost £500 to make. I could have sold them for a thousand quid, all through my career. They're a miracle of technology. They give you a headache after a while. They make you feel sick.

I tell you what it is, I really like making them. And I really like the machine, and I really like the movement. The movement sort of implies life. Every time they're finished, I'm desperate to do another one. The moment they stop, they start to rot and stink. But it's so much fun to actually make them. I've

Spin Machine, Minet Road Studio, Brixton, 1995

got a video of David Bowie trying to stick his watch in one. I think he thought I painted them by hand. I said, 'Wear some old clothes,' on the phone. So he turned up all Gucci-ed up. And he's got gloss paint on his scalp, up his neck, on his watch… He wanted to make a painting with me. When we were finished, I said, 'You better pick up a bottle of turps on your way back to the Bahamas, Terry.' [*Laughter*.]

How do you feel about *Modern Painters* [part owned by David Bowie]?

The magazine? I find it amusing that it's the bestselling art magazine in Britain. It figures, I guess. It would be, and it is.

Bowie's trying to harness the power of art for his own good in his own work. And he's just failing miserably. He's basically trying to turn David Bowie the musician into David Bowie the artist. Which is just sick. [*Pause*.] I'm going to be so proud of myself. Little kids are going to love my punk attitude. [*Laughter*.]

INTERVIEW 12

LUNDY

SATURDAY.

22.04.00

Theories, Models, Methods, Approaches,
Assumptions, Results and Findings (Installation, Gagosian Gallery), 2000

DAMIEN HIRST Theories, Models, Methods, Approaches, Assumptions, Results and Findings, September 22 to December 23, 2000
Gagosian Gallery 555 West 24th Street, NYC

<Gordon Burn> The publicity surrounding the £1 million that Saatchi paid for *Hymn* immediately guaranteed it some kind of iconic status, even before it had been seen. Presumably this was all factored in, and becomes part of the life of the work?

<Damien Hirst> I think all publicity helps everything. Except maybe your personal life. I don't think it's a bad thing.

You still believe inches make miles?

Yeh, but I don't mean column inches. I mean in terms of the journey.

As long as you're open and honest and naked all the time, then the media can't touch you.

You weren't all that open about your drug-taking, for instance, until recently.

I was *very* open about it. But I didn't talk about it to journalists. As I've said, I had the best two years of my life on drugs. We used to celebrate. I used to walk in the Groucho Club with my arm in the air going: '*Chop 'em out!*' And I used to love it. So it didn't used to seem like news. But then suddenly when it changed into something else, that's when it became news.

I mean, it's illegal, for fucksake. You don't want to talk about it while you've got it in your pocket. That's dumb. It's against the law. I suppose you cross the line from an artist into a celebrity. And people who don't know much about art can treat you a little bit like [Michael] Barrymore or something. But at the end of the day you're a hell of a lot more like Bacon than you are like Barrymore, and it's not news.

But you can't constantly talk about what's going on, you know? Some things are embarrassing, and you don't want to talk about them sometimes.

Do you think you hadn't got your mind around the drug thing, and what it meant, and why you did it?

I just think, as you get older, your relationship to it changes. It used to be funny and amusing, and we used to all laugh when we didn't make meetings and we stayed up all night. And then somehow you're not laughing any more. You're kind of making excuses, and you're a bit embarrassed.

DH, Grape-picking, Vendange, 1983

Can't say I've noticed.

Well, I still stay up all night and miss meetings. But not as much. The difference now is that I can find myself thinking, Shit, I wish I hadn't done it. Whereas before, I was going, 'Who gives a fuck! Let's go!'

Do you regret that quote in *Sunday Sport* about Keith Allen having your cock in his mouth to test the extent of your homophobia?

It was the *Sunday Sport*! 'World War II Bomber Found on Moon.' Why are they suddenly going to start taking it seriously because it's about me? If they said, 'Damien Hirst is a heterosexual', in the *Sunday Sport* I'd be worried. I'm not a homophobe. I'm too aware of it for it to be a problem. I'm from Leeds, get your knob out.

Do you think that's possible? It could be so deep-seated that you can't handle it in a rational kind of way.

I think it's very difficult to have any kind of fascist artists. I think it undermines it. You've got to be very open. I think it's very difficult to have locked rooms in your mind if you're an artist.

There have been fascist writers.

Yes, but only in very high, passionate times of the planet.

I mean, you can paint *Guernica* if you feel passionately about something. I don't think the world is in a clear political crisis. But I think in a clear political crisis you can get fascist art. You can make art for the Third Reich when it's on its rise. But I don't think you can make fascist art in a pub in Vauxhall.

How often do you think about your work?

Constantly. *Constantly.* It's insanely obsessive. I do it when I'm *with* people.

Talking about one thing and thinking about something else?

I do it all the time. I've done it all my life. I'm constantly doing it. And then occasionally when it builds up, sometimes I've got to switch off and go and lie down. Or go to the toilet. I go to the toilet so I can sit down and have a think. In the Groucho Club.

Do you ever go to the toilet and physically make notes, about an idea or an overheard or a joke?

Yeh. I mean, I used to remember everything. But then sometimes you start forgetting. I wake up in the morning and I've lost a few things, and I hate it. Because I've been pissed. I've got a lot of train tickets with things written on them.

I've got the feeling that you've got a fantastically sophisticated filter system going, and that anything that might end up producing a good piece of work, you would jettison all the rest of the night's memories and goings-on in order to hold on to that.

Sometimes you wake up in the morning and it's meaningful, sometimes it isn't. Odd times, you can't retrace it; you can't recapture it. And that's really annoying. Now I write them down on train tickets.

If you're on the lookout for things, then whatever you see you've got to react to. You can't start pretending you haven't seen it. That's the only thing. I wrote something down Jay [Jopling] said to

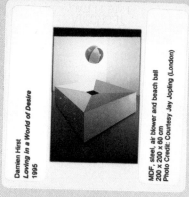

Simon Browne the other day, 'I just did a humungous shit in your new house.' I don't know how I might use it, but I liked it a lot.

Towards the end of his life, Duchamp said that all artists since the time of Courbet had been 'beasts' and should be put in institutions for exaggerated egos. 'Why should artists' egos be allowed to overflow and poison the atmosphere? Can't you just smell the stench in the air?'

Art is theatre. And it's very difficult to get on a stage without creating an ego problem. Especially after the performance when you're knackered. You start to be able to unravel it when you compare it to theatre. But once you're shoving it really close to religion and things like that, then it starts to stink.

But if you're standing out on a limb, it's very difficult not to have an ego, when you pull it off. I mean, you're looking way out of the present, into the future. So the people around you are going to look at you, and they're going to start to resent the fact that you're not concentrating on being here now. You spend a lot of time not being there as an artist. And that can be interpreted as an ego problem.

Is it a problem not being able to draw a line between your personal life and your working life? Most people clock on and clock off. I've always thought how lucky they are to be able to do that.

I always think of it like that painting by Bacon, and by van Gogh. *The Artist on His Way to Work*. Which always seems ridiculous. But I love it, just because when you're an artist then you're always an artist. So where the fuck are you if you're on the way to work? It creates this existential dilemma. Which is why I think Bacon copied it. I'm sure van Gogh was going, 'What the fuck *am* I?' And that's why it's such a great painting. Because you've got to get from A to B. And the artist does go to work. But to be suddenly looking at the world and thinking about it...

I mean, I remember when I was young having arguments with girls, who were going, 'It's either me or your painting.' And I'm going, 'Well, it's my painting. Fuck off.' D'you know what I mean? But to have the clarity of mind while you're walking to work and knowing that there's nowhere to go and you are an artist – it's a great thing to do.

You do have to have a cup of tea in the morning with your wife, and your cornflakes; put your backpack on, and walk down the street. 'Bye, honey!' I mean, I've got to do it in Gloucestershire. I've got to go to work.

It's like taking what's in the wings and putting it centre stage. And that's what art's all about.

For some reason it makes me remember Andy Warhol's instructions to two of the actors in one of his early films: 'Just start talking about your life, and at some point one of you take your pants off.'

That to me makes me think he's an absolutely phenomenal director. I did read the other day that Lou Reed said that most of the time Warhol didn't have any film in his camera. He was just using it to hide behind. Which is a fantastic idea.

It's inevitably exhausting, trying to record what's happening while it's happening. Every time, you always fuck it up. If you record it, you fuck it up. That's probably why Warhol was great. Because he just accepted it and did it.

Life scares me. And the media's just a very crass way of recording life. Hopefully, by getting involved in it you can refine it. As an artist. Same as anything else. It's a tool. You try to redirect it.

Some of your contemporaries are still shy of it.
I think they're probably nervous of *me*. A lot of people I think are nervous of me. Because I'm just a fucking cunt. If I died they could all get on with it. But I won't. And when I don't, it's like: 'Oh God, he's still here. Bastard.'

A quote from David Cronenberg: 'I think I can say without any fear of contradiction that my life is completely meaningless. Although it feels kind of interesting in my mouth as I say it.'
I think life's completely meaning*ful*. I think everybody's life is completely meaningful. I mean, we're all the star of the show.

That's why I say I'm Matisse. Cut us all in half, we're all the fucking same. Even the moaners. We're all complicated biological fucking lifeforms. Amazing. Everything is just so fucking complicated, whichever

FUJIFILM RDPII 14760 CE AGGD

please return to **science** ltd.
2 bloomsbury place london wc1a 2qa

The History of Pain, 1999

DH, Bill Hirst, Horseforth, Leeds, 1967

angle you look at it from. Art's a puff. There's no need for this overabundance of complexity. It's ridiculous. Isn't it, darling? [*Laughter.*]

More questions!

I'm looking for some.
Unlucky for some! Thirteen!

Right, Nathaniel Hawthorne. *Fanshawe.* 'If his inmost heart could have been laid open, there would have been discovered that dream of undying fame; which, dream as it is, is more powerful than a thousand realities.'
Yeh, if you're a cunt.

What's the point of being remembered after you're dead? You've disappeared. You are no more. You're just a name.
Fuck off, we're *en masse*. This is a group planet. It's a fucking group effort.

Some people want to push the boat out and get everybody on board. Everybody wants to be remembered, but remembered for what?

I don't, actually.
Well, you probably won't be. [*Laughter.*]

It's just the facts. The mark you make on this planet and the effect you have on this planet are going to outlast you. You can't avoid that. If you do something well, if you do something nice, it's going to last.

But most people's marks are negligible marks.

It depends what you want to do. You don't want to be remembered for the sake of being remembered, which is a lot of people's fuck-ups. That's stupid. They want to pull the wool over people's eyes, and bullshit and manipulate their way into the history books. And I'm sure a lot of it goes on. But in the whole scheme of things, it's bullshit.

At the end of the day you want to be remembered for noticing what was going on and helping to channel it in the right direction. I want to be remembered for brightening people's lives up. First and foremost, the people around me at the time. From the cradle to the grave, everything I ever experience I will guarantee can be transformed into a universal truth that will be meaningful to people on a much larger scale as long as I take out my personality and present it in a global fucking fashion. We all feel like a died-out cigarette now and again. Everybody gets into dark holes. And it's always reassuring to find out you're not the only one. Always.

In the new work, there's more inputting of your personality and your life, isn't there? You're more interventionist?

But I only chose things out of my house that represent real things in everyone's houses. I would never take something that's so personal that it's only meaningful for me. I only look for things that are universally true to everybody. Or try to.

Or something that means something to me which is locked. It's a locked secret that people can see. There's a secret of mine locked in an object that they can't see. But they can see the object locks and holds the secret, so they realize they've got their own objects that have these secrets locked within them as well. And that's a universal truth.

But I would never open one of these secrets. Because people are not interested in me. They're interested in themselves.

You've been sneakily looking at Proust again. 'The past is hidden somewhere outside its own domain in some material object which we never suspected. And it depends on chance whether or not we come upon it before we die.'

Well, there you go. That's why I say I'm trying to avoid nostalgia.

A lot of artists try to extrapolate from the personal. Artists and writers.

My personal life is my own. My personal life is my personal life. And nobody wants to get involved with anyone else's personal life unless you're having a very heavy direct relationship with that person.

I don't see *how* you can communicate how you *really* feel if you're an artist. If you're an artist I don't see how you can communicate how you really feel through your art.

Art is traditionally seen as self-expression – expressing the self.

I've talked about that before. It's impossible to be able to achieve that. Yet everything is an expression of the self.

You have to be able to attain what you attempt in art. You *have* to be able to attain it. If you can't attain it, the whole world is fucked.

And these things you talk about, I don't see how you can attain them. I don't see how you can publicly communicate personal ideas on a massive scale. Because it's like it's a quiet moment between two people with two sets of eyes. I don't see how you can recreate that on a large scale. It's fucking cursed. You can't do it.

Listen. Even when I'm miserable I love it. That's just me. I boldly presume, if people can understand that, then it's a good thing. I mean, I'm happy when I'm miserable. I really am. 'There's money to be made in misery.' [*Laughter.*]

I tell you what, if God just walked over that hill now and went, 'Hi, boys', I would fucking punch his lights out and smash him right in the fucking face. And if he doesn't know what it's for, then he's a bigger fool than I thought he was. I'd pin him to the floor with my boot on his neck, all-powerful though he is. I'd punch his lights out for this fucking fabulously optimistic planet with fuck-all behind it. 'What d'you mean? You can't give me all this and then take it away.' It's insane. I'd have to smack him in the fucking face.

That's it. That's life and death in a nutshell.

A lot of people would say you were a vulgar little yob. What would you say vulgarity was?
Life with the crusts cut off. [*Laughter.*] Definitely. That's vulgar. Eat the fucking crusts, you cunts. I mean it.

Fucking gorgeous though, isn't it?
[*We're sitting on a cliff on Lundy looking across to Ilfracombe and the coast of North Devon, the sun shining; gulls wheeling.*]
Jeezuschrist. What a huge planet. What a still, calm day.

Look at that. Twenty miles. That's where I live. That's where we're going. I live over there.

DH, Blackpool, 1968

This book is dedicated to Tina Gier

Photo Credits
© Damien Hirst
cover, end papers, pages: 5, 23, 33, 47, 48, 56,
59, 64, 70, 78, 87, 97, 109, 118, 121, 123, 124,
130, 138-139, 161, 163, 166, 170, 185, 187,
194, 195, 197, 209, 217, 224, 226

© Maia Norman
pages: 4, 6, 44, 46, 53, 61, 69, 72, 92, 98, 104,
105, 113, 132, 146, 149, 152, 157, 165, 174, 203

© Damien Hirst/White Cube
pages: 9, 13, 15, 17, 18, 21, 26, 28, 34, 35, 36,
45, 52, 75, 76, 84, 85, 94, 106, 111, 143, 151,
176, 177, 181, 183, 204, 210, 218, 227

© Science
pages: 24, 88, 91, 102, 114, 117, 128, 129, 135,
137, 142, 144, 150, 155, 164, 169, 189, 191,
193, 198-199, 211, 212, 213, 214, 222, 228

© Mary Brennan
pages: 31, 58, 74, 173, 223, 229, 231

© Hugh Allan
pages: 32, 207

© Simon Browne
page: 38,

© Rachel Howard
pages: 40, 42, 49, 50, 54, 63, 66, 73, 81, 221

© Connor Hirst
pages: 89, 90, 215

© Jay Jopling
pages: 101, 110

© Frank Dunphy
pages: 141, 158, 190, 201, 206

© Gordon Burn
pages: 178, 179

*We're grateful to the following photographers
for the use of their work:*

Alex Hartley, Marcus Harvey, Robert McKeever,
Anthony Oliver, Mike Parsons, Stephen White,
Andrew Whittuck, Gareth Winters, Edwrad Woodman

PAINTING

INVENTION

HISTORY

FAMILY ———— FRIENDS ———— people selling the art then give them ART

GOD MORALITY not sure about these

LOVE

COMEDY

FEAR

MY ART / MY LIFE (2 seperate things?)